Chinese Writing and Calligraphy

WENDAN LI

Chinese Writing and Calligraphy

A Latitude 20 Book

UNIVERSITY OF HAWAI'I PRESS

HONOLULU

14 13 12 11 10 09 6 5 4 3 2 1

Library of Congress Cataloging-in-Publication Data

Li, Wendan.

Chinese writing and calligraphy / Wendan Li.

p. cm.

"A Latitude 20 book."

Includes bibliographical references and index.

ISBN-13: 978-0-8248-3364-0 (pbk. : alk. paper)

ISBN-10: 0-8248-3364-3 (pbk. : alk. paper)

1. Calligraphy, Chinese. 2. Chinese characters. 3. Calligraphy, Chinese—Technique. I. Title.

NK3634.A2L4975 2010

745.6'19951—dc22

2009047054

University of Hawai'i Press books are printed on
acid-free paper and meet the guidelines for permanence
and durability of the Council on Library Resources

Designed by Julie Matsuo-Chun

Contents

..

Preface

This book is a collection of teaching materials I accumulated over the past ten years, during which I taught the course Chinese Culture through Calligraphy at the University of North Carolina at Chapel Hill. The materials and the order of topics were tested and revised throughout these years. They reflect special concerns in teaching Chinese calligraphy to college students in the West who may not have any background in Chinese culture and the Chinese language. For these students, the instructor needs to be meticulous not only in demonstrating the details of the techniques, but also in explaining cultural manifestations, significance, and differences. The goal is to make the traditional Chinese art reverberate on the harp of the American brain, which has been tuned to the scales of Western culture.

I had rich resources to draw from when writing this book. The long history of Chinese culture, language, and calligraphy and the numerous scholars who studied and wrote about Chinese calligraphy or simply practiced the art were a joy to read about and to reflect on. I learned a great deal from the works of many other scholars who are pioneers in introducing Chinese culture to Western readers and who wrote extensively about Chinese art and calligraphy in English. Notable among them are Yee Chiang, Yuho Tseng, and Da-Wei Kwo. I am deeply grateful to the late Tsung

Chin, professor at the University of Maryland. It was through working with him on a collection of papers following the First International Conference on East Asian Calligraphy Education in 1998 and also through our personal conversations that my idea of offering a Chinese calligraphy course started to take shape.

I wish to express my gratitude to the Grier/Woods Presbyterian China Initiative and to the Freeman Foundation for fellowships and travel awards I received through the University of North Carolina at Chapel Hill that allowed me to work on this project, to the Boardman Family Foundation for their support in my teaching and research, and to the Department of Asian Studies of the University of North Carolina at Chapel Hill for its support in furnishing optimal teaching facilities for the Chinese calligraphy course I teach. I have also benefited from presenting parts of the materials in this book and discussions of course design at conferences, including the International Conferences of East Asian Calligraphy Education (2004 in Columbia, South Carolina, and 2006 in Hiroshima, Japan) and annual conferences of the Chinese Language Teachers Association.

I owe a special debt of gratitude to Dwight St. John, Kay Robin Alexander, Carl Robertson, and two anonymous reviewers for their careful reading of earlier drafts of the manuscript and their invaluable advice and suggestions for revision. My sincere thanks also go to Susan Stone for excellent copy editing and to Keith Leber of the University of Hawai'i Press for his assistance throughout the publication process.

I would like to thank calligraphers Xu Bing, Harrison Xinshi Tu, Ren Ping, Mao Rong, and Wang Chunjie for permission to use their artwork in this book. Thanks also go to the National Palace Museum, Taiwan, for their permission to use images from their collection as illustrations. Sources of other illustrations, for which I am also grateful, are mentioned in the captions of specific figures.

To the students at the University of North Carolina at Chapel Hill who took the Chinese calligraphy course with me over the past years, I say thank you. Your learning experience and feedback on the course played an important role in shaping this book.

...

Introduction

Chinese calligraphy, 書法 *shū fǎ* in Chinese, has been considered the quintessence of Chinese culture because it is an art that encompasses Chinese language, history, philosophy, and aesthetics. The term's literal translation, "the way of writing" (*shū*, "writing," and *fǎ*, "way" or "standard"), identifies the core of the art, which has close bonds with Chinese written signs, on the one hand, and painting, on the other. In China, adeptness in brush calligraphy is among the four traditional skills that cultivate the minds of the literati, along with the ability to play *qín* (a stringed musical instrument), skill at *qí* (a strategic board game known as "go" in the West), and ability to produce *huà* (paintings). In the modern age, *shū fǎ* is known worldwide as a unique type of art, representing one of the most distinctive features of Chinese civilization.

To people in the West, Chinese calligraphy symbolizes a complex, distinct, remote, and mysterious cultural heritage. These perceptions stem in part from differences between Eastern and Western worldviews, but the written signs themselves also present a seemingly insurmountable barrier. However, Chinese calligraphy is also fascinating and attractive in Western eyes. Recent advances in communication between China and the rest of the globe have piqued interest in China's culture, language,

worldview, and way of life. Both within China and elsewhere, knowledge of Chinese calligraphy is seen a mark of education, creativity, and cultural sophistication.

THIS BOOK

This book introduces Chinese calligraphy and its techniques to anyone with an interest in Chinese brush writing. It does not presuppose any previous knowledge of the Chinese language or writing system. The chapters are designed with the following objectives: (1) to describe in detail the techniques of Chinese brush writing at the beginning level, (2) to provide high-quality models with practical and interesting characters for writing practice, and (3) to introduce linguistic, cultural, historical, and philosophical aspects of Chinese calligraphy. In the discussion comparisons are made with Western culture and characteristics of the English language and calligraphy. The book consists of fourteen chapters of text supplemented in an appendix with models for brush-writing practice.

Detailed instruction in brush-writing techniques form the heart of the book. A standard training procedure is outlined first, followed by a detailed examination of three fundamental elements of Chinese calligraphy: stroke techniques, the structure of Chinese characters, and the art of composition. Training in brush writing begins with brush strokes in the Regular Script. According to the traditional Chinese training method, domestic calligraphy students always spend a substantial amount of time mastering the Regular Script before moving on to other styles. Learners in the West, however, generally prefer to have the opportunity to learn about and practice writing various scripts. Therefore, this book focuses on basic brush writing skills in the Regular Script in the first half and then introduces Small Seal Script, Clerical Script, and Running/Cursive styles in the second half.

Learners are exposed to a diversity of script styles. They are not expected to master them by the end of this book, although some students, with repeated practice, may be able to write some characters in a particular script quite well. Some learners or instructors may prefer not to practice all the scripts introduced in this book. Instructors or individual learners can decide the number of additional script types to be included in the course of study, whether hands-on writing practice is done for all of them, and the amount of time to be devoted to each script. Serious students will no doubt need further training and practice in order to gain competence in artistic and creative production. For this purpose, the reading list at the end of this book provides some resources for further study in English.

The book also describes in detail the formation of Chinese characters, their stroke types, stroke order, components, and major layout patterns. Many of the explanations given here are not found in other calligraphy books. The book title *Chinese Writing and Calligraphy* well reflects this special feature. The history of the Chinese calligraphic art is presented through a review of early Chinese writing, the

development of different writing styles, the ways in which calligraphy is adapting to the modern age, and the ongoing debate on the future of the time-honored traditional art. Cultural aspects discussed in the book include writing instruments (their history, manufacture, and features), Chinese names and seals, the Chinese worldview (for example, the cyclic view of time), and the Daoist concept of yin and yang as a fundamental philosophical principle in Chinese calligraphy.

Model sheets for brush-writing practice are designed to accompany the discussion in the chapters and to provide opportunities for hands-on writing practice. Learners are guided from tracing to copying and then to freehand writing. Single strokes are practiced before characters, which are followed by the composition of calligraphy pieces. Writing skills are developed in the Regular Script first. Then opportunities are provided for learners to write characters in Small Seal, Clerical, and Cursive styles so that they can explore and identify their personal preferences. The selection and arrangement of model characters reflect a number of considerations. Preference is given to characters that serve practical teaching and learning goals or characters that frequently appear in calligraphy pieces. Repetition of characters, either in the same or different scripts, also serves specific pedagogical functions. Since no two calligraphy courses are the same, instructors or individual learners may decide to repeat or to skip certain pages depending on their specific goals.

On the model sheets for brush-writing practice, each character is marked with its meaning in English and the stroke order in Regular Script. The model characters are also sequenced by level of difficulty. After individual characters, well-known phrases are also practiced. The brush-writing models in the four script types are all based on works of Wang Xizhi (303–361 CE), the calligraphy sage of the Jin dynasty whose writing represents the peak of the art. As is traditional and to avoid confusion, Chinese personal names throughout the book are presented with the family name first, followed by the given name; the Chinese characters presented in this book are in their full (traditional) form. The romanization of Chinese terms is in Pinyin.

As will be discussed in Chapter 2, Chinese calligraphy is written on absorbent paper. Following that tradition, the learner is advised to use absorbent paper, ideally "rice paper," for writing practice. Nowadays, such paper (even with a printed grid specifically for Chinese calligraphy practice) can be purchased online or in art stores. Rice paper, which is quite transparent, can be laid on top of the model characters provided in this book for tracing.

THE CHAPTERS

Chapter 2 first describes the instruments used in Chinese brush writing, including their history, manufacture, features, and maintenance. Elementary training issues are dealt with next, including steps of the training procedure, the management of

pressure, and the roles of moisture and speed in writing. Other rudimentary issues such as brush preparation and arrangement of writing space are also discussed.

Chapters 3, 4, and 5 expound upon the basic skills in writing individual strokes. First the techniques of pressing down and lifting up of the brush are discussed and illustrated, followed by an overview of the eight major stroke types. Step-by-step instructions on how to write each stroke type are then laid out and amply illustrated. The discussion also includes variant forms of each stroke type, techniques involved in writing, stroke-order rules, and common mistakes made by beginning learners. Models for writing practice are provided. To prepare learners for producing calligraphic pieces and one's signature, cultural topics related to calligraphy are also discussed. Chapter 4, for example, offers a discussion of Chinese names, including how a Chinese name is chosen for a person based on his or her original Western name.

The next chapters proceed to the actual formation of Chinese characters. *Chapter 6* describes the nature of Chinese written signs and categorizes characters in terms of their composition. *Chapter 7* delineates the internal layout patterns of characters and some basic principles of writing. The cultural topics for these two chapters are dating in Chinese according to the Western calendar and the themes and content of calligraphy pieces.

Historical factors that molded Chinese calligraphy are presented in *Chapters 8 through 11*. Since this evolution started more than three thousand years ago, the discussion only summarizes the major line of development, emphasizing the events and calligraphy masters with a profound influence on the art. Each of these chapters deals with one script type (Seal Script, Clerical, Regular, and Running/Cursive). Together these chapters seek to foster an understanding of the historical development of the calligraphic art, to build a knowledge base for distinguishing and appreciating the various script styles, and to provide opportunities to practice the major scripts. Discussion concentrates on how each script was developed, how it differs from other styles, its main characteristics, and life stories of major calligraphers. Illustrations and model sheets are also provided. For the Regular Script, the personal styles of the three greatest masters, Wang Xizhi, Yan Zhenqing, and Liu Gongquan, are compared in Chapter 10, so that learners have a chance to examine subtle differences within one major script type. For a cultural topic, Chapter 9 describes the Chinese traditional time-recording method commonly used to date calligraphy works.

Composing a calligraphy piece is the topic of *Chapter 12*. Details of components and layout patterns are described, followed by a discussion of the making and use of the Chinese seal. *Chapter 13* explores the Daoist concept of yin and yang, and its significance in Chinese culture. This chapter also discusses how to appreciate a calligraphy piece and the relation of calligraphy and health: it will be shown that calligraphy practice is a healthy union of motion and tranquillity. The motion of calligraphy writing not only corresponds to rhythms of the physical body, such as breathing and

heartbeat, but also accords with the writer's moods and emotions. *Chapter 14*, the last chapter, examines how calligraphy, as a traditional art form, is adapting to the age of modernization and globalization.

WRITING AND CALLIGRAPHY IN CHINESE SOCIETY

All languages serve the practical function of communication. In different cultures and societies, however, language and its roles are perceived differently.

According to Jewish and Christian cultures, God created language (human speech). In Chinese culture, however, the origin of speech is never accounted for; instead, the historical emphasis has always been on writing. To the Chinese, the creation of language means the creation of Chinese characters. Credit for this invention is given to a half-god, half-human figure called Cang Jie, who lived about four thousand years ago. The ancient Chinese believed that Heaven had secret codes, which were revealed through natural phenomena. Only those with divine powers were endowed with the ability to break them. Cang Jie, who had four eyes (Figure 1.1), had this ability. He was able to interpret natural signs and to transcribe the shapes of natural objects (e.g., mountains, rivers, shadows of trees and plants, animal footprints, and bird scratches) into writing. Legend has it that when Cang Jie created written symbols, spirits howled in agony as the secrets of Heaven were revealed. Since then all Chinese, from emperors to ordinary farmers, have shared a tremendous awe for written symbols. They have venerated Cang Jie as the originator of Chinese written language. Today shrines to Cang Jie can be found in various locations in China. The one in Shanxi Province, not far from the tomb of the Yellow Emperor, the legendary ancestor of the Chinese people (ca. 2600 BCE), is at least 1,800 years old. Memorial ceremonies are held every year at both shrines.

FIGURE 1.1. Cang Jie, creator of Chinese characters (legendary). [FROM ZHOU, *HANZI JIAOXUE LILUN FANGFA*, P. 5, WHERE NO INDICATION OF SOURCE IS GIVEN]

One reason for the great respect for the written word in China has to do with the longevity of Cang Jie's invention: the written signs he created have been in continuous use throughout China's history. This written language unites a people on a vast land who speak different, mutually unintelligible dialects. It is also the character set in which all of the classics of Chinese literature were written. Using these characters, the Chinese were the first to invent movable type around 1041 CE. It is estimated that, until the invention of movable type in the West, no civilization produced more written material than China. By the end of the fifteenth century CE, more books were written and reproduced in China than in all other countries of the world combined!

The central, indispensable role of the written language in China nurtured a reverence for written symbols that no other culture has yet surpassed. Written characters hold a sacred position, being much more than a useful tool for communication. As we will see throughout this book, characters have been incised into shells of turtles and shoulder blades of oxen; they have been inscribed on pottery, bronze, iron, stone, and jade; they have been written on strips of bamboo, pieces of silk, and sheets of the world's first paper. They are on ancestral worship tablets and fortuneteller's cards; they appear at building entrances and on doors for good luck. When new houses are built, inscriptions are put on crossbeams to repel evil spirits. Significant indoor areas or the central room in a traditional residence always have brush-written characters visible at a commanding height. Decorating such halls and rooms with calligraphy is a ubiquitous tradition in China, which should not be compared to the Western tradition of hanging framed biblical admonitions, printed in Gothic letters, on the wall of an alcove. The importance of the latter resides much more in its message, whereas that of the former is predominantly its visual beauty. (See Figures 1.2–1.4).

Written characters are also an integral part of public scenes in China. Simply by walking down the street, one can enjoy a feast of numerous calligraphic styles on street signs, shop banners, billboards, and in restaurants and parks. During festivities and important events, brush-written couplets are composed and put up for public display. There are marriage couplets for newlyweds, good-luck couplets for new babies, longevity couplets on elders' birthdays, spring couplets for the New Year, and elegiac couplets for memorial services. Calligraphy works written in various styles can be purchased on the street or in shops and museums; these may feature characters, such as 福 *fú*, "blessings," and 壽 *shòu*, "longevity," written in more than one hundred ways. (See Figures 1.5–1.8).

The decorative function of Chinese calligraphy is a common sight in China. At tourist attractions, writings of past emperors and calligraphy masters or famous sayings and poems written by famous calligraphers are engraved on rocks or wood to enhance the beauty of nature. They can even be found on sides of mountains, where huge characters are carved into stone cliffs for all to view and appreciate

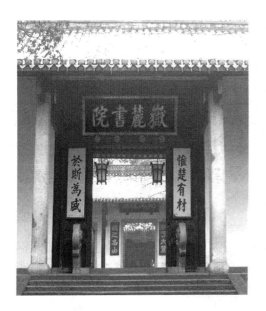

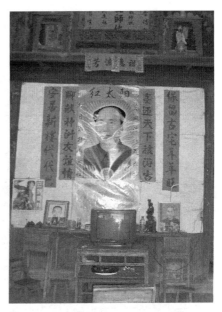

FIGURE 1.2. Entrance of the Yuelu Academy 岳麓書院 in Changsha (established 1015 CE), one of the four great academies of Northern Song China. The horizontal inscription bearing the name "Yuelu Academy" was bestowed by Emperor Zhenzong. The couplet, which reads vertically from right to left, says: "Promising scholars gather on the land of Chu; the majority of them are here." [PHOTO BY WENDAN LI]

FIGURE 1.3. Central room of a traditional Chinese house, where everything of spiritual value to the owner is displayed and worshiped, from Buddha to national leaders to photos of deceased family members. Brush-written couplets are indispensable to such a display. Photo taken in rural Guangxi. [PHOTO BY WENDAN LI]

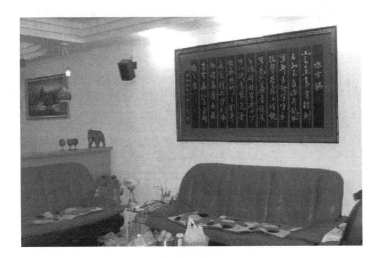

FIGURE 1.4. Living room in a modern urban residence with a piece of calligraphy carved on wood hanging on the wall. [PHOTO BY WENDAN LI]

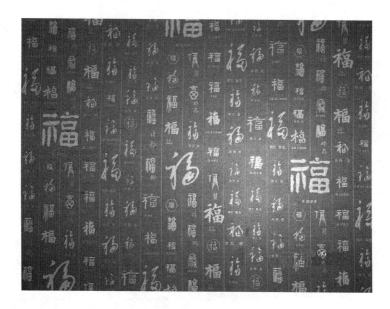

FIGURE 1.5. Wallpaper in a restaurant with 福 (blessings) in various styles.
[PHOTO BY WENDAN LI]

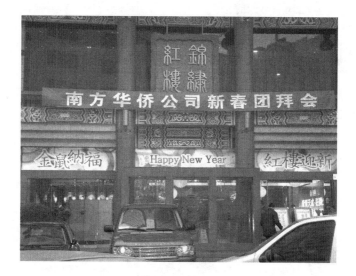

FIGURE 1.6. Restaurant sign Brocaded Red Mansion 錦繡紅樓 in Small
Seal Script. [PHOTO BY WENDAN LI]

FIGURE 1.7. Welcome sign 賓至如歸 (guests coming home) in Small Seal Script at the entrance of a modern hotel. [PHOTO BY WENDAN LI]

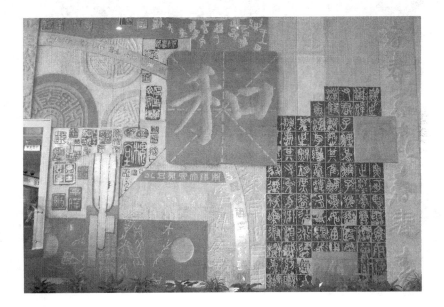

FIGURE 1.8. A wall decorated with characters at Beijing International Airport. The large character 和 in the middle means "harmony." [PHOTO BY WENDAN LI]

(Figures 1.9–1.12). The Forest of Monuments in the historic city of Xi'an and the inscriptions along the rocky paths of Mount Tai are the largest displays of Chinese calligraphy. Places well-known calligraphers visited and left such writing are historic landmarks protected by the government today.

The importance of writing in Chinese society and, more specifically, the importance of good handwriting are apparent to students of Chinese history. Before the hard pen and pencil were introduced to China from the West in the early twentieth century, the brush was the only writing tool. Brush writing was a skill every educated man had to master. In the seventh century CE, the imperial civil service examinations were introduced in China to determine who among the general population would be permitted to enter the government's bureaucracy. Calligraphy was not only a subject that was tested, but also a means by which knowledge in other subject areas (including Confucian classics and composition) was exhibited. In theory at least, anyone, even a poor farmer's son, could attain a powerful government post through mastery of the subjects on the exams. This new system standardized the curriculum throughout China and offered the only path for people with

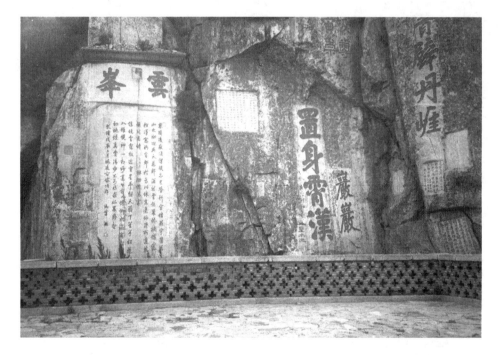

FIGURE 1.9. Daguan (Grand View) Peak inscribed wall at Mount Tai (1). Calligraphy written by emperors and famous calligraphers was carved into cliffs to praise the natural beauty and the scenery. The two large red characters on top left (meaning "peaks in clouds") were the calligraphy of the Kangxi emperor (1654–1722) of the Qing dynasty. The text below was written by the Qianlong Emperor (1711–1799), also of the Qing dynasty.
[PHOTO BY WENDAN LI]

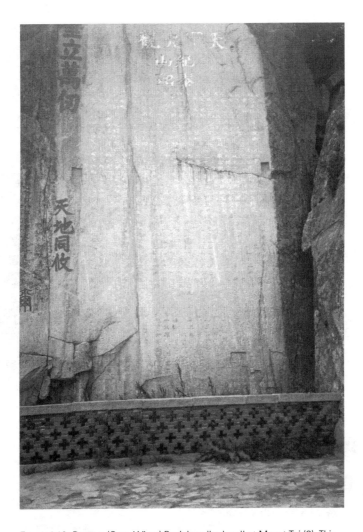

FIGURE **1.10.** Daguan (Grand View) Peak inscribed wall at Mount Tai (2). This lengthy prose text commemorating his visit to the scenic spot was written by Li Longji (685–762), a Tang dynasty emperor known for his calligraphy. Carved into the cliff in 726, it stands 43.6 feet high and 17.4 feet wide and consists of 1,008 characters. Each character is 6.5 x 10 inches in size, written in the Clerical Script. The other carvings were added later during various dynasties. [PHOTO BY WENDAN LI]

talent and ability to move up in society. Accordingly, success in the civil service examinations became the life dream of generations of young men, and calligraphy was virtually a stepping stone. From a very early age, students would start practicing calligraphy and studying the Confucian classics. For thirteen centuries, the civil service examinations were central to China's political and cultural life. They created

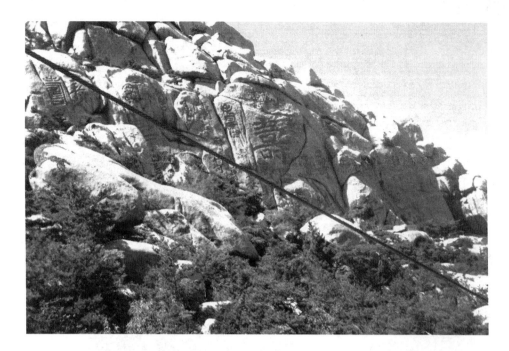

FIGURE 1.11. The Chinese character 壽 (longevity) in various styles engraved on mountain cliffs near Qingdao, Shandong Province. [PHOTO BY WENDAN LI]

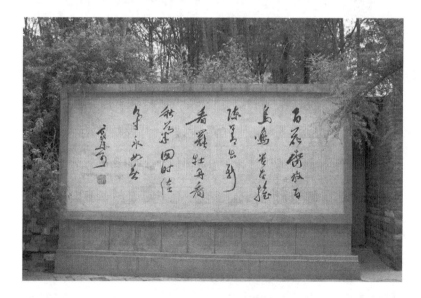

FIGURE 1.12. Calligraphy and poem by Guo Moruo, a well-known modern Chinese scholar, displayed outside the Guo Moruo Museum in Beijing. [PHOTO BY WENDAN LI]

a powerful intelligentsia whose skills in composition and calligraphy were highly valued. Consequently, in traditional China, excellence in learning, superb handwriting, and an official post were a common combination.[1]

This tradition is carried on in modern China. Today, during important events or official inspection tours, government officials often write or are asked to write words of encouragement and commemoration in calligraphy to be presented to the public. A person's learning is judged, at least in part, by his or her handwriting. A scholar's essay, however wise, is considered poor if the handwriting is inferior. Although the civil service examinations were abolished at the beginning of the twentieth century, China remains a society where good handwriting is uniquely valued.

China's rulers have played a role in promoting calligraphy. Numerous past emperors were masters of calligraphy and left their works for later generations to appreciate. Figures 1.2, 1.9, and 1.10 illustrate the calligraphy of Chinese emperors. Figure 1.13 below shows the calligraphy of Emperor Huizong (1082–1135) of the Song dynasty, who created his own style called "Slender Gold," which is still among the most popular and well-known calligraphic styles. Figure 1.14 was also written by a well-known ruler-calligrapher, Emperor Qianlong (1711–1799) of the Qing dynasty.

Writing takes place every minute of the day in every corner of the world, but in China it is elevated to a fine art that pervades all levels of society. The art of calligraphy is held in the highest esteem, surpassing painting, sculpture, ceramics, and even poetry. Yet, Chinese calligraphy is more than an art. It is a national taste, nourished in everyone from childhood on, that has penetrated every aspect of Chinese life. In China it is believed that a person's handwriting reveals education, self-discipline,

FIGURE 1.13. Slender Gold by Emperor Huizong of the Song dynasty. Collection of the National Palace Museum (Taipei). [FROM *MASTERPIECES OF CHINESE CALLIGRAPHY*, P. 8. REPRODUCED BY PERMISSION FROM THE NATIONAL PALACE MUSEUM]

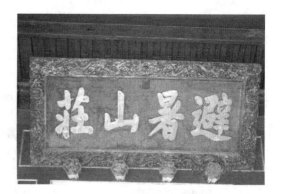

FIGURE 1.14. Signboard for Bishu Shanzhuang Imperial Palace. Calligraphy by the Qianlong Emperor of the Qing dynasty. [PHOTO BY WENDAN LI]

and personality; it measures cultural attainment and aesthetic sensitivities; and it even relates to physical appearance. Thus the instinct to judge or comment on a person's handwriting is as common as the instinct to judge people's appearance and personality. In a way, handwriting is like a person's face: everyone tries to keep it at its best. For the same reason, good handwriting brings satisfaction, confidence, self-esteem, and respect.

In modern China, calligraphy is not only a regular part of the school curriculum (Figure 1.15); it is practiced by people of all ages and from all walks of life. Although the practical function of brush writing is diminishing in modern society, calligraphy remains a widely practiced amateur art for millions of Chinese—an enjoyable pastime outside of work and daily chores. Along with calligraphy clubs, associations, magazines, and local and national competitions at all levels, prominent newspapers also publish columns on Chinese calligraphy.

Visitors to China today often notice a unique cultural phenomenon: In every town and city, in the early morning when a new day is just starting, people, old and young, male and female, gather in parks or even on sidewalks to do morning exercises. Many bring a special brush tied to a stick and a bucket of water; then they

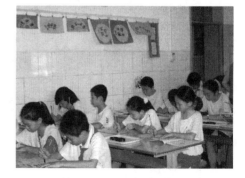

FIGURE 1.15. Calligraphy class in an elementary school in Beijing. [PHOTO BY WENDAN LI]

find a quiet spot and start wielding their brushes on the pavement. A new name, "ground calligraphy" or "water calligraphy," has been given to this new way of both practicing calligraphy and doing morning exercises (Figure 1.16). As will be discussed in Chapter 13, medical research has indicated that regular, sustained practice of calligraphy may improve body functions and is thus a good way to keep fit.

Chinese brush writing once served as the primary means of written commu-

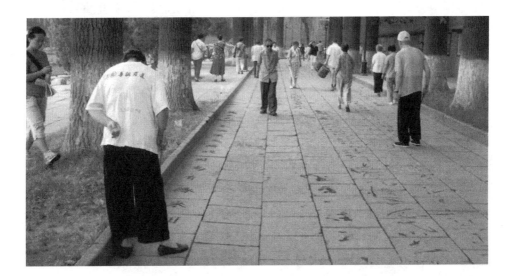

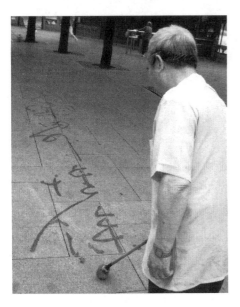
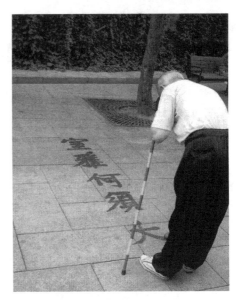

FIGURE 1.16. Ground calligraphy, 7:30 a.m. in Beijing. The writing on the right reads: "An elegant room does not have to be big." [PHOTO BY WENDAN LI]

nication. During thousands of years of practice, it developed into a fine art. In modern Chinese society, because of its combination of artistic characteristics, cultural underpinnings, and health benefits, calligraphy continues to flourish and break new ground. Love for the written word is not only present among the literati and promoted by the government, but also deeply rooted in the populace. The art of calligraphy has also spread to nearby countries such as Japan and Korea, where it is practiced and studied with great enthusiasm.

Why is writing so important to the Chinese? What makes it special and different from the writing of other languages? To answer these questions, let's look more closely at the nature of Chinese writing and then compare it with Western calligraphy.

THE ARTISTIC QUALITIES OF CHINESE WRITING

Chinese is one of the few languages in which the script not only is a means of communication but also is celebrated as an independent form of visual art. The best of Western calligraphy, for example, the scriptures written on parchment by monks in the Middle Ages and the letters written in golden ink by scribes at Buckingham Palace, exemplify its primary function as a means of documentation and communication. One might ask why Western calligraphy didn't evolve from the functional to the purely artistic, as Chinese calligraphy did. The answer has a lot to do with the nature of the scripts (see Figure 1.17).

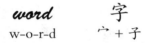

FIGURE 1.17. "Word" versus 字 (Chinese character).

Alphabetic writing consists of an inventory of letters that correspond to speech sounds. Sound symbols are simple in structure and small in number, ranging from about twenty to fifty for a particular language. The English alphabet, for example, has twenty-six letters. Each is formed by arranging one to four elements. The letter "o" has only one element; "i" has two, a dot and a vertical line; and the capital letter "E" has four elements. These elements are generally various lines, curves or circles, and dots. In writing, letters are arranged in a linear order to form words and texts. Because of the small number of letters, their frequency of use is high. Furthermore, the same letter repeated in a text is always supposed to be written in exactly the same way, except for larger or more ornate capital letters at the beginning of texts. Consequently, Western calligraphy concentrates on repetitive lines and circles.

Chinese is entirely different. Its written signs, or characters, are meaning

symbols, each functioning roughly as a single word does in English. Characters are also formed by assembling dots and lines, but there are more such elements with more varied shapes. Each element, a dot or a line, as a building block of Chinese characters, is called a stroke. In writing, strokes of various shapes are assembled in a two-dimensional space, first into components and then by combining components into characters. In the example in Figure 1.17, the character 字 $zì$ has two components, 宀 and 子, arranged in a top-down fashion. The component 宀 consists of three strokes, as does the other component 子. Generally speaking, the number of characters required for daily functions such as newspaper reading is three to four thousand. As meaning symbols, the characters have to be distinct enough for visual decoding. Therefore, they cannot all be simple in structure. Some are relatively simple with a small number of strokes, while others can be quite complex with more than twenty or even thirty strokes. Each character has a unique internal structure. The components making up these characters, for example, can be arranged in a top to bottom, left to right, or even a more complex configuration.

In calligraphy, the soft and resilient writing brush is used to vary the shape and thickness of each stroke. This tool, combined with ink on absorbent paper, makes each character distinct. When characters are put together to form a text, additional techniques create coordination and interplay not only between adjacent characters, but also among characters that appear in different parts of a text. Instead of striving to produce a uniform look, Chinese calligraphers make every effort to keep characters recurring in a text different from one another.

Generally speaking, Western calligraphy reflects an interest in ornamenting words on the page. It stresses perfection and rigidity; mastering exact duplication of letters is considered the pinnacle of the art. More modern works do overcome the traditional boundaries and allow for personal expression, but this is most often seen in high art and is hard to find from the average calligrapher. Thus calligraphy in the West is generally considered a minor art that tends to curb spontaneity. Chinese calligraphy, by sharp contrast, is an art form in which variation is the key. The freedom of personal expression or personal emotion that emanates through the work is its goal.

The ability to reach this goal depends on the nature of Chinese writing, the writing instruments, and the skill of the calligrapher. Together, these elements provide enormous opportunities for artistic expression. While creativity is the life of any art, the complex internal structure of Chinese characters and the unique writing instruments have allowed ample space in multiple dimensions for Chinese calligraphy to develop into a fine art whose core is deeply personal, heartfelt expression.

Another important aspect of Chinese calligraphy is the astounding variety of uses it serves. Western calligraphy is typically reserved for formal use such as in wedding invitations, certificates and awards, and other special documents. Its historical linkage with organized religion also places it outside the realm of ordinary human activity. In addition, its preindustrial origins and prevalence throughout medieval

and early modern Europe visually relegate it to the past. All of this is in stark contrast to China's continuous fascination with calligraphy, which is still a part of everyday life.

ABILITIES THAT CAN BE ACQUIRED BY PRACTICING CHINESE CALLIGRAPHY

"What can I learn by practicing Chinese calligraphy?" you may ask. First, practicing calligraphy cultivates sensibility and nourishes one's inborn nature. We know that our brains have two hemispheres, or parts. The left brain is verbal, analytical, logical, and linear, whereas the right brain is nonverbal, synthetic, spatial, artistic, and holistic. A balanced use of both hemispheres allows one to reach full potential, grants strength in problem solving, and encourages a healthy perspective on life. Traditionally, Western culture has been associated with left-brain habits and therefore places a stronger emphasis on reasoning and verbal abilities. Modern education also focuses more on analytical abilities, logical thinking, and verbal skills. Chinese calligraphy, which is both language and art, requires a balanced use of both sides of the brain. Using the right brain for visual imaging, spatial perception, and holistic thinking also provides a good opportunity to develop creativity.

In your study of Chinese calligraphy, you will learn to use your eyes to observe the details of writing as an art form, to discover the crucial features of a stroke, a character, and a piece of writing as a whole. You will learn to coordinate your mind with your hand and to maneuver the brush to produce different shapes and lines with the quality you want. In addition, you will also be trained in image memory, artistic thinking, and creativity, as well as visual expression, endurance, discipline, and hard work.

The purpose of education is to develop human potential. In today's world, globalization plays an increasing role in how we experience life. It has become essential to learn about other cultures and alternative ways of thinking, and to be trained to bring together all our mental and physical faculties, in order to meet today's challenges.

The principles of calligraphy contained in this book reflect Chinese philosophy, which can be widely applied to life anywhere in the world. Understanding the way of the brush increases appreciation of Eastern principles such as space dynamics, black and white contrast, and emphasis on consensus and models. Practicing calligraphy is also a good way to study Chinese history and language. Any degree of skill in the art is a sign of cultural exposure. For those of strongly artistic bent, Chinese calligraphy helps develop aesthetic vision through the basic elements of line, proportion, and space dynamics. It teaches you a way to appreciate and participate in a visual view of the world.

TO LEARNERS WITH NO BACKGROUND IN THE CHINESE LANGUAGE

The spirit of a foreign culture is often difficult to understand. It does not lend itself to easy expression. To many people in the West, Chinese culture is baffling and elusive. And the Chinese have such a complicated writing system that each character seems to be a mystery, a maze of lines. In this book, however, you will see that Chinese characters are well organized and based on inner logic. You will learn ways to look at them and understand their internal organization and aesthetics.

One does not have to learn the Chinese language in order to enjoy or even to write Chinese calligraphy. Calligraphy is a visual art, a unity of drawing and writing that appeals more to the eye than to the ear. While it is true that speakers of the language can appreciate the textual content, it is perfectly possible to enjoy and practice calligraphy as an abstract art without knowing the language. Calligraphy is much like music in that it can be enjoyed by different people in different ways. Some play musical instruments; some compose and analyze music; others simply enjoy listening to it. In China, many native speakers of Chinese today do not know how to write with a brush or to read cursive writing. But they may still enjoy calligraphy and the Cursive Style.

If you cannot read Chinese, do not be intimidated by the language barrier. Do not let the lack of verbal literacy hold you back. Learn to see the characters rather than read them. In this book, you will be introduced to brush writing gradually from the simplest dot to the full range of strokes, then to the writing of characters and calligraphy pieces. Each character in the writing model will be marked to indicate its meaning in English and the sequence of its strokes. You may choose for yourself what characters to practice writing and how many of them to learn by heart. The most important thing is to keep learning: to focus on your practical goals, to relax, and to move forward one step at a time.

For learners in the West, a course on Chinese calligraphy is like a journey to discover the unknown and the unfamiliar, and to find unknown qualities within yourself. Art can only be known through experience. What you will learn from this experience depends on how you approach the task. This book is a guide to equip you with the ability to appreciate the unfamiliar by looking at it with fresh eyes.

DISCUSSION QUESTIONS

1. How is Chinese calligraphy different from, for example, English calligraphy in terms of scripts, writing instruments, and societal roles?

2. What do you hope to learn by using this book? Having clear goals in mind will help you achieve them.

Writing Instruments and Training Procedures

This chapter lays out the preliminaries for training in Chinese brush writing. It introduces writing instruments, their history, how they are made, as well as how they are used. Preparations for writing, such as your state of mind, your writing space, your posture, and how to hold your brush are also discussed. The three most important factors in writing are identified: moisture, pressure, and the speed of the brush are of critical importance at all times when writing is taking place.

THE FOUR TREASURES IN A CHINESE STUDY

Chinese calligraphers throughout history have created countless works of art; many have gained permanent recognition. However, Chinese writing would not have become an art without its unique tools. Indispensable to the process of artistic creation are the "four treasures in a Chinese study," which are, in their proper order, brush pen (*bǐ* 筆), ink (*mò* 墨), paper (*zhǐ* 紙), and ink stone (*yàn* 硯).

THE BRUSH

Among the four treasures, the Chinese writing brush plays the primary role in writing. The techniques of calligraphy are collectively referred to as "brushwork."

The most distinctive feature of the brush is its flexibility. The tuft is made of hair from such animals as goats, weasels, rabbits, and horses. Other animals that provide hair for brushes include badgers, foxes, chickens, cats, and deer. Different types of animal hair create varying degrees of firmness and softness, from the softest rabbit hair to the stiffest horse hair. In addition, the parts of the animal's body from which the hair is taken and the season in which it is collected affect the quality of the brush.

Whether to use a soft or a hard brush depends on the writing style and the skills of the writer. Beginners are usually advised to use a brush with either goat hair or mixed hair. The most commonly used types are the following.

Goat hair is typically white and usually soft. Soft-hair brushes, although more difficult to control, allow more variation of strokes. Because they are also able to hold more ink, they are good for writing large characters.

Weasel hair, usually brown, is known for its elasticity and resilience. Being stiff and hard, these brushes do not hold a large amount of ink and are usually used to write relatively small characters.

Mixed hair is more versatile; one brush can be used for several different tasks.

Each type of hair lends its own assets to the whole. For example, horse hair, because of its stiffness, does not hold together when wet. Thus a writing brush could have a core of stiff horse hair surrounded by soft, sticky goat hair to hold the bristles together. (See Figure 2.1).

Brushes vary in both length and thickness, and brush size affects stroke size. The size of the brush one should use depends on the size of the characters to be written. For writing characters that are 1.5 to 2 square inches in size, for example, brushes with tufts that are 1 to 1.5 inches long are appropriate. If you plan to produce calligraphy pieces with inscriptions (written in characters smaller than those in the main text), you may want to have a smaller brush as well.

Chinese writing brushes have four important qualities.

Fineness. For maximum precision, the tip of the brush should be able to form a fine point that is extremely sensitive and pliable.

Evenness. The Chinese writing brush has a unique structure in which the long hairs at the core serve as the spine and those of the outside layer are of the same length. In between are some shorter hairs so that ink will

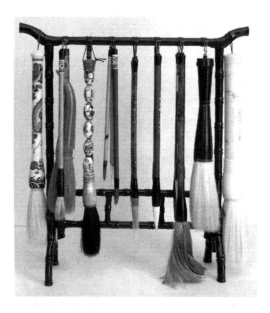

FIGURE 2.1. Chinese writing brushes on a brush stand.
[PHOTO BY WENDAN LI]

well up in the resulting pocket and be released when pressure is applied
to the brush. The longer hairs, which are trimmed to an even length,
should all meet at a point. During writing, these hairs hit the paper at
the same time and distribute ink evenly.

Roundness. The tuft of a Chinese calligraphy brush should be cone-shaped,
full, and round, which enables it to move easily in all directions.

Flexibility and resilience. The Chinese writing brush is flexible so that it can
be used to produce strokes of various shapes and thicknesses. Compared
to Western watercolor paintbrushes, Chinese writing brushes are usu-
ally stiffer. When the brush is lifted off the paper, its tuft should bounce
back to its original shape (or close to it) so that additional strokes can
be written before the tuft requires straightening. Such broad capacity
and versatility give the brush the power of expression. This is why the
Chinese brush can be used for painting as well as writing.

The brush can be a work of art in itself. Because the bristles must serve a purely
functional purpose, the handle is reserved for decorative expression. An array of
impressive materials can be used to make the handle: gold, silver, ivory, porcelain,
jade, and red sandalwood, although the most common is bamboo. It can be further
decorated by carving it into a desired shape or figure, or by carving calligraphy into
the handle itself, much as seals, ink stones, and ink sticks are decorated.

The writing brush originated in China in the Neolithic period. Traditionally, the Qin dynasty general Meng Tian (ca. 200 BCE) is credited with its invention. However, red or black brush strokes were found on the oracle bones of the Shang dynasty (ca. 1700–ca. 1100 BCE), which had been applied as guides on the shell and bone pieces before the characters were carved. The earliest brush, rabbit hair on a bamboo stem, dating to the Warring States period (475–221 BCE), was discovered at an archaeological site near the city of Changsha (Hunan Province), which was a major economic, cultural, and military center of the Chu state.[1] Today the best brushes are thought to be "Hu brushes" 湖筆 *Hú bǐ*, made in Huzhou of Zhejiang Province, owing to their long manufacturing history since the Jin dynasty (265–420) and the high-quality goat hair in the area.

The tuft of a new brush is always glued together to prevent damage during shipping. Before using a new brush, soak the tuft in lukewarm water for twenty to thirty minutes; then rinse out the glue and gently loosen the bristles. Before writing, make sure there is no loose hair, because that will destroy the appearance of the stroke. Take special care of the tuft and thoroughly rinse out the ink under a cold tap with gently running water every time you finish practicing.

INK

Most beginners nowadays choose to use liquid ink, which is both convenient and inexpensive. Experienced calligraphers, however, grind their own ink from ink sticks so that they can vary the ink solution's consistency for better control in getting the specific effect they have in mind. Bottled liquid ink does not have this adaptability.

The ink used in traditional Chinese calligraphy is always black. It is made primarily from two ingredients: lampblack (or some form of carbon soot) and glue made from animal hides or horns. These ingredients are mixed to form a claylike paste, then put into wooden molds to be formed into small pieces of various shapes. When the mold is removed and the pieces are dry, the ink sticks are then decorated with painted designs and characters. Some of these designs can be quite elaborate.

To make ink for writing, pour a small amount of water onto an ink stone (depending on the size of the ink stone and how much ink is needed for the project), and then rub the ink stick in a smooth circular motion. As ink paste rubs off the stick, it mixes with the water to form liquid ink. Care must be taken to ensure that the proper amount of water is used so that the resulting mixture is neither too runny nor too thick. If the ink is very thick, it will not run freely on paper. If it is very thin, it will blot and expand into thick lines. Enough ink to compose the entire piece must be mixed at the outset, as ink from consecutive mixings is never exactly the same hue or consistency. Having to remix ink in the middle of a piece would lead to undesirable differences in the color and overall character of the writing.

Although the ink is mixed with water, it becomes waterproof when applied to the paper. Chinese ink does not fade the way that Western ink does when exposed to light, and thus it can last far longer than Western ink. That is why the ink on ancient Chinese scrolls and paintings is still very clear even when the paper has changed color with age.

Chinese ink is easily diluted with water into different shades of blackness. To a layperson, ink is simply black; but to a Chinese artist, there are many colors and tonalities. In traditional calligraphy a uniform tone of ink is applied throughout a work, whereas in painting different shades of blackness (thin or thick ink) can be used. In modern calligraphy, however, experienced calligraphers adapt the ink method from painting to add artistic effects by varying the light and dark gradations of ink on a single piece of work. They purposely use runnier or thicker ink to express ideas or feelings in the writing. For example, a lot of ink makes for fatter, bolder characters, which could represent heavy ideas or thoughts, whereas light, thin characters written with less ink may express lofty visions and ideals. In a solid stroke, the ink sinks into the paper to produce a sturdy line, while a swift brush stroke produces lines with white streaks. In this sense, brush and ink go hand in hand and depend on each other for artistic expression. Because ink is mostly water and the basic action in Chinese calligraphy is largely managing a flow of water with a soft brush, the writer must take control while—literally—going with the flow.

Ink is not only important as a practical tool in calligraphy, it also carries cultural significance. Through the centuries, ink stick making has evolved into an art. Ink sticks may carry as much artistic value as the calligraphy they are used to compose. Valued ink sticks, which are painted with natural mineral colors and valued by ink connoisseurs, feature engraved designs of mountains, rivers, trees, and often fine examples of calligraphy as well. Even today, ink sticks are adorned with characters that range from the name of the manufacturer to full poems or pictures. Many museums in China house ancient ink sticks and feature the works of ink makers throughout the ages (see Figure 2.2).

FIGURE 2.2. Ink sticks of the Ming dynasty (made around 1400 CE) with calligraphy and dragon design in gold. Collection of the National Palace Museum (Taipei).
[FROM *MASTERPIECES OF CHINESE WRITING MATERIALS IN THE NATIONAL PALACE MUSEUM*, P. 6. REPRODUCED BY PERMISSION FROM THE NATIONAL PALACE MUSEUM]

Ink is believed to have developed in China as early as 3000 BCE, although most sources point to a date around 2500 BCE for its official creation. While no reference to the use of black ink appears in the literary records of this period, archaeological evidence indicates that some kind of writing fluid was used as early as the Neolithic Age and much more commonly in the Shang dynasty. Chemical microanalysis of red and black inscriptions of characters on oracle bones dating from the Shang shows that the black is a carbon mixture similar to traditional Chinese ink.[2] Ink in the form of ink cakes first appeared during the Han period (206 BCE–220 CE). The cakes had evolved into ink sticks, similar to the ones used today, by the Tang period (618–907 CE). Also since the Tang dynasty, Huizhou in Anhui Province has produced the best ink, called *Huīmò* 徽墨 (Hui ink).

PAPER

For Chinese calligraphy, coarse-textured and absorbent paper is used. The best kind is Xuan paper 宣紙 *xuānzhǐ* ("rice paper" in English) produced in Anhui Province. It is made of plant fiber and thus has good tensile strength (surface tension). Xuan paper is white and delicate, doesn't tear easily, and can be preserved for a long time. Owing to its absorbency, the paper responds well to different qualities and amounts of ink in the brush by showing a variety of effects. When a very wet brush with watery ink moves across the paper, the stroke will be dark in the middle with lighter shades of ink at the sides. If a relatively dry brush with thick ink sweeps quickly across the paper, white streaks will be seen in the stroke. These techniques and effects add variety and interest to one's work.

The invention of paper was credited to Cai Lun in about 105 CE, although archaeological findings suggest that the use of paper, probably of inferior quality, started in an earlier period.[3] Papermaking technology, which provides ideal media for brush writing, has played an indispensable role in the development of Chinese calligraphy into a true and unique art. Before paper was invented, China had a history of writing on wooden and bamboo strips as well as other materials for more than a thousand years. After paper was invented, it was favored by artists and calligraphers because of its absorbent nature and the variety of textures and finishes it offered. However, paper did not immediately become widely available or affordable. From anecdotes of famous calligraphers, we know that those from poor families practiced writing on banana leaves, palm leaves, stones, walls, or even in the dirt when they were young. Paper gradually replaced fabrics (such as silk) and other materials that had long been used for painting and writing. Techniques and processes of papermaking were brought by Buddhist monks from China to Korea and Japan, and then gradually to the West.

Traditionally, Chinese calligraphy is always done on white paper, although other types of paper are also used for special occasions, such as red for festivals. Paper may

also be sprayed with gold flakes or feature faint background designs. Nowadays, works in modern calligraphy are often done on colored backgrounds.

In the United States, the most commonly found paper for East Asian painting and calligraphy is a Japanese product called *sumi* (ink) paper. But beginners may use blank newsprint, which is less expensive, for practice. It is recommended that beginners apply the brush to the coarse side of the paper, to develop hand and wrist strength.

INK STONES

The Chinese ink stone can be compared to a Western inkwell, although their functions in fact are very different. Because Western calligraphy and writing are typically done with a pen and a much more transient form of ink, the Western inkwell serves only one purpose: holding ink. The Chinese ink stone, by contrast, serves multiple purposes. It is a surface on which an ink stick can be ground into ink, a container for holding ink, a paperweight, a decorative piece of art in itself, and, depending on its quality and design, a collector's item. (See Figure 2.3).

Ink stones (or ink slabs) are typically made of a fine, dark, solid natural stone that is flat and smooth, with a hollowed-out portion to hold ink. They come in all sizes—the biggest have to be carried by several people! Calligraphers and painters whose work requires large quantities of ink and those who grind their own ink usually use large ink stones; the ones for ordinary uses are four to eight inches in size. An ink stone should be heavy enough that it is not tipped over easily and it will not move when the ink is ground against it. During ink making, when an ink stick is

FIGURE 2.3. Chinese ink stone. [PHOTO BY WENDAN LI]

rubbed in a circular motion across the depression in the center of the ink stone, the slightly rough surface of the ink stone slowly grinds off small particles of the ink stick and mixes them with the water. Because the process is slow and rather time-consuming, liquid ink is more practical. However, experienced calligraphers often choose to grind their own ink, especially when they intend to produce unusual tonalities or consistencies of ink for special purposes.

The quality of the ink stone directly affects the quality of the ink made from it and the speed at which the ink forms. The surface of ink stones is not supposed to be too smooth or too coarse. If the stone is too smooth, it does not yield ink. If it is too rough, the ink will be ground into pieces that are too large to form a fine liquid. Another quality necessary in an ink stone is the ability to preserve the wetness of the ink that is ground and left on it. If a stone is too porous, it will absorb the liquid ink and cause it to dry out much faster than it can be used. The best stones, called *Duānyàn* 端硯, come from Duanzhou in Guangdong Province.

Although art is said to come from the ink stone, the ink stone is a precious object in itself. Along with its function in conjunction with ink, brush, and paper, the presence of ornate, intricate, and delicately carved decorations may make it an invaluable piece of art. Some collectors' items are made of valuable materials such as jade and carved with pine trees, fish, dragons, or lotus flowers along the edges. Although nothing short of a masterful invention, the Chinese ink stone is meant to have a subtle beauty. It rests at the calligrapher's side, sitting at the top corner of the work, as the artist pours out heart and soul onto a piece of paper.

The four treasures of Chinese calligraphy—brush, paper, ink, and ink stone—have played a crucial role in Chinese culture. The true beauty of calligraphy lies in the fact that they work together to express artistic intentions. Historically, they were major inventions that spearheaded the evolution of knowledge and the ability to pass that knowledge down through texts and records. Culturally, they represent artistic achievements that are uniquely Chinese. In the practice of calligraphy, they are the scholar's invaluable treasures, used to give life and definition to the ideas and emotions of a calligrapher, providing a medium by which deeply personal sentiments and emotions are preserved for later generations.

THE TRAINING PROCESS

For beginning students, learning to use a Chinese writing brush can be an awkward experience at first. The hand may feel clumsy because the brush is held differently than other writing instruments. You may feel like a child because even writing a straight line takes so much effort. The bristles are difficult to control, and it is easy to make foolish mistakes.

Learning Chinese calligraphy is more than learning to write with a Chinese brush. It is a sophisticated form of visual, tactile, and mental training that demands

(1) a calm and relaxed mind, (2) correct posture, (3) concentration on the task at hand, (4) coordination of mind and body, and (5) patience. In China, traditional teaching and learning practice includes a stage of tracing and copying to help the learner acquire these abilities.

THE IMPORTANCE OF TRACING AND COPYING

At the beginning stage, learners embark upon the task of acquiring a number of new skills: how to handle the brush to produce various strokes, the pressure to apply and the proper amount of ink to keep in the brush, and the speed with which the hand moves the brush. Tracing and copying from models is always the first step, first faithfully stroke by stroke, and then character by character until the spirit of the art penetrates the student's mind. Traditional Chinese training methods have always put a strong emphasis on imitation and copying. This is often puzzling to Westerners, who are used to being urged to express themselves and avoid imitation.

In Chinese calligraphy, in fact in Chinese art in general, imitation and copying are considered virtues. Good copies and imitations are appreciated as well as the originals. This is why, over the course of the long history of Chinese calligraphy and painting, old masters' works have constantly been copied. One often sees works that openly acknowledge being "an imitation of so-and-so." In fact, many of the famous early calligraphy works extant today are copies rather than originals.

It is believed that a beginner must first learn the essentials from masters of the past before trying to develop an individual style. Tracing and copying, like gathering information by reading books, are shortcuts or aids in learning the fundamentals and establishing a solid foundation. For a schoolchild, learning may eventually happen without reading books, but the discovery process will be much longer. In calligraphy learning imitation is also a process leading to discovery, a discovery of the good qualities in the model and the techniques used to produce them, a discovery of one's own limitations so that efforts can be made to overcome them, and a discovery of one's options in individual freedom without violating general principles. It is also through imitation and copying that the tradition of the art is carried on. Lack of sufficient training in the necessary principles and techniques will result in chaos.

Tracing and copying also help to develop the coordination of mind and body. When one is an experienced artist, the mind leads the brush; that is, the mind knows what to do, and the body is able to implement the plan. Such coordination and confidence, so important for the creation of art, are often difficult for beginning learners. All too often, writing is started without a plan for how to proceed so that, in the middle of a stroke, the question may pop up: "What am I supposed to do now?" Writing is a productive process with several components, from projecting an image of the end product in your mind, to knowing the creative steps leading to the end product, to having the skills to faithfully produce the specific effects in your

mind. Tracing and copying are techniques that break down the components and focus on training in one area at a time. A three-step procedure is followed to help learners gain more and more control gradually, from skills of the brush, to execution following a model, and finally to a full creative agenda.

TRILOGY IN TRAINING

The training procedure process consists of three steps.

Tracing

Tracing means writing over the characters in your copybook. There are two forms of tracing. In outline tracing the outline of a character is printed on paper (Figure 2.4). The learner fills the outline with black ink. Before model sheets with the printed outline of characters became available, students traced the outline of the characters manually with pencil, pen, or the fine tip of a brush and then filled in the outlines with black ink. Even today, devoted students still do this, as tracing the outline of characters manually is considered a good way to study the structure and details of model characters before writing them with a brush. The other form of tracing, red tracing, is writing over characters already printed in red with black ink (Figure 2.5). In tracing, since you can see exactly what your end product should

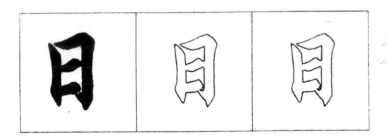

FIGURE 2.4. Outline tracing.

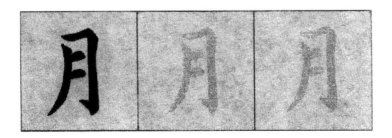

FIGURE 2.5. "Red tracing" (shown in grey here).

look like, your mind can concentrate on building the skills to produce the effect. Your goal at this stage, therefore, is to learn to maneuver the brush to produce the shape of brush strokes already shown on paper.

The focus of tracing is mainly on the shape of strokes. You should try to cover the size and shape of the strokes completely and exactly as shown, no more and no less.

Copying

When copying, the model is placed to one side and then imitated in a two-step procedure. First, look at the model and try to keep the details in your mind. Then, produce what you have in your mind on paper. The challenge at this stage, then, is to observe the important features of the model and faithfully reproduce them. To assist learners in this process, a grid is usually laid both over the model characters and in your writing space. Gazing at the grid that divides the model into small sections will help you gauge the position, shape, and size of the model. Then, using the writing space with the same grid pattern, you will know exactly where a stroke should start and end. This helps in positioning the strokes and controlling the size of the characters you write.

The focus in copying, as the second step in learning, should be mainly on the structure of characters. Note that characters only take up about 80 percent of the square space; don't forget to leave "breathing space" around each character.

We are going to use two grid patterns. First is the eight-cell pattern that divides a character space like a pie. Because this grid resembles the Chinese character 米 *mǐ*, it is called the *mǐ*-grid in Chinese (米字格 *mǐzìgé*). The second, the square-grid pattern (方格 *fānggé*), defines the space for a character without further dividing it (Figure 2.6). The eight-cell grid pattern is for beginners, and the square grid is for people with some experience. There are other commonly used grid patterns, for

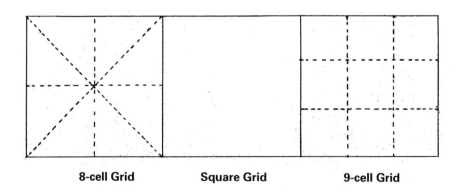

| **8-cell Grid** | **Square Grid** | **9-cell Grid** |

FIGURE 2.6. Grid patterns for copying.

example, the nine-cell grid (九宮格 *jiǔgōnggé*), which divides the space for a character horizontally and vertically.

Copying is first done stroke by stroke and then character by character. Carefully studying the model before writing remains an indispensable step. Tracing or copying without thinking, even dozens of times, leads nowhere. It is not the number of times the model is practiced that counts, but the quality of the writing. Before writing a stroke, make sure you know by heart exactly how it should be written from the moment the brush touches the paper to the moment it is lifted. Each stroke must be made in one continuous movement. Once you start, you cannot turn your eye to the model to see how you should proceed, because doing so will slow down your brush, and your stroke will show marks of hesitation. Similarly, after you complete a stroke, you cannot go back to touch it up. If you do, the corrected area will show traces once the ink is dry, and the entire piece will be spoiled.

Study your model character to see the correct sequence for writing the strokes, the position of the strokes, their size compared to other strokes in the same character, how the strokes are put together to form components, and how the components are put together to form the character. After you have copied the character, compare the character you have written with the model to see the differences and determine what needs to be done to make your writing better. Then, write the same character again. There should be improvement each time you repeat the same character.

Traditionally, characters in the Regular Script are divided into three different sizes for practice: The large size (大楷 *dàkǎi*), which is about four square inches or more for each character, the midsize (中楷 *zhōngkǎi*), about two square inches, and the small size (小楷 *xiǎokǎi*), about half a square inch or less for each character. The grid size for the brush-writing exercises in this book is about two square inches, that for midsize characters.

Free Writing

The third stage is for those who have gained confidence in the structure and size of characters and are ready to write without using models. An experienced writer, having learned the basics by tracing and copying, develops a signature style that is personal but, still, is usually based on or influenced by a calligraphy master of the past. Nonetheless, even an experienced writer makes plans before actually picking up the brush to write.

Since imitating models is such an important step in learning, a good model must be chosen. This is why calligraphy learners over the centuries have always used works of renowned calligraphy masters such as Yan Zhenqing and Liu Gongquan as models. Switching between models should be avoided. In this book, we use the writing of Wang Xizhi, the calligraphy "sage" of the Jin dynasty. The writing styles of these three masters will be discussed and compared in Chapter 10. When tracing

and copying, try your best to capture the good qualities of your model. You will profit from this practice by avoiding the pitfalls old masters have uncovered. This is an efficient way to shorten the path to good writing.

GETTING READY TO WRITE

PREPARE YOUR MIND AND YOUR WRITING SPACE

Start writing with a quiet and relaxed mind. One has to be calm and able to focus and concentrate. There is no point writing in a hurry or when your mind is not ready.

You also need a comfortable space on the table so that you can sit in the correct posture and move your arms freely without bumping into anything. If you copy from a model book, put your model close by so that you can easily see it (usually on the left of the writing paper if you use your right hand to write). Use your ink stone as a paperweight to keep the top of your writing paper in place.

POSTURE

Body

Unlike Western painting with its vertical or tilted canvas, Chinese calligraphy is mostly done on a horizontal, flat surface. Beginners should write at a table, although experienced writers may also write on the floor.

The weight of your body should be kept forward, about two or three inches away from the table. Your center of gravity should be the lower abdomen, which is also the core of your torso. During writing, no matter how your arms move, this should be the center that generates force that passes through the brush to the characters. When both feet are placed solidly on the floor in front of you, you will be sitting in the position known as the "horse stand." This posture helps to bring the center of gravity forward and gives you the flexibility to control the movement of your arms. Both your elbows should be on the table, away from your body. Do not lean too much over the table, and do not tilt your head too far sideways.

Wrist

The size of the characters to be written governs the position of the wrist. Usually for a beginner, for practical purposes, your wrist should be resting on the table. This is so especially when writing relatively small characters of one to two square inches, because such writing only requires the manipulation of the brush by finger and wrist movements. Training in brush writing usually starts with characters of this size to develop finger maneuvering skills. As an alternative, some people cushion their wrist with their nonwriting hand, palm down.

For more experienced writers, the "lifted wrist" position can be used to obtain greater freedom and particularly for larger characters. In this posture, the wrist is lifted one to two inches off the table, but the elbow should be touching the table.

The "suspended wrist" position, in which both the wrist and elbow are lifted, is the most sophisticated. This is for writing characters of larger sizes.

Writing Hand

Keep your thumb pointing up and all the other fingertips pointing down. The way you handle your brush is of the utmost importance. Owing to the nature of the Chinese writing brush, the way you hold it will affect the quality of your strokes. As shown in Figure 2.7, the brush is held upright. Your thumb should be tilted with the nail pointing up; all the other fingertips should be pointing down. Your grip on the brush stem should be comfortable and flexible, similar to the way a dart is held before throwing.

Follow these four principles:

1. Your palm should be loose and hollow, curved enough to hold a small egg. If you squeeze your fingers too tightly toward your palm, you lose flexibility.

2. All your fingers should be involved in controlling and maneuvering the brush. Refer to Figure 2.8 for finger positions and height. The thumb and the forefinger are responsible for holding the brush at the correct height, and the middle finger gently pushes the brush inward (toward the palm). The fourth finger supplies pressure onto the other side of the brush, to counterbalance the inward pressure from the middle finger. The little

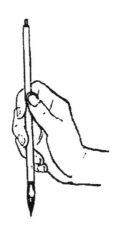

FIGURE 2.7. Standard brush grip.

finger should assist the fourth finger naturally but should not touch the brush, the palm, or the paper when writing.

3. Both of your forearms should be kept level with your elbows on the table, to help with brush control. Do not drop your elbow down from the edge of the table.

4. For maximum flexibility, all muscles directly involved in writing should be relaxed—this includes your fingers, wrists, arms, and shoulders. Be careful not to tense your neck either. Strained muscles and a tight grip limit movement, the hand is more likely to shake, and you will become fatigued more easily.

Brush

When writing, the brush stem should be kept vertical most of the time. Concentrate your mind on the bristles, whose impact is strongest at the tip. You will rarely write with more than one-third of the brush at the tip. The upper two-thirds of

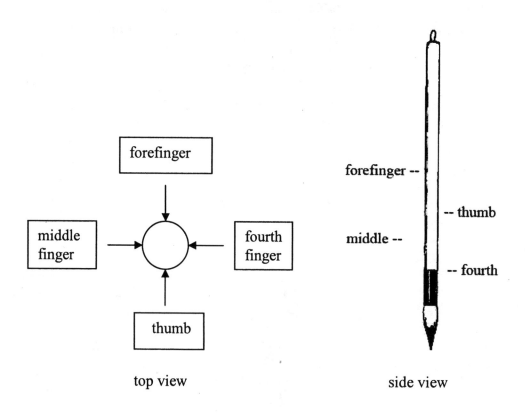

FIGURE 2.8. Finger positions.

the bristles act as an ink reservoir so that you can finish several strokes before re-charging your brush with ink. To deposit ink into this reservoir, the brush should be fully saturated. Saturation also stabilizes the spine of the brush and holds the hair together. If only the tip of your brush is dipped into ink, the bristles will become dry and split too soon.

The brush operates most effectively when all the hairs are relatively parallel. The easiest way to maintain this alignment is to avoid pressing down too hard on the paper. The correct amount of pressure causes the bristles to bend but does not crush their elastic spring. If the brush becomes bent and twisted, readjust it by dipping it back into the ink or by brushing it lightly against the side of the ink stone.

Paper

The paper for writing should be placed straight on the table in such a way that the bottom edge of the paper is parallel with the edge of the table. This may be difficult at first for some learners who are used to writing English with the paper turned sideways. Doing that when writing Chinese with a brush would cause you to lose your ability to judge, for example, whether your vertical lines are going straight down as required.

Breathing

Write with controlled and continuous exhalation. There is no need to hold your breath when you write. Breathe smoothly with the brush, exhaling as you write and inhaling when the brush is between strokes. It is difficult to write a strong and steady line while inhaling. Become calm before writing. There is no point in writing in a rush. Also, do not overconcentrate, as this will make you stiff, tense, and tired.

Eyes

Look at your character as you are writing it. Whenever your brush is moving on paper, your eyes should be fixed on your writing. A common beginner's error is to look back and forth between your model and your own writing while the brush is moving. This movement creates hesitant strokes, and the lines may also swell as you look away and your writing slows down. To avoid these problems, make sure you know by heart how to write a stroke from the beginning to the end and its exact position in a character before you put your brush to the paper so that you do not have to look at your model in the middle of writing the stroke.

The Free Hand

Use the free hand as paperweight. Lay the elbow of your free arm on the table, and use the fingertips of your free hand to hold the paper in place when writing. Hold the paper at the top when writing a vertical line and at its side edge when writing a horizontal line.

MOISTURE, PRESSURE, AND SPEED

Three important, constant concerns during writing are moisture, pressure, and speed.

MOISTURE

The brush should be slightly damp before it is dipped into the ink. As you dip, first give the bristles a chance to absorb as much ink as they can, and then gently squeeze out excess ink by sliding the tuft against the edge of the well of the ink stone. Do not apply too much pressure to the bristles as you slide, as that will break the ink reservoir in the brush center and overly drain it. Proper dipping and squeezing of excess ink will allow all the hairs in the brush, especially those in the center, to be involved in the management of ink in writing. A brush with a dry center will easily split, which in turn will make it impossible to form a solid line on paper. The absorption and draining of ink into and from the brush is like a person's inhaling and exhaling: a large vital capacity and proper coordination are essential for prolonged, smooth movements.

How much ink should you have in the brush before writing? If you can see ink accumulating at the tip of your brush, you have too much. However, you need enough ink to write at least a couple of strokes before the brush runs dry. A little trial and error will help you develop good instincts about this. Remember, when writing the Regular Script, characters in the same piece of work should look the same in terms of the amount of ink used. Even in modern styles, ink variations are by design rather than by accident. Therefore, control of ink is among the first things to be learned and experimented with in brush writing.

Try to start a stroke with a straight brush and the right amount of ink. That is, no hair is bent or sticking out, and the bristles are straightened and form a point at the tip. After writing a couple of strokes, if the bristles are bent and/or split, you should straighten them out on your ink stone. This is also an opportunity to re-charge your brush with more ink.

PRESSURE

Pressure is the amount of force employed to press the brush down on the paper. The harder you press, the wider the line. Because calligraphy brushes are so flexible, pressure control is the most important and yet difficult skill to master. The harder you press down, the more difficult it becomes for the brush to maintain its original resilient strength. Once a tuft of hairs is distorted, it needs to be fixed on the ink stone to regain its elastic power.

SPEED

The speed of the brush, another important concern, is determined by a number of factors: the script that is chosen, the thickness of the desired strokes, and the amount of ink in the brush. When writing, the brush will discharge ink as long as it remains in contact with the paper. To avoid blotting, the brush must be kept in constant motion. Varied speed combined with the flow of ink produces visual effects. Moving too fast produces a hasty line; the strokes will not look solid enough. When the brush is moving too slowly, the line will show signs of hesitation; the strokes may also run or bleed. In general, a wet brush should move more quickly and a dry brush more slowly to give the right amount of tone to the stroke. Also, speed up on straight lines and slow down on curves and at corners.

The control of moisture, pressure, and speed are important skills to acquire. It takes a great deal of experimentation and practice, as you begin writing, to put these skills together to produce desired line quality. The next three chapters contain detailed descriptions of individual strokes and the techniques involved in writing them.

DISCUSSION QUESTIONS AND WRITING PRACTICE

1. What are the special qualities of the Chinese writing brush that make it an ideal instrument for Chinese calligraphy?

2. Discuss the role ink plays in Chinese calligraphy.

3. You will be able to write a character well if you write it two dozen times. Is this true? Why or why not?

4. Prepare your brush for writing by following the instructions described in this chapter.

...

Brush Techniques
and Basic Strokes I

Knowledge of Chinese brushwork is a key to understanding not only Chinese calligraphy but also Chinese painting. In this and the next two chapters, we explore some basic brushwork techniques. We also go over the major stroke types in brush writing, their variant forms, and how they are used to compose Chinese characters. After reading about each technique and stroke type, you will be guided through hands-on practice first writing individual strokes step by step and then tracing the provided model characters.

BRUSH TECHNIQUES (1):
PRESSING DOWN THE BRUSH AND BRINGING IT UP

The most important feature of the Chinese writing brush is its soft, elastic bristles, which allow variation in the width of the strokes as the calligrapher applies pressure to the brush or lifts it up. In fact, calligraphy writing can be seen as a process of alternately lifting up and pressing down (Figure 3.1). Thus, pressing down the brush and bringing it up are the most basic calligraphic skills. Even when writing a straight line, one needs to vary the thickness of the stroke. Experienced writers

are able to control the brush in order to produce desired stroke shapes. Sometimes, at a sharp turn or a point where a change of direction is needed in a stroke, the brush is lifted almost (but not completely) off the page and held delicately poised on the tip before taking off in a new direction.

As can be seen in Figure 3.1, although the stem of the brush is kept nearly vertical, the force applied to the brush tip as it is pressed down is not directly vertical but rather slightly to one side of the tip. This is to keep the hairs all bent together in the same direction. A simple up-and-down lifting motion should produce a brush mark that is pear- or paisley-shaped, with the narrow end pointing to the ten o'clock position. The results of both pressing and lifting can change, depending on the amount of pressure applied. For beginners, brush control requires much practice until the hand can direct the brush at will and produce forms of infinite variety. It also takes considerable practice to produce smooth transitions when the pressure is changed while the brush is in motion.

Now, to get the feel of the brush, let's pick it up and try a few things.

First, sit up (in the "horse-stand" posture) and hold the brush correctly. With no ink in your brush, try pressing it down on a piece of paper and then lifting it up, as shown in Figure 3.1. Repeat this a few times.

Second, dip about two-thirds of the brush in ink and then gently squeeze the bristles along the side of the inkwell to get rid of excess ink.

Now, with ink in your brush, practice pressing down and lifting to make dots on the paper. You may want to try this on normal printing paper first so that you can take your time to gain a feel for how different amounts of pressure interact with the resilience of the brush. Writing on rice paper requires more confidence and experience because of its absorbency; the amount of ink in the brush also plays a bigger role on more sensitive paper.

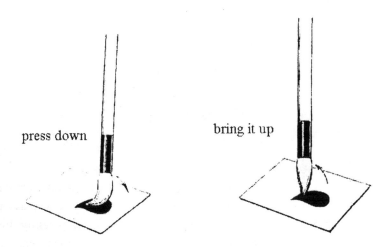

FIGURE 3.1. Pressing down the brush and bringing it up.

Next, hold the brush loosely and draw lines of different shapes: straight lines, curves, and zigzags. Try to loosen up your wrist. You will find that the brush will move more smoothly over the paper and produce clearer shapes when it has been freshly dipped in ink. After a couple of strokes the brush will become twisted and dry, which makes it more difficult to create smooth lines. This is when you need to go back to your ink stone to fix the brush and recharge it with more ink. If you load the brush with too much ink, your lines will begin to spread out in blotches on the absorbent paper.

Now, write a horizontal line across the paper, alternately pressing and lifting the brush. Try to make the transitions as smooth as possible. This will also give you a chance to feel the elasticity of the brush. You may also want to draw the lines and patterns shown in Figure 3.2 in order to gain more control over your brush.

AN OVERVIEW OF THE MAJOR STROKE TYPES

As described in Chapter 1, the most distinctive feature of Chinese writing is that characters are constructed not from letters such as those in English, but from basic units called "strokes." A stroke is one continuous line of writing, made from beginning to end without any intentional break. In alphabetic languages such as English, letters are arranged in a linear order (e.g., from left to right) to form words. In Chinese writing, however, strokes are assembled in a two-dimensional space to form characters. As an example, the word "sun" in English is spelled with letters, s-u-n, that are read from left to right to indicate its pronunciation. In Chinese the character for "sun" is 日, pronounced *rì*. This character consists of four strokes: one vertical line |, a turn ㇆, plus two horizontal lines — —. The strokes do not correspond to sounds, nor do they carry meaning. They are basic materials used to build up characters.

An initial glance at Chinese brush writing may give you the impression that there are countless ways of writing strokes and that the characters they form are

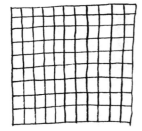 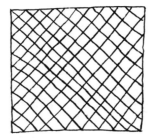

Figure 3.2. Lines to practice before writing strokes.

often forbiddingly complicated. This perception relates to the pictographic origin of Chinese characters, which is more fully discussed in Chapter 6. In the early development of Chinese writing, any line could be used to compose writing symbols. It was only gradually and over hundreds of years that lines in writing were abstracted and stylized into eight major stroke types. The basic forms of the eight major stroke types in the Regular Script of modern Chinese are displayed in Table 3.1.

The horizontal line and the vertical line are the most important, because they determine the overall structure and the balance of a character. The single-direction lines (the first six types in Table 3.1) are the most basic. The last two stroke types, which contain a change in direction, are called "combined strokes."

It should be noted that each of these eight types can appear in varied forms. Just like the seven basic notes of the tempered musical scale, which vary according to the composition in which they are used, Chinese calligraphy strokes are rendered differently according to the design of individual characters. In actual writing, each calligrapher may also add his or her own characteristics to strokes and characters to produce a personal style—this would be comparable to the same musical notes played on the same instruments but by different musicians. The art of calligraphy employs and combines various forms of the eight major stroke types in a myriad of ways.

TABLE 3.1. The Eight Major Stroke Types

	NAME	STROKE	DIRECTION OF WRITING	NAME IN CHINESE	
1	dot	`	↘	點 *diǎn*	
2	horizontal line	—	→	橫 *héng*	
3	vertical line			↓	竪 *shù*
4	down–left)	↙	撇 *piě*	
5	down–right	\	↘	捺 *nà*	
6	up–right	/	↗	提 *tí*	
7	hook		↓ ↖	鈎 *gōu*	
8	turn	ㄱ	→ ↓	折 *zhé*	

At first glance, the strokes seem simple. But the simplicity is deceptive. Remember: your task is not just to draw a line or to make a dot but to reproduce the strokes you see in your model in exactly the same shape. This cannot be done without a great deal of skill and control, which is gained only through practice. A good way to start, even before taking up your brush, is to use your forefinger to familiarize yourself with the steps of writing a stroke, following the numerical sequence marked on the model strokes.

As will be discussed in Chapters 8 through 11, Chinese characters can be written in a variety of script styles. Beginners usually start by learning and practicing the Regular Script, which has the most standardized structure and the most complete set of brush techniques. This style is also written with an upright and solemn look. In China, children in elementary schools practice writing the Regular Script before they move on to the Running Script in middle school. The traditional wisdom of calligraphic study dictates that Regular, Running, and Cursive scripts are three stages like standing, walking, and running. We all learned to stand still first, before we attempted to walk and run. Without the ability to stand still, we would fail at walking or running. Learning Chinese calligraphy is the same. The brushwork in the Regular Script is the most basic, with explicit rules. For beginning learners, it is the most essential script for the practice of basic brushwork skills and character composition. After learning the Regular Script, you can venture on to other styles of your choice.

Now, keeping in mind the concerns of moisture, pressure, and speed, let's examine how individual strokes are written.

STROKE TYPE 1: THE DOT

The dot is the most fundamental of the eight basic stroke types because the method by which dots are created is used to write many other strokes. A horizontal line, for example, both starts and ends with the brush movement of the dot, and so does the beginning of a vertical line. Furthermore, although they are usually small in a character, dots play the role of adding vitality to the character as the eyes add spirit to a person.

The dot in Chinese calligraphy can be formed in many different shapes. One notable common feature is that they are never circular, as a dot is in English. Instead, the most typical Chinese dot is triangular, as shown in Figure 3.3.

Note that in Figure 3.3 (a) the line in the center of the stroke shows the direction of force applied in writing. Do not trace this line with the tip of your brush as if it were a hard-tipped pen. Rather, the dot should be produced mainly by pressing down the brush and lifting it up. The trace of the brush is illustrated in (b). Familiarize yourself with this step-by-step procedure before trying to write a dot with a brush (see page 200 in Appendix 1).

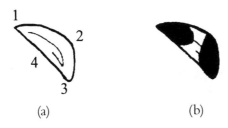

(a) (b)

FIGURE **3.3.** The dot.

1. Starting from the upper left corner (1), press down at an angle of approximately 45 degrees so that the bottom of your brush reaches (2). Note that although the brush stem is vertical, the force applied to the bristles is not absolutely vertical, but rather slightly diagonal. In other words, when the entire head of the brush is involved in writing, only one side of the brush touches the paper (as in Figure 3.1).

2. Move the head of the brush slightly toward you and downward so that the bottom reaches (3).

3. Push the bristles slightly away from you, to launch the brush in an upward motion toward (4); gradually lift it off the paper.

Examples of dots in complete characters are shown in Figure 3.4.

VARIATIONS

The dot is the stroke with the largest number of variant forms. How a specific dot should be written has a lot to do with its position in a character. Some dots are quite distinct, as shown in Figure 3.5. When writing dots, you must attend to the details patiently and try to grasp their individual characteristics.

In Figure 3.5, the dots in (1) are always on the character's left side. Those in (2), by contrast, are always on the right side. They are also written in opposite ways. Note that the dots in (2) are longer than the basic dot shown in Figure 3.4; hence they are named "long dots." The dots in (3) are located at the bottom of characters

FIGURE **3.4.** Examples of the dot in characters.

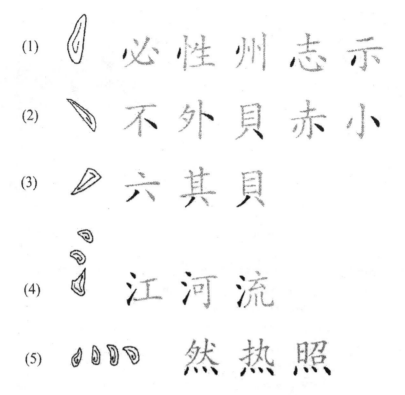

FIGURE 3.5. Variations of the dot.

when two dots are written as a pair, one on the left, the other on the right. The one on the left is always finished with a leftward movement and a pointed ending; the one on the right is slightly longer than a normal dot. They are like two legs on which the character stands and, therefore, should finish on an imagined horizontal line. The characters in (4) have three dots arranged vertically, always on the left side. In fact, the three dots form a semantic component meaning "water," as will be discussed in Chapter 6. Note also that the three dots are shaped differently from one another. The characters in (5) have four dots at the bottom, which are also a semantic component meaning "heat." Be careful to observe how each dot is written.

The categorization of stroke types, like many other linguistic categories, has grey areas. You may have noticed that in Figure 3.5 the dot in (3) looks similar to a short down-left slant, but here it is treated as a dot. This dot always appears in a pair of dots at the bottom of a character like two legs standing, one to the left, the other to the right. A similar case is (4), the last dot at the bottom. Although it looks similar to a right-up tick, it is considered a dot, and it always appears as the last stroke in the component on the left side of a character.

STROKE TYPE 2: THE HORIZONTAL LINE

Horizontal lines, like dots, can be written in different ways. Depending on its position in a character, a full horizontal line can function as a top beam (as in 下 xià, "under"), a center sill (as in 六 liù, "six"), or a bottom bracket (as in 土 tǔ, "dirt"). This stroke often determines the structure and stability of the entire character. Thus it is important that it be written correctly. In shape, a full horizontal line is thicker on both ends and thinner in the middle; the transition should be gradual, as if the line is held at both ends and stretched out. Such a stroke, resembling the shape of a piece of bone, gives the line a look of strength, as shown in Figure 3.6 below. Figure 3.7 provides examples of full horizontal lines in characters.

When writing a full horizontal line, follow this procedure (also see page 201 in Appendix 1).

1. Press down at (1) at approximately a 45-degree angle (the same angle used in writing a dot). The tip of the brush remains at (1) without moving to the right. Pause.

2. Slanting the brush handle slightly to the right, move the bristles rightward toward (2), gradually lifting them slightly as the brush approaches the middle of the stroke. The center of the brush tip should remain to the left as the brush moves to the right.

3. At (3), lift the brush slightly to bring the tip in line with the rest of the bristles. This should be the highest point of the stroke.

4. Press down so that the thickest portion of the bristles

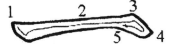

FIGURE **3.6.** The horizontal line.

FIGURE **3.7.** Examples of the horizontal line in characters.

reaches (4) at a 45-degree angle (the same angle you used for the first point). Again, this is done without actually moving the brush downward on the paper; the tip of the brush stays at (3).

 5. Turn the bristles to the left, gradually lifting them as they move toward (5).

Note that the line should be produced with no hesitation. In fact, the brush can speed up slightly when writing the middle portion of the stroke. Because you are using the technique known as center tip (discussed below), both the top and bottom edges of the line should be smooth.

VARIATIONS

In characters with more than one horizontal line, only one of them, usually the longest, is written in its full form. The others are simplified, often at the beginning of the stroke, as shown in Figure 3.8. Such a horizontal line shows no clear sign of pressing down at the beginning.

STROKE TYPE 3: THE VERTICAL LINE

A vertical line, like the backbone of a person, plays the role of pillar in a character. As such, it should always be written upright and straight, like a soldier standing at attention. The shape of a full vertical line (thicker at the ends, thinner in the middle) is similar to that of a full horizontal line (see Figures 3.9 and 3.10).

 The vertical line is made with similar movements to the horizontal line. Here are the steps to follow (also see page 202 in Appendix 1).

 1. Press down at (1) at a 45-degree angle so that the bottom of the brush reaches (2).

 2. Start moving the brush downward.

 3. At (3), bring up the brush and adjust the position of the tip so that it fills out the point.

 4. Press down at a 45-degree angle so that the bottom of the brush reaches (4).

 5. Move back up toward (5), gradually lifting the brush from the paper.

VARIATIONS

Alternatively, the same vertical line can be written as shown in (1) in Figure 3.11. As a variant form, vertical lines are often written with a pointed ending at the bottom, called a "vertical needle," as shown in (2).

FIGURE **3.8.** Variations of the horizontal line.

FIGURE **3.9.** The vertical line.

FIGURE **3.10.** Examples of the vertical line in characters.

TRACING

After practicing these three individual strokes, you can write some simple characters beginning with outline tracing using the eight-cell grid (see pages 203–204 in Appendix 1).

When tracing, try your best to cover the strokes exactly as they are written in the model characters, no more and no less. Although the outline of the characters is provided, you should always be aware of where the center of each character is.

FIGURE 3.11. Variations of the vertical line.

FIGURE 3.12. Examples of "vertical needles."

The strokes in each character follow a prescribed sequence. Throughout this book, the stroke order in the Regular Script model characters is indicated by numbers marked on the characters. You should always follow this order in writing, completing one stroke before moving on to the next. The importance of following the prescribed stroke order is discussed in Chapter 5.

Traditionally, the direction of writing a Chinese text is vertical (top to bottom) starting from the upper right corner of the page. Character columns are placed from right to left. This book, however, arranges the practice of individual characters horizontally, from left to right. Concentrate on one character, writing it repeatedly, in order to make sustained progress before moving on to the next character.

DISCUSSION QUESTIONS AND WRITING PRACTICE

1. Why do we practice writing Regular Script first?
2. What do you pay attention to when you trace a character?
3. Without looking at the book, verbalize the procedure of writing a dot, a

horizontal line, and a vertical line. Verbalization is very important at the beginning stage. You will write much better if you can verbally describe the details of every step.

4. Practice the stroke types and their variations on pp. 200–202 in Appendix 1. Write on normal paper first to get a feel for the brush and the ink. When you do it on absorbent paper, you will notice the difference and the need to adjust the amount of ink in your brush. Remember, when you do outline tracing, fill the stroke outlines exactly as they are, no more and no less. Pay attention to producing the right shape of strokes by applying the right techniques. Follow the numbered procedure, and do not skip any step.

5. Pages 203–204 in Appendix 1 contain two sets of model characters for the chapter. For each set, trace first, then copy. When copying, try to retain the size and structure of the model characters by using the grid. Follow the numbered stroke order as a guide to forming characters. Stroke order rules will be discussed in Chapter 5.

6. Check the way you hold your brush against Figure 2.7 three times to make sure you do it correctly: before writing a page, in the middle of writing a page, and when you finish writing a page.

··

Brush Techniques
and Basic Strokes II

In the previous chapter, three basic stroke types were described. This chapter first illustrates two important brush techniques that affect the quality of strokes. After that, three more stroke types, the down–left slant, down–right slant, and right–up tick, will be introduced. The last section discusses Chinese names, including how Chinese names are chosen based on Western names.

BRUSH TECHNIQUES (2):
CENTER TIP VERSUS SIDE TIP

Tip, *fēng* 鋒, refers to the brush tip formed by the long hairs in the brush. Writing with the tip of the brush either in the middle of the stroke or on one side of the stroke are two different ways to produce brush lines. The center-tip technique, in which the tip of the brush travels along the center line of the brush stroke (Figure 4.1), is a means to exert vigor and to produce full, sturdy, firm lines. The side-tip technique, where the tip of the brush travels along one side of the stroke (Figure 4.2), produces elegant yet delicate lines. The center-tip and side-tip methods are used as the need arises. Good writing with strength is produced using mainly center-tip strokes, supplemented by side-tip strokes.

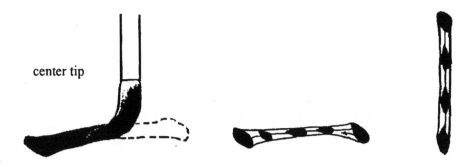

FIGURE 4.1. Center tip.

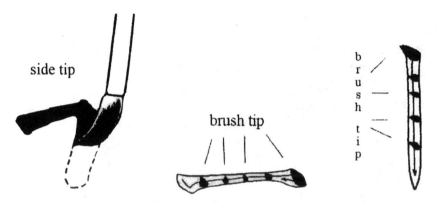

FIGURE 4.2. Side tip.

BRUSH TECHNIQUES (3):
REVEALED TIP VERSUS CONCEALED TIP

The revealed-tip (露鋒 *lòufēng*) and concealed-tip (藏鋒 *cángfēng*) techniques are different ways to produce the first and last touches of a stroke. In Chinese calligraphy, one can choose to show or hide the first and last touches of a stroke for a deliberate display or understatement of the power of the brush. So far, this book has shown how to start horizontal and vertical lines with revealed tips because the method is simpler. Using concealed tips, an advanced method, adds more strength to a stroke. Therefore concealed tips are used very often, especially for a character's primary strokes.

As seen in Figure 4.3, to conceal the tip of the brush at the beginning of a stroke, the bristles are contracted slightly, in the opposite direction of the stroke.

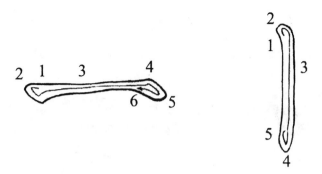

FIGURE 4.3. Concealed tip.

To conceal the tip at the end of a stroke, the brush is brought back again before it is lifted off the paper, ever so slightly, in the direction opposite to the stroke. In Figure 4.3, the contractions added at the beginning are (1) to (2); those at the end are (5) to (6) for a horizontal line and (4) to (5) for a vertical line.

To understand the function of the concealed tip, apply one of the basic principles of physics to calligraphy: for every action there must be a reaction. You crouch down before jumping up; a hammer is lifted up before it falls onto a nail; a leg is swung back before it kicks out and connects with a ball. Similarly, for a horizontal line to be written with strength (from left to right), the brush must move left before it goes right.

The same principle applies to other stroke types. In classical literature on Chinese calligraphy, the concealed tip at the end of a horizontal line is likened to riding a galloping horse toward a canyon and halting abruptly at the cliff's very edge. In writing, such a technique enables the power of the brush to be kept within the stroke. A good stroke with concealed tips, written with the flow of energy from the writer's body to the brush tip, increases the sturdiness of the line and gives it a restrained inner strength.

The concealed-tip technique reflects a profound principle in Chinese aesthetics and philosophy. Starting with Confucius, modesty and moderation have been considered primary Chinese virtues. A refined person is one who withholds strength by concealing his or her cutting edge. This is well captured in the saying *bú-lù-fēng-máng* 不露锋芒, literally "not revealing cutting edge." This saying describes a refined, able person who has inner strength but at the same time is modest and discreet.

STROKE TYPE 4: THE DOWN-LEFT SLANT

The down-left slant is characterized by a wide top and a pointed ending. In Figure 4.4, (1) shows a revealed tip at the beginning; (2) indicates, with the trace of

brush, that the stroke should be written with a center tip; and (3) is written using the concealed-tip method. Follow these steps to write a down-left slant with a concealed tip (also see page 205 in Appendix 1).

1. At (1), the tip of the brush touches the paper slightly and moves upward to (2).

2. At (2), press down at a 45-degree angle and pause.

3. Start moving the brush downward and leftward to (3).

4. When approaching (4), gradually lift the brush to make a pointed ending.

Examples of the down-left slant in characters appear in Figure 4.5.

VARIATIONS

The down-left stroke may vary in length, the angle of slanting, and the speed of writing. Compared to the down-left slants in Figures 4.5, those in Figure 4.6 are shorter in length.

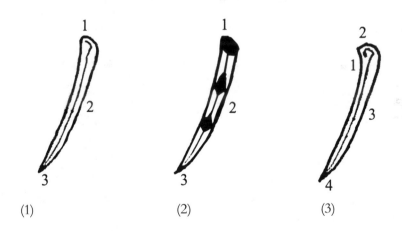

(1) (2) (3)

FIGURE 4.4. The down-left slant.

FIGURE 4.5. Examples of the down-left slant in characters.

In traditional Chinese calligraphy treatises, a short down–left stroke is described as having been written with force and at a fast speed, like a bird pecking at grain. A long down–left stroke, by contrast, is made slowly, with ease, like a woman combing her long hair all the way to the end.

STROKE TYPE 5: THE DOWN-RIGHT SLANT

The down–right slant is characterized not only by the direction of writing, but also by the "foot" at the end of the stroke, shown from (3) to (4) in Figure 4.7.

The procedure for writing the down–right slant is as follows (also see pages 206–207 in Appendix 1).

1. Start lightly at (1), moving down and right toward (2) and gradually putting more pressure on the brush.
2. Press down hard at (3) and pause slightly.
3. Change the direction of the brush, now moving right-ward toward (4) and gradually lifting the brush.
4. Make a pointed ending at (4).

Examples of the down–right slant in characters appear in Figure 4.8.

FIGURE **4.6**. Variations of the down-left slant.

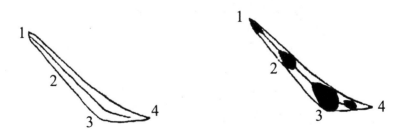

FIGURE **4.7**. The down-right slant.

VARIATIONS

In Figure 4.8, each down-right slant stroke is paired with a down-left slant, like two legs on which the character stands. The down-right slant may also be written more horizontally at the bottom of a character as in Figure 4.9.

STROKE TYPE 6: THE RIGHT-UP TICK

The right-up tick is a distinct stroke that starts from the lower left corner and slants up to the right.

The stroke is usually made quickly, with strength, in the following way (also see page 207 in Appendix 1).

1. At (1), press down (with either a revealed or a concealed tip) and pause.
2. Start moving upward to the right (2), gradually lifting the brush.
3. Make a sharp ending at (3).

大 人 足 火

FIGURE **4.8.** Examples of the down-right slant in characters.

道 之

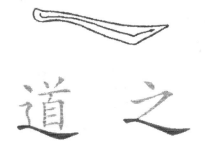

FIGURE **4.9.** Variations of the down-right slant.

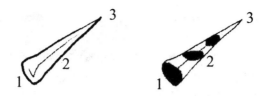

FIGURE 4.10. The right-up tick.

FIGURE 4.11. Examples of the right-up tick in characters.

Figure 4.11 shows examples of the right-up tick in characters. Note the slight variations in the direction of writing.

We have looked at six stroke types so far, with two more to go. You will need lots of writing practice before moving on! For now we will switch to a cultural topic relevant to the signature of a calligraphy piece: Chinese names. We will discuss the structure and components of Chinese names and how Chinese names are given based on Western names.

CHINESE CULTURE (1): CHINESE NAMES

To a learner of the Chinese language or of calligraphy, Chinese names are interesting because they say a great deal about the language, Chinese culture, Chinese society, and change over time. When appreciating and producing a calligraphy piece, the signature carries much weight. Chinese names are discussed early in this book so that you will have time to obtain a Chinese name (or choose your own), to learn as much as you can about it as we discuss various aspects of Chinese writing, and to practice writing it with a brush. Your Chinese name will be a personal link to the Chinese language and culture.[1]

Chinese names are most different from Western names in that the family name (surname) goes first, before the personal (given) name. Thus, "John Smith" as a Chinese name would be "Smith John." An old tradition places a generational name in the middle: family name + generational name + personal name.

Interestingly, this order follows the typical Chinese perceptual pattern moving from the most general to the most specific, which can also be seen in the way time and location are recorded. Usually each of the three parts in a Chinese name is expressed in one character. In writing no space is left between characters. In speech, because one character is always pronounced as one syllable, a name with three characters is pronounced as three syllables. When Chinese names are romanized and written in English, the family name always appears separately although the other two syllables may be written together (e.g., Mao Zedong) or linked by a hyphen (e.g., Mao Ze-dong). In a Chinese name with two parts—one with a single syllable and the other with two syllables—the part with a single syllable is almost always the surname. A two-character surname with a single-character personal name, while possible, is very rare.

In old China, the traditional social structure offered low mobility; large families usually lived together, sometimes with as many as four generations. Close relatives also lived near each other, often in the same village. By using generational names, family members of the same generation would share both the family name and the generational name. Thus they could be identified no matter how far apart they lived or how vast their age differences. For example, Mao Zedong had two brothers named Mao Zemin and Mao Zetan. They share the generational name Ze, "beneficence." Mao Zedong's sons (Mao Yuanren, Mao Yuanyi, Mao Yuanzhi) and nephews (Mao Yuanxin, Mao Yuanda) share the generational name *Yuan*, "far distance." Generational names were very important for a society dominated by Confucianism in which social order and status were of utmost significance.

In modern China, with the breakdown of the traditional family structure and lifestyle, and with rapid social changes and increases in geographic mobility, generational names have lost their function and are no longer commonly used. People may have a two-character given name, still resulting in a full name of three characters or syllables, or a one-character given name, which yields a full name with only two characters or syllables. Full names with only two characters have disadvantages, especially when the family name is a popular one. With China's large population and the popularity of certain last names, the chance of exact duplication is very high. If these people come to the West and romanize their names, it is often difficult to tell which is the surname and which is the given name because both have only one syllable.

SURNAMES

Although statistics show about three thousand surnames in use by the Han Chinese nowadays, the distribution of these surnames is very much skewed. About 40 percent of the 1.3 billion Chinese use ten major surnames (Zhang 張, Wang 王, Li 李, Zhao 趙, Chen 陳, Yang 楊, Wu 吳, Liu 劉, Huang 黃, and Zhou 周).[2] Among

these, Li 李, Wang 王, and Zhang 張 are the most common, used by about 250 million people. According to the latest statistics, within mainland China, people with just the surname Zhang 張 number more than 100 million, almost the combined populations of Britain and France.

Given the popularity of major Chinese surnames, it is easy to understand that variety depends mainly on given names. This contrasts with names in English, in which given names are common and surnames are more distinctive. An interesting consequence of this difference is that people in the West are often introduced informally by their given names (such as John or Jennifer). However, in China or among Chinese people, Mr. or Ms. plus the surname (Zhang or Li, for example) are used for people you don't know well. Chinese immigrants to the West also mix their names by choosing an English given name followed by their Chinese family name. This, also results in common names in Chinese communities, such as David Zhang or Mary Wang. In some cases, the original Chinese given name is kept as a middle name to make the name more distinctive.

GIVEN NAMES

It is said that the way of the pine is not the way of the willow. In Chinese, as in Native American languages, gender in personal names is often indicated by choosing words such as "pine" for males and "willow" for females. Characters identifying traditional Chinese virtues or symbolizing moral imperatives may also be used. Male names often represent a hoped for destiny or character trait, such as modesty or wisdom, or they are linked with strength and firmness. Female names tend to be more poetic but with less profound significance, linked with flowers, lotus, precious jade, or beauty, reflecting the traditional status of women in Chinese society. Table 4.1 explains how characters in a given name are chosen.

Names in the "neutral" column can be used for men or women, while those in the other columns are more gender-specific. It is a common practice for siblings to share a character in their given names. For example, a brother may be named 春松, "spring pine," and his two sisters may be called 春柳, "spring willow," and 春梅, "spring plum." In this case, the first character is gender-neutral and the second characters are gender-specific. Alternatively, both characters in a given name could be gender-specific (for example, 國強, "country strong," for a male and 美玉, "beautiful jade," for a female), or both names could be gender-neutral (such as 春華, "spring magnificent," for either a male or a female person). These are only examples of the most popular characters used in traditional names. Modern people, especially the urban intelligentsia, often make their children's names more unique by selecting less commonly used characters.

If you want to choose your own Chinese name and you do not know much about the Chinese language, make sure to check with a Chinese person because

TABLE 4.1. Commonly Used Characters in Chinese Given Names

NEUTRAL	MALE	FEMALE
春 spring	松 pine	柳 willow
華 magnificent	仁 benevolence	梅 plum
英 outstanding	忠 fidelity	花 flower
荣 prosper	德 virtue	玉 jade
明 bright	志 aspiration	珍 treasure
文 elegant	智 intelligence	秀 pretty
君 gentle	國 country	芳 fragrance
云 cloud	軍 military	鳳 phoenix
星 star	強 strong	麗 pretty
金 gold	偉 grandeur	美 beautiful
曉 early morning	富 wealth	蓮 lotus
敏 smart	義 righteousness	香 fragrance

Chinese names offer more complications. For example, a name does not sound good if all three characters start with the same (or very similar) initial consonants, which is acceptable in English. A name should not sound similar to a phrase with negative meaning or to a brand name. For example, 黄蓮素 Huáng Liánsù would be a fine name except that it sounds the same as a well-known brand of Chinese medicine for diarrhea. The characters in a name should also go together to denote a plausible meaning. This can be tricky because when two characters are put together, the meaning is often different from the cumulative meaning of the two individual characters. For example, 美金 does not mean "beautiful gold" but rather "U.S. dollars."

No standard convention exists for choosing a Chinese name for a person in the West. The most common practice is to find Chinese characters that match the sounds of the person's Western name (surname or given name, or both) as closely as possible. Because surnames are distinctive in the West, figures of historical significance are commonly referred to by transliteration of their surnames. For example, 馬克思 Mǎ-kè-sī for Karl Marx, 林肯 Lín-kěn for Abraham Lincoln, 羅斯福 Luó-sī-fú for Franklin Roosevelt, 愛因斯坦 Ài-yīn-sī-tǎn for Albert Einstein, and

莎士比亞 Shā-shì-bī-yà for William Shakespeare. You may notice that the Chinese transliterations often have more syllables than their Western counterparts. This is because Chinese syllables mostly consist of a consonant followed by a vowel.[3] No consonant clusters are allowed. Therefore, in transliteration, a vowel is often inserted between two consonants in Western names to make them into separate syllables.

Informal common practice exists for the transliteration of popular Western first names, such as 麗莎 Lì-shā for Lisa, 珍妮 Zhēn-ní for Jenny, and 湯姆 Tāng-mǔ for Tom. These names have no meaning attached; they are simply gender-specific, nice-sounding transliterations of Western names. It is ideal if the meaning of the characters also works together to yield a typical Chinese name, such as 大偉 Dà-wěi (meaning "big-grandeur") for David.

Since Western names often have three parts, a common practice is to use the first syllable of each part to make up the Chinese name. An example is 費正清 Fèi-zhèng-qīng for John King Fairbank, who was a professor and historian at Harvard and founder of the university's Asia Center. *Fèi*, a Chinese surname, is based on the first syllable of his Western last name. *Zhèng*, for John, means "upright," and *qīng*, for King, means "pure." Sometimes transliteration of the surname alone yields a good Chinese name. For example, 衛奕信 Wèi-yì-xìn is based on the last name of David Clive Wilson, British diplomat and former governor of Hong Kong. *Wèi*, a Chinese surname, is followed by *yì*, "bright," and *xìn*, "trust." Both of these are excellent Chinese names based on Western names.

DISCUSSION QUESTIONS AND WRITING PRACTICE

1. What are the center-tip and side-tip techniques? Write two horizontal lines, one with center tip and the other with side tip, to see how they differ. Then do the same with two vertical lines.

2. Practice writing the strokes with concealed tips on page 201 in Appendix 1. Then compare and discuss how they differ from the strokes written with revealed tips.

3. Without looking at the book, verbalize the procedures for writing a down-left slant, a down-right slant, and a right-up tick.

4. Practice the strokes types and their variations on pp. 205–207 in Appendix 1.

5. Practice writing the model characters on pp. 208–210 in Appendix 1. When copying, focus on one stroke at a time. Examine its shape, size, where it starts, and where it ends, and then duplicate that in your writing square before moving on to the next stroke. Note also the space you should have around each character.

Basic Strokes III
and Stroke Order

Chapters 3 and 4 have described six stroke types. All of these are considered simple strokes because each stroke is written with brush movement basically in a single direction (setting aside the concealed tips). This chapter first examines the remaining two stroke types, the turn and the hook. These are "combined strokes" because they contain a change in the direction of brush movement. Then writing at the beginning level is reviewed, with precautions concerning common pitfalls in writing and advice on how to avoid them. General rules of stroke order are laid out in the last section.

STROKE TYPE 7: THE TURN

Simply put, the turn is a combination of two strokes with a turn at the joint. The strokes that are combined can be different, resulting in different turns. Here we start with a turn that combines a horizontal line and a vertical line (Figure 5.1); other combinations will be described as variations in the next section.

Follow the steps below when writing the typical turn (also see page 211 in Appendix 1). You will see that steps 1 through 3 are the same as those for writing a horizontal line.

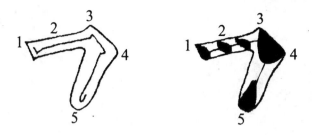

FIGURE 5.1. The turn

1. Starting from (1), press down and move to the right toward (2).

2. At (3), lift the brush slightly to bring the tip to the highest point of the stroke.

3. Press down at a 45-degree angle so that the bottom of the brush reaches (4); then pause. This is done to make the thick turning point. Be sure that the brush tip remains at (3).

4. Start moving down toward (5) and end the stroke.

Steps 2 and 3 are crucial for making the turn. This procedure is similar to driving in that one must apply the brakes before making a turn. In calligraphy, however, simply slowing down is not enough. You have to lift the brush to adjust the tip and then press down with a brief pause to make the shape at the turn before moving in the new direction. The combination is considered one stroke because there is no intentional stop at the turn, and the brush is not lifted completely off the paper. Shown in Figure 5.2 are some examples of the typical turn in characters.

VARIATIONS

Different strokes can be joined to make different types of turns. In addition to the above example, a horizontal line can also be combined with a down-left slant, and a down-left slant can be combined with a right-up tick. The writing techniques involved are very similar, as illustrated in the examples in Figure 5.3.

STROKE TYPE 8: THE HOOK

The hook is a combined stroke because it is always attached at the end of another stroke, such as a vertical or horizontal line. Like turns, hooks involve more writing technique and have more variant forms than a simple stroke.

The most common type of hook is attached at the end of a vertical line and usually flows to the left, as shown in Figures 5.4 and 5.5.

FIGURE 5.2. Examples of the turn in characters.

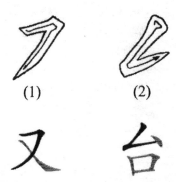

(1) (2)

FIGURE 5.3. Variations of the turn with examples.

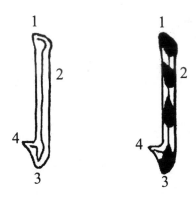

FIGURE 5.4. The hook.

FIGURE 5.5. Examples of the hook in characters.

A vertical line with a hook is a difficult stroke for beginners. Here is the procedure for writing one (also see page 212 in Appendix 1).

1. At (1), press down and pause, as with a vertical line.
2. Start pulling the brush downward to the middle of the stroke (2), keeping the brush tip on the center line of the stroke.
3. When approaching (3), press down slightly in a leftward motion and pause at (3).
4. Move back slightly, and then make the hook to the left, gradually lifting the brush to form the tapering end.

It will take some practice before you can do it right. If written correctly, the hook will look like a goose head turned upside down.

VARIATIONS

Hooks can be attached to a number of strokes, although the method of making the hooks is similar in each case. Note that the direction in which the hook is made may vary according to the stroke to which it is attached (see Figure 5.6).

From the examples in Figure 5.6 we can see that, although there are eight major stroke types, their variations are numerous. Strokes can be further combined. For example, the character 乙 *yǐ*, "second (of the Heavenly Stems)," combines a horizontal line with a down-left slant and then, after the curve, with a hook at the end. In actual writing, you will encounter strokes you have never practiced before. At such times you need to use your skills creatively. When basic techniques are intact, creativity can take flight.

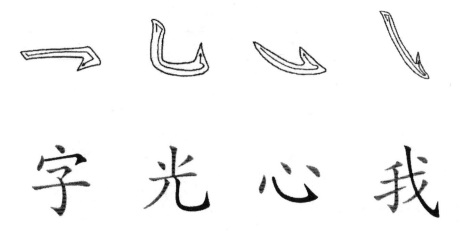

FIGURE 5.6. Variations of the hook with examples.

SUMMARY OF MAJOR STROKE TYPES

Simple strokes can be divided into two types: straight lines and slightly curved lines. The former include horizontal lines and vertical lines. Although they are straight, they should not look stiff. Slightly curved lines include the down-left stoke, the down-right, and, surprisingly, the dot. These strokes should not be straight but should be made with a slight natural curve. Often strokes with a hook attached are also written with a slight bend, as shown in Figure 5.6. Note also that the part of a stroke that curves is always thinner, while the end of a stroke where the hook is attached is thick, an effect produced by pressing down with the brush. Make sure that you attend to such details. If you can produce such minute differences, your strokes will look much better.

Horizontal and vertical lines can vary in relative length or thickness. These variations are determined by the position of a particular stroke in a character. For example, the first horizontal line in 天 *tiān*, "day/sky," has to be shorter than the second horizontal line. By comparison, variations in curved lines may be in the direction of a stroke and the degree of the curve. The down-left stroke in 人 *rén*, "person," for example, is different from the down-left stroke in 月 *yuè*, "month/moon." The former is a more simple down-left stroke, while the latter starts with a vertical line and then changes into a down-left stroke with more of a curve. Learners should note two important points here. One is that such details should not be overlooked in writing. The other is that strokes of the same type may look different in different characters or even in different parts of the same character. Versatility of strokes is important in the art of Chinese calligraphy.

There is one Chinese character that uses all of the eight major strokes and only those eight. This is the character 永 *yǒng*, meaning "eternity" (Figure 5.7). For this reason, the study of stroke types and how they are written is called "the eight meth-

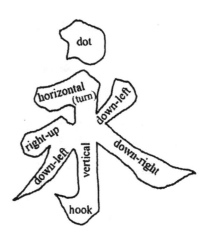

FIGURE 5.7. The character *yǒng*, "eternity."

ods of *yǒng*." In China, students of calligraphy always spend years practicing the eight stroke types. It is said that, as a young student, Wang Xizhi, the calligraphy sage of the Jin dynasty, spent fifteen years on the eight methods of *yǒng* to build a firm grasp of stroke techniques.

The analysis of stroke types has changed over the long history of Chinese calligraphy. For example, the second stroke in Figure 5.7 has a turn that joins a horizontal stroke and a vertical stroke. However, the turn did not receive much attention in ancient times; it was not even mentioned in calligraphy treatises on the eight-stroke method until the Tang dynasty, when the Regular Script was fully developed. Instead, the short down-left slant on the upper right side of the vertical line and the long down-left slant on the lower left side were once seen as two different stroke types. Thus the total number of stroke types has remained eight.

SUGGESTIONS FOR BEGINNERS TO AVOID COMMON PITFALLS

Feeling nervous at the beginning is natural. If you are nervous, you may hold the brush incorrectly. As a result, the hand may shake and your writing may be affected. If this happens to you, relax and make sure you are not holding the brush too tight. To help stabilize your writing hand, you may use your free hand as a cushion by putting it under the wrist of your writing hand.

Brush writing is like driving in that the calligrapher, like the driver, should always be in total control. The beginning and ending of strokes are particularly crucial points because they show the quality of strokes and features of the writing style. They should never be taken lightly. Make sure you have a clear plan in your mind for how to write them, and the way your strokes are written should clearly show your intention. In other words, no stroke should be written at random. This is especially important for beginners.

A common beginner mistake is to use the brush like a hard pen, drawing lines without motions of pressing and lifting. Do not drag the brush when writing a stroke, because brush writing involves constant changes in the amount of pressure applied to the brush through pressing and lifting, although the changes may be very slight. When studying model characters, pay special attention to the way the pressure of the brush alters from one point to the next, and try to imitate that without overdoing it.

Some beginners write characters all of which tilt in the same way and to the same degree. This is most likely a consequence of their English writing habits. Unfortunately, although such a look may be acceptable and even desirable for other scripts, it is considered a pitfall in Chinese brush writing. Every effort should be made to correct this tendency. Sit up when writing and put the writing sheet right in front of you, without turning it sideways. Pay special attention to your vertical lines. They should go straight down with no sideways tilt.

Table 5.1 shows some common errors in writing brush strokes. Remedies are recommended.

Note the following additional points:

- Do not make indecisive strokes. Before putting your brush down on the paper, have a good idea of what you are going to write; know the shape, size, and position of each stroke within an imagined square; and know how you are going to start, continue, and finish the writing. Once you start a stroke, do not stop in the middle to glance at your model. Even if you slow down, the ink in the brush will keep flowing out of the brush and onto the absorbent paper. Your line will begin to spread out in blotches, destroying the momentum of the stroke.
- Readjust and recharge your brush frequently.
- A stroke is executed by a single effort, whether it turns out to be good or bad. Touching it up afterwards would destroy its life.
- The ability to develop your own style and to do it well depends on good early training and unremitting practice. Practice with patience. Write slowly and pay attention to every detail in every part of each stroke and character. Repeat not for the sake of repetition but for improvement. Every time you write there should be a process of studying, learning, and improvement until your writing becomes satisfactory.

STROKE ORDER

We know that Chinese characters are constructed from strokes. The number of strokes in a character varies from the most simple 一 *yī*, "one," written with only one stroke, to the most complex, *tiè* or "verbose," shown in Figure 5.8, which is a combination of four 龍 *lóng* (dragon) characters and has as many as sixty-four strokes.

FIGURE 5.8. The number of strokes in characters.

TABLE 5.1. Common Errors in Stroke Writing

ERRONEOUS STROKES	PROBLEM AND EXPLANATION	REMEDY
	In the Regular Script, no stroke should start or finish with split endings.	(1) Start the stroke with a straightened brush. (2) Slow down at the end to make a pointed ending.
	In the Regular Script, no streaks are supposed to be seen within strokes.	Load the brush with more ink and reduce the speed of writing.
	The beginning and ending of these horizontal lines were not created with proper pressing down of the brush. Rather, the brush was used like a hard pen to trace or paint the thicker endings of the strokes.	Press down properly at both ends without tracing the outline.
	The transition between the two ends and the middle part of the stroke is not smooth.	The change in pressure on the brush should be more gradual.
	The center part of the stroke is too thin. The brush is brought up too much.	Apply more pressure in the middle of the stroke.
	The brush is held at an angle. An angled brush typically produces asymmetrical lines that are straight on one side and rough on the other, like a saw.	Make the brush more vertical and use the center-tip technique.

The number of strokes in a character is a practical matter directly related to writing speed. There is no doubt that characters as complex as *tiè* take too much time to write. In fact, characters with more than thirty strokes are rarely used in modern Chinese. They are mostly ancient characters that appear in dictionaries only for the study of classical Chinese.

Ideally, the fewer strokes a character has, the better. However, since the number of frequently used characters (for newspaper reading, for example) is about three thousand, and since each character has to be distinct enough for visual decoding, they cannot all be simple. In modern Chinese, the majority of characters in use contain fewer than twenty-five strokes. According to statistics, the top two thousand most frequently used characters in their traditional form have an average of 11.2 strokes. This number was brought down to 9.8 through a simplification campaign in the mid-twentieth century.[1] If we divide frequently used characters according to stroke count, the groups with the largest number of characters are those with nine to eleven strokes. There are only two characters with one stroke, 一 *yī*, "one," and 乙 *yǐ*, "second (of the Heavenly Stems)."

If a character has a number of strokes that crisscross each other, how does a calligrapher know where to start, how to proceed, and where to end? With sufficient knowledge of strokes, this question is not difficult to answer: the characters are written following a prescribed sequence, stroke by stroke. The sequence of strokes is governed by a number of general rules, as shown in Table 5.2. Following these rules, each character has a prescribed, fixed stroke order. The first two rules are the most basic: from top to bottom and from left to right. For characters with multiple components, each component as a unit is also written according to these rules. For example, the character 的 (a noun modifier marker) has two components in a left to right arrangement. The part on the left is written first, following stroke order rule 2.

Students of the Chinese language often ask why characters must be written in such an exact, specific stroke order. This question can be answered with reference to brush writing.

Because the stroke order rules are the result of many years of collective writing experience and study of character structure, they represent the most efficient way of writing. They also help the calligrapher to locate each character's center of gravity as early as possible during writing so that other strokes and components can be added with respect for internal balance. Take the character 水 *shuǐ*, "water," for example: as soon as the first stroke is put down (the vertical line with a hook that forms the middle of the character), we know how tall and how wide the character is meant to be, and where the center of the character is. This gives us an idea of where the strokes on the left and right should start, and how far apart they should be—and all of this is indicated by the central vertical line.

The prescribed stroke order also facilitates accelerated writing. When a rapid hand produces linked strokes, the characters will remain legible only when the same

TABLE 5.2. Stroke Order Rules

STROKE ORDER RULE	EXAMPLES
1 Top to bottom	一 二 三 , 丶 二 亠 立
2 Left to right	丿 人 , 丶 亻 白 白 白 的 的
3 Horizontal before vertical	一 十 , 一 十 卡 古 古
4 Central vertical before shorter symmetric strokes on two sides	亅 刀 水 水 , 亅 小 小
5 Outline before content	丿 刀 月 月 , 丨 冂 内 内
6 Content before closure of outline	丨 冂 日 日 , 丨 冂 月 内 囷 因

characters are written following the same conventionalized stroke order and the strokes are linked in the same way. This is illustrated in Table 5.3, which compares the same characters written in Regular Script and Running Style. If the characters are written with an incorrect stroke order in the Running Style, the strokes will be linked differently, resulting in undecipherable characters.

In speedy writing, even when the strokes are not linked by solid lines, they still correspond to each other; a previous stroke points in the direction of the following stroke or vice versa. The two dots at the bottom of 只 *zhǐ*, "only," are a good example. There is a relationship between the two dots that gives the whole character a unified look.

The stroke order rules also point to an essential difference between calligraphy and other forms of visual art for which there is no fixed order of production. Not only does the writing of each stroke in Chinese calligraphy proceed from a fixed beginning point to a fixed end point, but strokes in characters are sequenced. The stroke order also represents a flow of energy during writing. In the process of writing, an experienced calligrapher uses energy that originates from the lower abdomen (丹田 *dāntián*) and travels through the arm and fingers and ultimately, by way of the brush, onto the paper. The energy is rendered visible by the linear route of the ink. The stroke order, surprisingly, is followed not only in calligraphic production, but also in a serious reader's appreciation when he or she retraces the flow of energy

TABLE 5.3. Stroke Order and the Speed of Writing

Standard Script	Stroke Order	Running Script
立	丶 亠 六 方 立	立
文	丶 亠 ナ 文	文
小	亅 小 小	小
京	丶 亠 六 六 古 亨 京 京	京
我	丿 二 手 手 我 我 我	我
只	丶 冂 口 尸 只	只

while enjoying the quality of writing. It is believed that the energy emanating from the paper may even be absorbed by viewers and thus energize their bodies.

For beginners, the best way to learn correct stroke order is to gain a general understanding of the stroke order rules and then to practice writing characters until they become second nature. After your hand becomes accustomed to the repeated patterns, a stroke written out of order feels wrong. To help you learn the exact stroke order of every character, in this book all of the model brush-written characters in Regular Script are marked to indicate the proper stroke order.

The general rules listed in Table 5.3 apply to the majority of characters in Regular Script. Exceptions do exist, especially when writing in faster modes such as the Running and Cursive styles.

DISCUSSION QUESTIONS AND WRITING PRACTICE

1. Without looking at the book, verbalize the procedures for writing a typical turn and a hook.

2. Name the six general stroke order rules, and provide two examples for each of them.

3. Why is stroke order necessary?

4. Practice the stroke types and variations on pp. 211–212 in Appendix 1.

5. Practice character writing on pp. 213–214 in Appendix 1.

6. Prepare to write your Chinese name. If you have a Chinese name already,

make sure you know how it is written, the meaning of each character, and how it is pronounced.

If you do not have a Chinese name yet, there are some websites that will generate a Chinese name after you key in your English name. However, since this is done by a computer based purely on the sound of your English name, it is a good idea to check with a Chinese person to make sure it is indeed a good name.

7. Find out the stroke order of your Chinese name, and practice it using a hard pen first and then a brush.

..

The Formation of Chinese Characters

The distinct look of Chinese written signs has given rise to misconceptions, one being that Chinese is a pictographic script and that each symbol in Chinese writing is a picture of something. Even college students may fall into this trap. "How do you draw this character?" they ask, reluctant to use the word "write."[1] Apparently, this misunderstanding arises because Chinese is not alphabetic. The written symbols do not directly relate to sounds. Rather, they are meaning symbols that sometimes have a connection with the shape of objects.

In this chapter, we take a close look at Chinese written signs by examining their formation, their components, and the function of different types of components. We start the discussion by comparing Chinese with alphabetic languages such as English.

THE NATURE OF CHINESE WRITTEN SIGNS

In the Western world, since Phoenician businessmen taught their method of writing to customers around the Mediterranean more than three thousand years ago, writing systems have been alphabetic—representing sounds of speech. Previously,

however, writing throughout the world was no different from Chinese. Everywhere, written expression was logographic—symbols represented words rather than sounds. Many logographic language symbols, especially in early writing, were pictographic (they resembled the physical appearance of the objects they represented). This was true for all ancient languages, including cuneiform (used in ancient Sumer, Assyria, and Babylonia), hieroglyphics (Egypt), and Chinese (China). A check on the origin of the English alphabet shows that the twenty-six letters evolved (with intermediate steps) from proto-Phoenician "pictographic" symbols. The letter "A," for example, began as the image of an ox's head turned sideways: ⟨. Now, however, the letter "A" and all the other symbols in the alphabet are sound symbols. Keep in mind that no language, even ancient languages, can be completely pictographic, because once a language system is in use, there have to be symbols that represent abstract ideas and indicate grammatical relations between words. Those symbols cannot be pictographic.

What distinguishes Chinese from the rest of the world's ancient logographic languages is that Chinese logographic writing was not abandoned in favor of alphabetic writing. Instead, Chinese writing has remained logographic up to the present day. This is not to say that Chinese has not changed; in fact, although the writing system has never taken the revolutionary step of adopting an alphabetic scheme, primitive pictographs and logographs have gradually been refined and stylized into an intricate and highly sophisticated system.

The question of why Chinese has never adopted an alphabetic scheme would take an entire book to answer. What can be briefly mentioned here is that, geographically, China is very much isolated from the rest of the world by oceans to its east and mountains and deserts in the west. This separation was accompanied by the development of a high culture, early in Chinese history, that greatly influenced its surrounding areas. Chinese customs and Chinese characters in writing were adopted by many of its neighbors. But until the nineteenth century, only one major foreign influence had a broad impact on China: Buddhism, from India. Even so the Chinese writing system has never been affected. Having developed in a geographic vacuum and resisted foreign influences, the Chinese writing system remained purely indigenous by keeping its logographic nature.

Thus not only has the Chinese language been in continuous use for several millennia, Chinese written symbols still bear traces of their origins. A person today with only partial knowledge of classical Chinese grammar can still read classical literature written two thousand years ago. For English readers, whose language consists of words with origins in Anglo-Saxon, Norman French, Latin, and Greek, and who cannot read English texts written as recently as seven hundred years ago, the unbroken chain of an ancient written language elicits wonder and fascination.

Given that Chinese writing does not show pronunciation directly, how, then,

are the writing symbols constructed? As stated earlier, the number of characters even for the most basic functions goes to thousands. These characters, however, are not a collection of unrelated arbitrary symbols. Analyses of characters since ancient times have indicated several major methods by which characters were formed.

This work was first done in the Han dynasty (206 BCE–220 CE) by a philologist named Xǔ Shèn 許慎 in a book titled *Shuō wén jiě zì* 說文解字, or *Analysis of Characters*. Xu Shen divided all characters used in his day into two broad categories: single-component characters (such as 木 *mù*, "tree") and multiple-component characters (such as 林 *lín*, "woods," which combines two "tree" symbols into one character). Single-component characters are called 文 *wén* and multiple-component characters 字 *zì*. Hence, the literal translation of the title of Xu Shen's book is "speaking of *wen* and explanation of *zi*." Six categories of characters were identified that reflect major principles of character formation and use. The book lists 9,353 characters plus 1,163 variant forms. It is believed to be the most comprehensive study of characters in use during that time.

Since the Han dynasty, the Chinese writing system has not changed much overall, nor have there been changes in the principal methods of character formation, although the number of characters in use grew to about 47,000 in the Qing dynasty (1644–1911) and is well over 60,000 today. For more than 1,900 years, Xu Shen's analysis in terms of six classes has remained an influential categorization method of Chinese characters, although alternative etymology theories have also been proposed.

CATEGORIES OF CHARACTERS

Within Xu Shen's six classes, four (classes 1, 2, 3, and 5) have to do with the formation of characters. The other two regard character use. The sixth class, known as 轉注 *zhuǎnzhù* or "semantic transfer," will not be looked at in detail here because it involves disagreement among scholars, and examples are scarce. For people without knowledge of Chinese writing, the etymology of the examples for each category is quite interesting. They make useful mnemonic devices for learning some characters.

PICTOGRAPHS

Many early written signs in Chinese originated from sketches of objects. Thus they bore a physical resemblance to the objects they represented, like pictures, which is why they are called pictographs. Typical pictographs are illustrated in Figure 6.1.

Apparently, the written signs in Figure 6.1 were invented to represent physical objects in the world, and gradually they evolved from the original pictographic

Picture	Evolution	Modern character	English
☀ → ⊙ →	日	日	sun
☽ →	月	月	moon
🌳 → 木 →	木	木	tree
⛰ →	山	山	mountain
〰 →	水	水	water
▦ → 井 →	田	田	field
門 →	門	門	door

Figure 6.1. The evolution of pictographic characters.

symbols into their modern forms by a process of simplification and abstraction, during which details were left out and curves were changed into straight lines. As a result, modern characters are far removed from their original pictures, although they sometimes still show traces of the objects they represent. Although these are the most frequently used examples of pictographic characters, modern people without any knowledge of Chinese characters, when seeing these symbols, would make no connection to their referents before the similarities were explained. The character 日 *rì*, "sun," for example, looks more like a window, while the character 月 *yuè*, "moon," resembles a stepladder. Generally speaking, without knowing the meaning of these characters, one cannot decode them by merely looking.

Although pictographic characters are the best known type among people who are not very familiar with Chinese written signs, their number is much smaller than one might think. Even in the earliest writing we know of, the Shell and Bone Script (ca. 1400–ca. 1200 BCE), pictographic signs were a small portion of characters, about 23 percent. Even then the majority of written symbols did not depict physical shapes of objects. The decline of pictographic signs was well under way by the Han dynasty. When Xu Shen did his study based on Small Seal characters (see Chapter 8), pictographic signs comprised only 4 percent of all Chinese characters.[2]

In modern Chinese, even fewer characters show their pictographic origin clearly. A more common function of these "pictographic" signs today is to indicate the semantic category of a compound character (see below).

INDICATIVES

An indicative is a character made by adding strokes to another symbol in order to indicate the new character's meaning. For example,

刃 *rèn*, "blade." A dot is added to 刀 *dāo*, "knife."

旦 *dàn*, "morning." A horizontal line is added underneath 日 *rì*, "sun" to show the time when the sun is just above the horizon.

本 *běn*, "root." A short line is added to 木 *mù*, "tree."

SEMANTIC COMPOUNDS

Semantic compounds are constructed by combining two or more components that collectively contribute to the meaning of the new character. Examples are

明 *míng*, "bright," is a combination of 日 *rì*, "sun," and 月 *yuè*, "moon."

信 *xìn*, "trust," combines 人 *rén*, "person," and 言 *yán*, "words."

看 *kàn*, "look," has 手 *shǒu*, "hand," over 目 *mù*, "eye."

林 *lín*, "woods," shows two 木 *mù*, "tree."

森 *sēn*, "forest," is composed of three 木 *mù*, "tree."

囚 *qiú*, "prison," is represented by a 人 *rén*, "person," in 口, "confinement."[3]

The methods of character formation represented by pictographs, indicatives, and semantic compounds are all iconic. They are limited in that new signs have to be created for new words. As a result they could not meet the needs of a fast-developing society and its increasing demand for new written signs. In addition, abstract ideas and grammatical terms (such as prepositions, conjunctions, and pronouns) were impossible to represent with pictographic signs. The solution was to break away from iconic representation and to use existing written signs to phonetically represent the sounds of new words. This process is called "borrowing."

BORROWING

Borrowing in this context refers to the use of existing characters to represent additional new meanings. Two frequently used examples are

來 *lái*, originally a pictograph for "wheat." The written character with its pronunciation was later borrowed to mean "to come." In time, the borrowed meaning prevailed, and the original meaning of "wheat" died away.

去 *qù*, originally a pictograph for a cooking utensil. Later the character was borrowed to mean "to go." The borrowed meaning also prevailed, and the original meaning died away.

In cases such as 來 *lái* and 去 *qù*, only the borrowed meaning has survived in modern Chinese.

SEMANTIC-PHONETIC COMPOUNDS

Semantic-phonetic compounds are a hybrid category constructed by combining a meaning element and a sound element. This method of character formation thrived as a means to solve the ambiguity problem caused by borrowing. As can be easily seen, when a particular character is borrowed to mean more and more different things, sooner or later, the interpretation of the multiple-meaning written sign becomes a problem. To solve the problem and to allow borrowing to continue, a semantic element is added to indicate the specific meaning of the new character. This process led to the creation of semantic-phonetic compounds.

Thus, a semantic-phonetic compound has two components, one indicating meaning and the other pronunciation. Take 主 *zhǔ*, "host," as an example. In modern Chinese, the character is used as a phonetic element in more than ten semantic-phonetic compounds, five of which are shown in Table 6.1. The five characters in the first column are pronounced exactly the same way, *zhù*, although they are different in meaning. They share the same phonetic element, 主 *zhǔ*, which is the right-hand side of the characters. The signs on the left are semantic components, which offer some clue to the meaning of the characters.

The semantic elements, for example, 亻, "person," 氵, "water," and 木, "tree," are pictographs commonly known as "radicals." Their function is to hint at the meaning of the characters in which they appear. At the same time, they also group semantically related characters into classes. For example, all the characters with 亻, "person," as a component have to do, at least in theory, with a person or people; all the characters with 木, "tree," as a component have to do with wood or trees. Traditionally, Chinese characters are categorized under 214 radicals.

One way to organize characters in dictionaries is to group them under these radicals.

Table 6.2 briefly illustrates the combination of semantic and phonetic elements in the formation of characters. The vertical columns group characters by phonetic elements, and the horizontal rows group characters by semantic elements. In other words, characters in the same column have phonetic similarities and those in the same row share semantic features. As seen in Table 6.2, the arrangement of the two elements in a semantic-phonetic compound can be left to right or top to bottom (as in 菁, 筒, and 苛). Other patterns not shown here include outside to inside, as in the character 国 *guó*, "country." Radicals may take any position in a character.

In modern Chinese, the majority of characters in the writing system belong to the category of semantic-phonetic compounds. From as early as the Han dynasty, this became the most productive method for creating new characters. It is worth noting, however, that there are problems with extensive reliance on semantic-phonetic characters. Languages change over time, and Chinese is no exception. Both the pronunciation and the meaning of characters are in a state of flux. While the written signs remain constant, over time sound change and semantic evolution have eroded the relationships between characters and their sound and semantic components, making it more and more difficult to deduce the meaning and pronunciation of a character from its written form. Now, as can be partially seen in Table 6.2, phonetic elements do not indicate the pronunciation of the characters

TABLE 6.1. Semantic-Phonetic Compounds: zhù

CHARACTER	SEMANTIC PART	MEANING	PHONETIC PART	PRONUNCIATION
住	亻 person	live	主 *zhǔ*	*zhù*
注	氵 water	to pour (liquid)	主 *zhǔ*	*zhù*
柱	木 tree	pillar	主 *zhǔ*	*zhù*
蛀	虫 insect	boring (of insects)	主 *zhǔ*	*zhù*
驻	马 horse	halt, station	主 *zhǔ*	*zhù*

TABLE 6.2. Examples of Semantic-Phonetic Compounds

	主 ZHǓ	可 KĚ	青 QĪNG	同 TÓNG
亻 **person**	住 zhù, "live"	何 hé (family name)	倩 qiàn, "pretty"	侗 dòng (name of a minority group)
氵 **water**	注 zhù, "to pour (liquid)"	河 hé, "river"	清 qīng, "clear"	洞 dòng, "hole"
虫 **insect**	蛀 zhù, "boring by insect"		蜻 qīng, "dragonfly"	
木 **tree**	柱 zhù, "pillar"	柯 kē, "stem of plant"		桐 tóng, "phoenix tree"
艹 **plant**		苛 kē, "severe"	菁 jīng, "lush"	
竹 **bamboo**			箐 qìng, "bamboo woods"	筒 tǒng, "things in bamboo-tube shape"

clearly and accurately; nor do semantic elements show the exact meaning of char-acters. In modern Chinese, the value of semantic-phonetic characters resides in the combination of these two types of information to determine a character's meaning and pronunciation.

THE COMPLEXITY AND DEVELOPMENTAL SEQUENCE OF THE CATEGORIES

The five categories of characters described above represent three stages of de-velopment in character formation. The first stage is represented by pictographs, indicatives, and semantic compounds. At this stage, written signs were created based on a physical resemblance of some sort. This process also corresponds to an early mode of human cognition, perceiving the world through the senses. Of the three categories, pictographs are the simplest; indicatives and semantic compounds involve more complex and abstract concepts.

The second stage is phonetic borrowing. Initially, single-element characters such as 主 zhǔ, "host" were borrowed to represent additional meanings. As the multiple meanings of single characters became a source of enormous confusion,

semantic elements were added to differentiate meanings more clearly, which led to the use of semantic-phonetic compounds.

The third stage combines semantic and phonetic information to create new characters. This is the highest stage of development, completed in the Han dynasty, about two thousand years ago, when the Chinese writing system reached maturity. No new method has appeared since then, although the existing categories of characters have grown and shrunk. In modern Chinese, more than 90 percent of characters in use are semantic-phonetic compounds; those that can be traced back to their pictographic origins comprise less than 3 percent.

CHINESE CULTURE (2): DATES IN CHINESE ACCORDING TO THE WESTERN CALENDAR

The date of a work of Chinese calligraphy is recorded as part of the inscriptions. This can be done in using the traditional Chinese method, which will be discussed in Chapter 9, or using the Western solar calendar. To learn about the latter system, you need the following basic numbers:

0	1	2	3	4	5	6	7	8	9	10
0	一	二	三	四	五	六	七	八	九	十
líng	*yī*	*èr*	*sān*	*sì*	*wǔ*	*liù*	*qī*	*bā*	*jiǔ*	*shí*

11	15	20
十一	十五	二十
shí-yī	*shí-wǔ*	*èr-shí*

21	25	30
二十一	二十五	三十
èr-shí-yī	*èr-shí-wǔ*	*sān-shí*

YEAR

In English, the year is sometimes pronounced based on the four-digit number, such as two thousand eight for 2008, and sometimes by two-digit units, such as nineteen ninety-one for 1991. In Chinese, years are pronounced digit by digit. The four digits are always followed by the word 年 *nián*, "year." For example, 2009 and 2010 are

二〇〇九 年	二〇一〇 年
2-0-0-9 year	2-0-1-0 year
èr líng líng jiǔ nián	*èr líng yī líng nián*

MONTH

Unlike English, in which each month is indicated by a different word, months in Chinese are numbered. For example, February would literally be "the second month of the year." The number is followed by 月 *yuè*, "month":

一月	二月	三月	四月	五月	六月
first month	second month	third month	fourth month	fifth month	sixth month
yī yuè	*èr yuè*	*sān yuè*	*sì yuè*	*wǔ yuè*	*liù yuè*

七月	八月	九月	十月	十一月	十二月
seventh month	eighth month	ninth month	tenth month	eleventh month	twelfth month
qī yuè	*bā yuè*	*jīu yuè*	*shí yuè*	*shí yī yuè*	*shí èr yuè*

DAY

A specific day of the month is indicated by the number followed by 日 *rì*, "day":

一日	四日	八日	十日
first day	fourth day	eighth day	tenth day
yī rì	*sì rì*	*bā rì*	*shí rì*

十一日	十四日	十八日	二十日
eleventh day	fourteenth day	eighteenth day	twentieth day
shí yī rì	*shí sì rì*	*shí bā rì*	*èr shí rì*

二十一日	二十四日	二十八日	三十日
twenty-first day	twenty-fourth day	twenty-eighth day	thirtieth day
èr shí yī rì	*èr shí sì rì*	*èr shí bā rì*	*sān shí rì*

To put a date together, use the following format. Remember, the units are always arranged from the most general to the most specific.

_____ 年 _____ 月 _____ 日

_____ (year) ____ (month) ____ (day)

For example:

二〇〇七年 三月 十四 日
2007 year third month fourteenth day
March 14, 2007

一九九九 年 六 月 二十二 日
1999 year sixth month twenty-second day
June 22, 1999

DISCUSSION QUESTIONS AND WRITING PRACTICE

1. Name the five categories of characters discussed in this chapter, and give three examples for each category.

2. Is Chinese a pictographic language? Why or why not?

3. Using a hard pen, write down in Chinese (1) the birthday of a friend, (2) the date of last Christmas, and (3) the date of the coming Monday.

4. Practice character writing on page 215 in Appendix 1, first tracing and then copying. After that, practice writing the numbers on page 216 in Appendix 1 on a separate page.

5. Examine the sheet you just copied and identify three problems in your stroke writing. Discuss the remedy for these problems. Write the characters again to make improvements. This can be done repeatedly.

6. Find out more about each character in your Chinese name: Is it a single-component or multicomponent character? Is there a phonetic component and/or a semantic component?

The Internal Structure of Characters and the Aesthetics of Writing

As we have seen in previous chapters, Chinese characters are constructed by assembling strokes in a two-dimensional square. Some characters consist of single signs; others combine multiple components to form complex characters. This chapter examines the shapes and structural configurations of characters, their internal layout patterns, and the proportions of components, all of which are of primary importance for writing Chinese characters. In addition, it also discusses and illustrates basic aesthetic principles together with rules for balance and techniques to increase stroke dynamics.

THE STRUCTURE OF CHARACTERS

Chinese characters are, like buildings; they have to be built with good materials and a fine design. In writing, strokes are like building materials; high quality is most essential. The composition of parts also requires good design. Strokes must be positioned properly in order for the character to have a pleasing and poised look. In a way, characters are also like people, each having a distinct facial sketch, body outline, posture, and movements.

OVERALL SHAPES OF SINGLE-COMPONENT CHARACTERS

The discussion in this section concerns the shapes of characters in the Regular Script only. Whether it consists of a single component or multiple components, each character has to fit into a square space.[1] Within this general convention, however, some characters are not exactly square in shape. This can mostly be seen in single-component characters. Table 7.1 displays examples of characters in various geometric shapes as well as their meanings. In the first row are characters in the standard rectangular shape of the Regular Script, to which the majority of characters conform. The rest of the table lists the shapes that deviate slightly from the norm. In writing, the overall shape of these characters should be maintained, just like the face of a person in a portrait.

TABLE 7.1. Geometric Shapes of Single-Component Characters

	SHAPE	EXAMPLES			
1	▭	父 father	肉 meat	门 door	年 year
2	▯	月 moon	日 sun	目 eye	片 slice
3	▬	四 four	心 heart	一 one	而 yet
4	△	上 up	火 fire	人 person	在 be/at
5	▽	下 down	可 approve	寸 inch	丁 fourth
6	⏢	里 mile	天 day/sky	五 five	王 king
7	⏢	百 hundred	言 words	田 field	甘 sweet
8	◇	十 ten	千 thousand	辛 laborious	中 middle

TABLE 7.1. Geometric Shapes of Single-Component Characters, continued

	SHAPE	EXAMPLES			
9	⬭	不 no	水 water	東 east	永 eternity
10	▱	夕 evening	力 force	方 square	万 ten thousand

LAYOUT PATTERNS AND PROPORTIONS
OF COMPOUND CHARACTERS

Multiple components in a character must fit together into an imagined square. Often components may also be characters themselves when they are written independently. For example, the character 明 *míng*, "bright," has two components, 日 and 月. 日 *rì*, by itself, is a character meaning "sun," and 月 *yuè* is a character meaning "moon." Only when they are written together to fit into an imagined square do they become a single character. Therefore, the way symbols are written directly affects the way they will be read.

For beginning learners of Chinese, fitting multiple components into a square is easier said than done. In English, each written sign (each letter), occupies a space of a fixed size. Letters are arranged in a linear order. The more letters a word has, the longer the word gets. People who are used to English writing do not usually think about how much space a word takes up until they come to the end of a line. When these people learn to write Chinese, they sometimes apply the same principle to Chinese characters, particularly characters with left to right components. Thus 明天, "tomorrow," may be written as 日月天, "sun + moon + day"; 一杯水, "a glass of water," becomes 一木不水, "one + tree + no + water"; and 一小时, "one hour," looks like 一小日寸, "one + small + day + inch." A personal name like 柯桃花 may be written as 木可木兆花. For characters of other configurations, common problems include running out of space before the character is completed or writing the components of a character in such a way that they are out of proportion. To solve these problems, one must always be conscious of the imagined square for a character. Also required is knowledge of layout patterns and proportions of components within characters. Such knowledge also helps students learn and memorize characters.

According to statistics, more than 90 percent of modern Chinese characters are compound characters, among which 64 percent have a left to right configuration

and 23 percent have a top to bottom structure.[2] Some of the most common layout patterns are shown in the three tables below. Table 7.2 displays characters in which the components are horizontally arranged (left + [mid] + right). The components can be of equal or unequal sizes; their approximate proportions are shown by the figures in the second column. In category 4, the major layout pattern is left to right, and then the part on the right is further divided into top and bottom components.

Table 7.3 contains characters with components arranged vertically (top + [mid] + bottom). Again, in category 4, the characters are divided primarily into

TABLE 7.2. Characters of Left-(Mid)-Right Layout Pattern

	PATTERN	EXAMPLES			
1	[1 \| 2]	龍 dragon	和 harmony	如 as	祥 propitious
2	[1 \| 2]	海 sea	仁 benevolence	法 rule	行 journey
3	[1 \| 2 \| 3]	謝 thank	街 street	做 do	樹 tree
4	[1 \| 2/3]	福 blessing	始 start	精 refined	清 light

top and bottom portions before the top portion is further divided into two left to right parts.

The third group of layout patterns, shown in Table 7.4, has surrounding or partially surrounding structures. Note that the patterns and proportions of components in characters are prescribed and fixed. They should not be altered in writing. Therefore, it cannot be overemphasized that one must have a plan in mind before writing.

ADJUSTMENTS FOR ACCOMMODATION

When multiple components come together to form a single character, two types of adjustments are made in order to fit the parts into a square shape. The first type is the adjustment of the shape and size of the components. For example, for a character with a horizontal arrangement of left + mid + right, such as 謝 *xiè*, "thank," the three components, 言, 身, and 寸, have to be narrowed to the proportion of the space they are supposed to occupy within the character. The same requirement applies to all other layout patterns.

TABLE 7.3. Characters of the Top-(Mid)-Bottom Layout Pattern

	PATTERN	EXAMPLES			
1		吉 auspicious	息 stop	志 aspiration	樂 happy
2		字 character	草 grass	華 best part	筆 pen
3		意 desire	常 often		
4		碧 green	想 think		

TABLE **7.4**. Characters with a Surrounding or Partially Surrounding Structure

	PATTERN	EXAMPLES		
1		國 country	因 because	圖 picture
2		同 same	風 wind	网 net
3		可 approval	司 manage	习 study
4		道 way	起 rise	

The second type of adjustment has to do with stroke types. In order for components to fit together, some strokes are changed into other stroke types so that they take less space. Such adjustments are frequently made in the radical part of a character so that other components can be accommodated without conflict between brush strokes. Table 7.5 shows some common adjustments of this type. As can be seen from these examples, adjustments in radicals are made in addition to alterations to the overall shape and proportion of components. Such adjustments have been standardized and have become part of the writing system.

AESTHETIC PRINCIPLES

So far we have discussed two major reasons that Chinese calligraphy has developed into an art form. The first is the large number of logographic symbols that provide unlimited variety. The second is the writing instruments used, which contribute greatly to the opportunity for artistic expression. This section illustrates another aspect of Chinese calligraphy that has made it an independent field of study. Throughout history, Chinese calligraphy has been practiced by many scholars, who have left not only a wealth of masterpieces, but also well-established aesthetic theories of calligraphy. Aesthetics is a comprehensive area of study closely related to culture, perception, and philosophy. Thus aesthetics of Chinese calligraphy,

TABLE 7.5. Adjustments for Accommodation

	COMPONENTS	CHARACTER	OTHER EXAMPLES	MAJOR CHANGE
1	人言	信 trust	何他休住	＼ → ∣
2	木主	柱 pole	村松梅桃	＼ → ﹀
3	土也	地 ground	址坎境	一 → ✓
4	王見	現 now	玲珠球	
5	金十	針 needle	錢釘鈔	
6	竹由	笛 flute	筆筷笑	∣ → ﹀
7	足包	跑 run	跳跟蹈	足 → 𧾷
8	食反	飯 meal	館餓餡	食 → 飠
9	示畐	福 blessing	祥祖神社	示 → 礻
10	衣由	袖 sleeve	衫初補	衣 → 衤

by nature, cannot be talked about without also discussing Chinese culture, philosophy, and other forms of art such as architecture, painting, music, and dance. Such discussions and the general aesthetic principles shared by different art forms exist at an abstract level. While this book is not intended to offer a comprehensive discussion of the aesthetics of calligraphy,[3] some basic aesthetic principles relevant to brush writing at the beginning level are illustrated and substantiated in various chapters, such as the strength of brush strokes in Chapter 4, the management of space in Chapter 12, the rhythmic vitality of writing in Chapter 13, and balance and other principles that improve the dynamics of writing below. The principles discussed below are most applicable to the Regular Script.

BALANCE

Balance is the essence of the world. It is something we learn from the moment we take our first step. Later in life, we learn that balance is not only a physical phenomenon; it can also be psychological and aesthetic. Calligraphy is an excellent example of this fusion because every character has a center of gravity. When the weight of a character is off-balance, it looks all wrong. Practicing calligraphy is a good way to improve one's sense of visual balance. In order for a character to be well balanced, its center of visual gravity should also be the center of the character. In writing, one should always be aware of where this center is. Using a grid sheet helps to keep this center visible.

In general, a character should stand on its foot or feet without looking as if it is stumbling. In most cases, the quantity of occupied space around a center or on both sides of an imagined vertical line should be the same or very close. Although this proportion is mostly instinctual and cannot be calculated, taking an initial look at some characters will help you. The majority of the characters below contain a vertical line that goes through the middle of the character. This line, or its extension, can serve as the vertical center of the character. In the last two characters (其 and 愛), however, this line does not exist and has to be imagined.

吉 雨 水 王 樂 其 愛
"good" "rain" "water" "king" "happy" "its" "love"

The following are three specific rules for balance.

Balance Rule 1

It is important for beginners to note that vertically arranged components should be centered and balanced on an imagined vertical line. This also applies to components as part of a character, as shown in the last three examples in Figure 7.1, 道, 流, and 福.

Balance Rule 2

Pairs of down-left and down-right slants at the bottom of a character are like the two feet of a person. They should finish (rest) on an imagined horizontal line. This also applies to cases such as 水 and 樂 below, where the downward slants hang on both sides of a vertical line.

人 天 愛 秋 水 樂
"person" "day/sky" "love" "autumn" "water" "happy"

"book" "foot" "will" "desire" "character" "way" "flow" "blessing"

FIGURE 7.1. Balance Rule 1.

Balance Rule 3

To keep components balanced, some characters are not written in an exactly square shape. This reflects a very important aesthetic principle in Chinese calligraphy: the principle of asymmetrical balance. When the left and right components of a character vary in complexity (that is, in the number of strokes), the positioning of the parts is often adjusted. For example, the characters below have a more complex component on the right. This component is written lower than the one on the left. The two components almost line up on top but not at the bottom.

峥 吃 硬 明
"lofty" "to eat" "hard" "bright"

When the component on the right side of a character has a vertical line going down, this component is also written lower. As an illustration, look at the brush-written character 即 *jì*, "at present" (Figure 7.3). The character 即 in (1) is written with its two parts at exactly the same height. This, however, creates a feel of instability, as if the character could stumble to the right. In (2), the component on the right is written lower, with the vertical line reaching down. The result is a much more stable structure, with the parts on both sides of the vertical line in good balance. The character in (3) shows this balance through a grid. Below are more examples.

FIGURE 7.2. The balancing of components in the character 峥 *zhēng*, "lofty and steep." This character is a semantic-phonetic compound. The left side is the semantic component, meaning "mountain"; the right side is the phonetic component, pronounced *zhēng*.

都　　　却　　　部　　　雄
"all"　　　"but"　　　"part"　　　"masculine"

The concept of asymmetrical balance can also be explained by comparing the two scales in Figure 7.4. The one in (1) has equal amount of weight on both sides; the one in (2) has unequal weight, yet its balance is still maintained. An uneven distribution of weight, as shown in Figure 7.4, can be seen in many Chinese characters. The characters in Figure 7.2 above have more weight on the right side. The characters in Figure 7.5 below are the opposite: the left side of the characters has more weight. Again, recognizing and maintaining aesthetic balance is based on experience. It requires practice and artistic talent to perceive and produce asymmetric structures with perfect balance and harmony.

OTHER AESTHETIC CONSIDERATIONS

1. In general, horizontal lines should be level, and vertical lines should go straight down. In Regular (and also Running) Script, however, horizontal lines go slightly up, about 5 degrees. Compare the styles in Figure 7.6. As these examples show, the slight upward tilt of the horizontal lines in Regular Script gives the writing a sense of motion. This kinetic tendency is even more obvious in the Running Style.

(1)　　　　　(2)　　　　　(3)

FIGURE 7.3. The balancing of components in the character 即 jí, "at present."

(1)　　　　　　　　　(2)

FIGURE 7.4. The balance of scales.

FIGURE **7.5.** 弘 *hóng*, "grand," and 也 *yě*, "also."

PRINTING	REGULAR	RUNNING	
三	三	三	"three"
成	成	成	"accomplish"
林	林	林	"woods"
我	我	我	"I, me"

FIGURE **7.6.** Printing, Regular, and Running styles—a comparison.

Note that all the horizontal lines on the same page should slope to the same degree (they should be parallel even when they appear in different portions of a text). This uniformity of angle, while maintaining a dynamic posture and momentum, keeps the text as an organic whole. Also note that this organic look is a natural tendency; as a beginner, be careful not to overdo it. All the vertical lines, no matter in what script, should go straight down.

2. If there are two parallel vertical strokes in a character, the one on the right is the primary stroke. It should be written slightly thicker than the one on the left and come down slightly lower. This rule also applies to boxes.

日	田	白	息	東	意	書
"sun"	"field"	"white"	"stop"	"east"	"desire"	"write"

3. All the horizontal lines involved in writing a box (including the horizontal lines inside) are parallel, but the vertical lines may vary. The vertical lines of a tall and slim box (as in 日 and 息 above) should be parallel and straight down, but in a wide and short box (田, 白, 東, 意, and 書) they should be written wider on top and narrower at the bottom.

4. Strokes in simple characters can be written slightly thicker, while those in complex characters should be thinner with a more compact structure. The overall look of a complex character, although it contains a large number of strokes, must be slender rather than bulky.

二　　　人　　vs.　餐　　繁　　紫
"two"　　"person"　　　　"meal"　"complex"　"purple"

5. Each character is a united, poised unit. No part should look crowded or too loose. In characters with more than two parts side by side, the strokes should be evenly positioned without conflict. The relationship between components is very much like relations among people, which function best and are most in balance when there is mutual respect, dependence, and coordination.

佛　　　　龍　　　　樂　　　　緣
"Buddha"　　"dragon"　　"happy"　　"destiny"

6. Horizontal lines should be arranged at equal intervals. This creates a sense of order and predictability, which is one of the important characteristics of the Regular Script. However, the length of horizontal lines should be varied to avoid a crushed look.

書　　　　至　　　　壽
"Han"　　　"true"　　"longevity"

7. Variation within unity is key in Chinese calligraphy. Strive for variation when writing the same strokes within a character.

三　　　　川　　　　注
"three"　　"river"　　"pour"

8. Variation may be achieved at the expense of changing stroke types. For example, the character 餐 *cān*, "meal," has three down-right slant strokes on the right side (shown by the three components written separately below). When the

components are put together to form a complex character, two of these down-right strokes, one on top and the other at the bottom, are changed into dots to avoid repetition:

又 人 良 → 餐

Writing characters with good composition is not simply a matter of following rules. Often there are no written rules, and the writer's choice is based on his or her own judgment. Good design and good execution require good taste, which must be cultivated by observation, practice, and experience.

CHINESE CULTURE (3): WHAT IS WRITTEN IN CHINESE CALLIGRAPHY?

Chinese calligraphy endows the beauty of form with the beauty of content. Traditionally, when brush writing played a major role in written communication, all writing was done with a brush. In modern society, where it is mainly a form of art, the content of writing becomes more selective. What is written is expected to be elegant and tasteful to serve the function of art. Calligraphy is also a cultural artifact. It embodies Chinese philosophy, beliefs, values, and lifestyle. What is written with a brush and put up for display should be culturally appropriate.

Generally speaking, depending on the space available, the content of the main text of a calligraphy piece may vary from a single character to an idiomatic phrase, lines from a poem, or even an entire work of prose. Some types of short idiomatic phrases that commonly appear in calligraphy pieces are listed below. These examples are selected partly for their relatively simple characters and straightforward meaning. For each example, a word-for-word translation is given first, followed by the translation of the entire saying or phrase. Additional examples can be found in Appendix 1.

1. *Phrases expressing appreciation of nature*
 日月山川 sun-moon-mountain-river, "sun, moon, mountain, and river"
 江上清風 river-on-light-breeze, "gentle breeze on the river"
 日出 sun-rise, "sunrise"
 春花秋月 spring-flower-autumn-moon, "spring flowers and autumn moon"
 鳥語花香 bird-chirp-flower-fragrant, "chirping birds and fragrant flowers"

2. *Phrases expounding a philosophical point or view*
 佛 Buddha

无为 no-action, "No action."

道法自然 Dao-follow-nature, "The Dao is modeled after
 nature."

大道無門 great-Dao-no-gate, "The Great Dao is gateless."
 (You can approach it in a thousand ways.)

仁義道德 kindheartedness-justice-morality, "humanity,
 justice, and morality"

3. *Phrases praising or promoting a positive feature of society or
 a person*

光明正大 open-righteous, "open and righteous"

誠信 honesty-trust, "honesty and trust"

仁者壽 benevolent-person-longevity, "Benevolence leads to
 longevity."

祥和 auspiciousness-harmony, "auspiciousness and harmony"

和平 peace

4. *Phrases expressing good wishes*

福壽 happiness-longevity, "happiness and longevity"

吉祥 auspiciousness, "good fortune"

萬事如意 everything-as-desired, "May everything go as
 you wish."

長樂永康 long-happy-forever-healthy, "Happiness and
 health forever."

5. *Phrases that encourage learning and diligence*

溫故知新 review-old-know-new, "Gain new insights
 through studying old materials."

自強不息 self-strengthen-no-ending, "Exert oneself
 constantly."

功到自然成 effort-complete-natural-success, "Continuous
 effort yields sure success."

靜思 quiet-thinking, "quiet thinking."

志在高遠 ambition-be-high-far, "Aim high."

Be wary when choosing your own phrase or saying for the content of a piece, especially for display, if you are unfamiliar with Chinese culture. In addition to using common sense, the following kinds of phrases should generally be avoided. First, avoid overt and direct expression of personal love and affection, such as, 我愛你, *wǒ-ài-nǐ*, "I love you." Second, since traditional Chinese culture is strongly influenced by Confucianism, concepts and sayings that do not conform

to principles of Confucian thinking are frowned upon. Once a student wrote 腳踏兩隻船, "feet-straddle-two-boats," as a piece, thinking that being prepared for various situations was a good principle. He was unaware that this phrase has the negative connotation of "sitting on the fence," which violates Confucian ethics of commitment and loyalty. A person familiar with Chinese culture usually has a tacit understanding of what should or should not be written in a calligraphy piece. Check if you can.

Needless to say, the content of writing is determined by the purpose of writing. In modern society, especially in the West, Chinese characters in brush calligraphy appear in a much greater variety of contexts than traditionally, on T-shirts, greeting cards, bracelets and earrings, small ornaments, and even tattoos. The content of writing also adapts to the new culture. Greeting cards and writing attached to flower bouquets and baskets for various occasions, for example, convey good wishes of all kinds:

生日快樂	birthday-happy, "Happy Birthday!"
新年快樂	new-year-happy, "Happy New Year!"
聖誕快樂	Christmas-happy, "Merry Christmas!"
恭賀新春	good-wishes-new-spring, "Happy Chinese New Year!"
早日康復	early-recovery, "Get well soon."
同心永結	same-heart-forever-unite, "Your union is forever."
馬到成功	horse-arrive-success, "[I wish you] speedy success!"
一路順風	all-way-smooth, "Bon voyage!" or "Have a good trip."

These sayings are for special occasions. They would not normally be written and displayed as a piece of artwork.

DISCUSSION QUESTIONS AND WRITING PRACTICE

1. Examine the following characters in Appendix 1 and discuss what rules illustrated in this chapter apply to writing these characters:

明 on page 215

年 書 on page 216

和而不同 on page 218

日月山川 on page 219

千里之行 始於足下 on pages 225 and 226

2. Practice the character writing on page 218 in Appendix 1. From this point

on, idiomatic expressions and sayings such as 和而不同 *hé-ér-bù-tóng*, "Harmony with diversity," will be provided for writing practice. The meaning of each character is indicated, and the meaning of the entire phrase appears in square brackets at the bottom of the page. These sayings are good candidates for the main text of a calligraphy piece.

3. Find out more about each character in your Chinese name: its components, their proportion, and their layout pattern; how the characters should be written stroke by stroke in the correct stroke order; what balance rules or aesthetic rules discussed in this chapter apply in writing the character.

4. Practice writing your Chinese name first using a grid sheet and then reducing the size of the characters. It is important to practice this because later on when you try to produce a calligraphy piece, your signature, which is part of the inscription (see Chapter 12), should be written smaller than the characters in the main text.

5. Three common layout patterns of calligraphy pieces are shown on page 219 in Appendix 1. Sketch your first calligraphy piece now using one of these patterns. Details of composition will be discussed in Chapter 12.

6. Examine the sheet you just wrote. Identify three problems in character structure and balance. Discuss the remedy for these problems before writing the characters again to make improvements.

··

The Development of Chinese Calligraphy I

THE SEAL SCRIPTS

The wonder of the Chinese brush resides not only in its ability to write an infinite variety of dots and lines, but also in the diverse scripts it produces. Chinese written signs have evolved through thousands of years, producing many different scripts and styles along the way, each with its own unique qualities. These styles are still in use today, in daily life and in art. In China, the knowledge of different writing styles is taken for granted in everyday life as well as in appreciating calligraphic artwork. The interplay of writing style, content, and purpose adds even more dimensions. Therefore, a review of the historical development of Chinese calligraphy and a general understanding of the various scripts are essential for new learners. This is our goal in Chapters 8 through 11, in which major scripts and styles are examined through history. Four scripts/styles are chosen for you, one in each chapter, to try in writing practice.

AN OVERVIEW OF SCRIPTS AND STYLES

The Chinese script spawned one of the most literate cultures of the world. The history of Chinese calligraphy is as long as that of the Chinese writing system,

which began more than three thousand years ago. Figure 8.1 shows at a glance the development of major scripts and styles through the ages, using the character 鱼 *yú*, "fish," as an example.

Several points should be made before we examine Figure 8.1 in detail. First, the scripts did not develop along a single line in time. More than one script could be developed and used simultaneously. The Small Seal and Clerical scripts, for example, both developed around the Warring States period.[1] Small Seal is generally thought to be the older of the two, partly because it belongs to the ancient scripts, while Clerical Script represents the beginning of modern scripts. A second and related point is that the development of the various scripts was not mutually exclusive. That is, the beginning of a new script did not define the end of an old

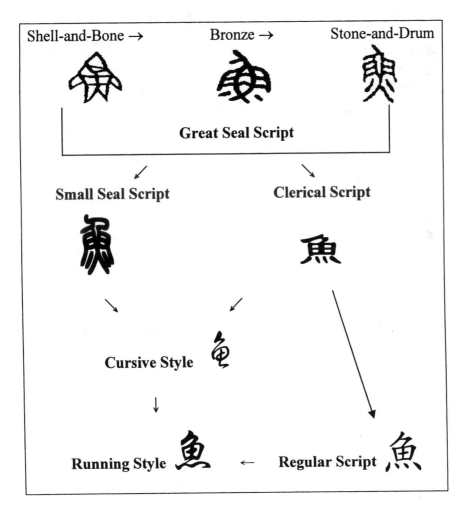

FIGURE 8.1. An overview of scripts and styles.

one. Rather, they complemented each other. The development of Regular Script, for example, helped the Cursive and Running styles mature. Third, the exact time of the development of various scripts, especially that of the Regular Script, is still an issue very much unsettled. Fourth, the variation among scripts is gradual. Many of the less important variations both within and between the major scripts will not be discussed here.[2]

Strictly speaking, only four scripts played major roles in the development of the Chinese writing system: Great Seal (大篆 *dàzhuàn*), Small Seal (小篆 *xiǎozhuàn*), Clerical (隸書 *lìshū*), and Regular (楷書 *kǎishū*). They are considered major scripts because at different times they were formally adopted for official documentation. Great Seal Script is a cover term for several ancient scripts used over 1,200 years before the Qin dynasty (221–206 BCE), including Shell and Bone Script (甲骨文 *jiǎgǔwén*), Bronze Script (金文 *jīnwén*), and Stone Drum Script (石鼓文 *shígǔwén*).[3] Since the Qin dynasty, three major script changes have taken place: from Great Seal to Small Seal, from Small Seal to Clerical, and from Clerical to Regular.

The Running (行書 *xíngshū*) and Cursive styles (草書 *cǎoshū*) were initially developed as informal ways to increase writing speed. Later they were also adopted for art. However, they do not represent major script changes; they only reflect modifications of the major scripts. As will be discussed below, they are much less standardized and are not used in official documents. For that reason, they are referred to as styles rather than scripts.

THE GREAT SEAL SCRIPTS

Legend has it that, about five thousand years ago, Chinese written signs were created by a four-eyed dragon god named Cang Jie, who observed animal footprints, bird scratches, rain, wind, thunder, and the shapes of natural objects such as mountains, rivers, and tree shadows, and created Chinese characters based on them. When he did so, it is said, the spirits cried in agony and millet rained from Heaven because the innermost secrets of nature had been revealed. This account is part of Chinese mythology. A more plausible explanation is that Chinese written signs originated in multiple locations. Cang Jie, as a minister of the Yellow Emperor (ca. 2600 BCE), may have been the first person to compile written signs for official use.

THE SHELL AND BONE SCRIPT

The earliest known examples of Chinese writing are inscriptions on scapulas of oxen and plastrons of turtles dating from the thirteenth century BCE during the late Shang dynasty.[4] At that time, the Shang people sought to learn the future through a method of divination that consisted of drilling holes into the underside

of a turtle shell and placing the shell over a fire so that it cracks. This would allow people to see the appearance of oracular lines. By reading the direction, length, and thickness of these lines, possible outcomes would be predicted or interpreted. Afterwards, the results of the divination would be carved onto the shell or onto a piece of bone (hence the name Shell and Bone Script, also known as oracle bone in-

FIGURE 8.2. Shell and Bone Script rubbing. Yinxu Museum, Anyang.
[PHOTO BY WENDAN LI]

FIGURE 8.3. Replica of Shell and Bone Script carved on stone. Yinxu Museum, Anyang. [PHOTO BY WENDAN LI]

scriptions). The contents of the inscriptions shed light on daily life three millennia ago. They contain divinations and predictions about imminent military campaigns and hunting expeditions, weather forecasts, health and recovery, dream interpretation, and auspicious dates for weddings, births, hunting, and farming. Shell and Bone Script was not known to the world until 1899. The fascinating events and people involved in its discovery tie China's ancient history to its recent past.

The turn of the twentieth century was a period of chaos for China. After losing two wars with Japan and England, the Qing government was forced to open its doors to foreign powers. In response to the government's obvious weakness, intellectuals began calling for China to embrace Western science and philosophy. At this time, the earliest scripts that had been identified in the study of the Chinese written language were those from bronzeware of the Zhou dynasty (ca. 1100–256 BCE). Records of the earlier Xia and Shang dynasties (ca. 2200–1100 BCE) did appear in the *Shi ji* (Records of the historian) written by Sima Qian in the Han dynasty (206 BCE –220 CE), but they looked fictitious and comprised little more than a list of kings. With so little evidence, Chinese historians had serious doubts about the existence of the Xia and Shang dynasties. Some even proposed to eliminate them from historical accounts.

In 1899 Wang Yirong, director of the Imperial Academy in Beijing and a scholar of ancient bronze inscriptions, fell ill with malaria. He was prescribed traditional Chinese medicine with an ingredient called *longgu*, "dragon bones." As he was examining the packages of medicine, he was struck by the distinctive look of some of the bone pieces, on which he could see carvings resembling scripts on ancient bronze vessels. Driven by curiosity and believing that these symbols might belong to an ancient script, Wang bought more bones with carvings and was eventually able to confirm his hypothesis. The characters on the bone pieces that he was able to decipher—sun, moon, mountain, water, rain, and others—clearly predated the Bronze Script he knew.

Overjoyed by his discovery, Wang dispatched members of his household to all the pharmacies in Beijing and spent his life savings buying up all their *longgu*. The merchants, however, would not reveal the source of their goods for fear of competition.

A year after that, in 1900, the Boxer Uprising raged across the nation to protest foreign occupation of Chinese territories. The Boxers were groups of mystical warriors whose reputation included invulnerability to bullets and other weapons. The Empress Dowager, who held supreme power in the Qing government, secretly summoned the Boxers to Beijing in the hope that they could oust the foreign powers from China. With her support, the Boxers attacked the foreign legations. Within days, the Eight-Power Allied Forces, which included twenty thousand Europeans, Americans, and Japanese, arrived. The Boxers, armed only with knives and spears, could not defeat foreign troops who had guns and

cannons; they were mown down like grass in the streets of Beijing. Before fleeing the capital on a "hunting tour" of the western provinces, the Empress Dowager hastily appointed Wang Yirong commander-in-chief of the government's defending troops. Soon, the city was captured. In shame and frustration and having little choice, Wang Yirong, who was credited for the discovery of the Shell and Bone Script, took his own life.

After his death, Wang's bone collection came into the possession of Liu E, a friend of Wang and a man of considerable wealth and erudition, who subsequently started his own collection and search. By 1903 Liu had collected more than 5,000 pieces, from which he selected 1,058, made ink rubbings, and published a compilation under the title *Tieyun Collection of Tortoise Shells* (Tieyun was Liu's official name). The book and the information it disclosed about oracle bones sparked a wave of investigation by both Chinese and non-Chinese scholars.

Searches identified the village of Xiaotun in Anyang, Henan Province (Figure 8.4), as the source of the bones. At that time, Xiaotun was only one of an abundance of small farming villages in the Central Plains area where it was commonplace for antiques and bones to turn up when farmers hoed their fields. Sold to merchants by the kilo, for about the same price as six small *shaobing* (baked cakes), bones were ground up and used as medicine for fever and skin ailments. After the small farming village was identified as the major cache of oracle bones, looters, collectors, and foreign traders flooded the area. Now the bones were sold according to the number of characters they bore.[5] Forgery became a serious problem both at Xiaotun and in big-city antique markets.

In 1910, scholars arrived at Xiaotun eager to begin work on the puzzle of the bones. What they did not know was that China was already on the eve of the 1911 nationalist revolution that would overthrow the Qing dynasty. For the next fifteen years, the country would be immersed in civil wars that would hamper further

FIGURE 8.4. Xiaotun Village, Anyang, Henan Province.

exploration of the area. In 1917, Wang Guowei, another renowned scholar, was able to decipher the oracle bone inscriptions of the names of the Shang kings and to reconstruct a complete Shang genealogy. The outcome of his study perfectly matched the accounts in the *Records of the Historian*, confirming the existence of the legendary Shang dynasty and the archaeological importance of the discovery of oracle bones.

After the civil wars ended, archaeologists conducted fifteen organized excavations at Xiaotun between 1928 and 1937. Soon they began to uncover ruined foundations of great antiquity, including royal palaces, royal tombs, and large amounts of bronze, jade, and pottery artifacts. One of the excavations conducted in 1936, for example, unearthed 17,096 shell and bone pieces from one pit! This site was eventually identified as Yin, the magnificent capital of the Shang dynasty. Apparently the pit had been an archive of the royal court, containing detailed records of various activities of the Shang dynasty royal family and aristocrats.

When the puzzle pieces were put together, the veil of mystery over Shang and Yin was lifted: Social problems had led to the dynasty's decline. Its last capital, Yin, was finally abandoned to fall into ruins when the Zhou dynasty established its capital near modern-day Xi'an. Quickly the Shang ruins were lost, their location forgotten, and the once-great city of Yin was relegated to legend along with the dynasty that founded it. The village of Xiaotun was built right on top of those ruins, some two thousand years later, without any knowledge of their magnificent past.

To date, about 154,000 pieces of oracle bones have been unearthed. Warfare and trade brought many of them overseas, where they are displayed in a number of the world's finest museums. The number of characters identified so far amounts to about 4,700; fewer than half have been deciphered.[6] The discovery of the Shell and Bone Script and the Yin ruins uncovered a part of China's history that had remained buried and obscured for more than 3,300 years. When the script was deciphered and documents read, the once-mythical Shang dynasty became historical. The discovery provided invaluable new resources for the study of Shang (and possibly even earlier) society and culture in areas such as history, politics, economics, philosophy, and astronomy.

For the study of the Chinese language, the discovery of the Shell and Bone Script pushed the material evidence of the Chinese written language back to the Shang dynasty. It is agreed that Shell and Bone Script is a mature language with a sophisticated grammatical system and all six classes of characters that are still in use today. This indicates that the Chinese language must have undergone earlier stages of development, although no records of that evolution have been found. Many symbols in the Shell and Bone Script resemble physical objects in the real world. For this reason, many contemporary artists use the classical script in their modern artwork. This adds interest to the writing and gives an impression of antiquity.

In the Shell and Bone Script, the square shape of the writing space for each

character is already evident. The space is divided into top and bottom, left and right, or inside and outside portions. Each symbol has a visual center around which the strokes are distributed to maintain the balance and stability of the character. Although many symbols are pictographic, some basic stroke types are in the process of being formed. Because the symbols were carved onto hard surfaces by sharp tools, the strokes are thin, stiff, and straight, with sharp angles. The script also shows the emerging stage of the three essential elements of calligraphy: stroke method, character structure, and principles of composition. The traditional method of arranging vertical lines of text from right to the left was also established in this period.[7]

THE BRONZE AND STONE AND DRUM SCRIPTS

As China entered the strife-ridden era called the Zhou dynasty, Great Seal Script continued to mature with significantly more characters. The late Zhou was a remarkable period in Chinese intellectual history. Using this script, scholars such as Lao Zi, Confucius, and others composed some of the greatest Chinese classics, such as the *Book of Poetry*, the *I Ching*, *Analects*, and the *Spring and Autumn Annals*.

Inscriptions on ritual bronze vessels in classical China—hence the name Bronze Script 金文 *jīnwén*—are well known (Figures 8.5 and 8.6). In the Shang and Zhou periods, bronze was the most precious metal, the use of which signified

FIGURE 8.5. Bronze Script on Xiaochenyu *zun* (liquor container) from Western Zhou. [FROM ZHU, *ZHUANSHU SHIJIANG*, P. 22, WHERE NO INDICATION OF SOURCE IS GIVEN]

FIGURE **8.6.** Bronze Script on Maogong *ding* (container for cooking or sacrifice) from Western Zhou. [FROM ZHU, *ZHUANSHU SHIJIANG*, P. 26, WHERE NO INDICATION OF SOURCE IS GIVEN]

the authority and power of the rulers. A little later, in about 800 BCE, Chinese characters were also chiseled on stone. This was known as Stone and Drum Script 石鼓文 *shígǔwén*. Owing to the variety of workmanship and materials, characters in these scripts had thicker and fuller strokes and were more rounded at the corners than the Shell and Bone Script. They also look more artistic and decorative.

Up to the Warring States period (ca. fifth century–221 BCE), China was divided into separate, isolated feudal states with no central government and, therefore, no standardized written language. Scripts were used by convention, with no collaboration across states. New written symbols, unique to their own regions, were developed as the need for written records arose. The situation was chaotic as regional scripts matured separately. Characters were written in different shapes, some resembling tadpoles (蝌蚪文 *kēdǒuwén*, Tadpole Script), bird scratches (鳥跡文 *niǎojìwén*, Bird Scratch Script), or animal footprints (獸痕文 *shòuhénwén*, Animal Footprint Script). The direction of writing varied as well. For example, vertical columns could be arranged from left to right or vice versa. Nor were characters within the same text uniform in size, as can be seen in Figures 8.4, 8.5, and 8.6. Because multiple versions of the same character were being created and used by different people simultaneously in different areas, a scribe could choose any version. As the situation got more and more out of control, language reform was called for and actually took place.

THE SMALL SEAL SCRIPT

During the Warring States period, the Qin state (one of the seven major states) sur-passed and conquered the other six, which brought about the beginning of the Qin dynasty in 221 BCE. The First Emperor of Qin, who was also the first emperor of China as a united country, demanded total control. The law under his rule was extremely severe. He built the Great Wall to fence out northern invaders as well as canals and irrigation systems to protect farmers from droughts and flood. He tried to obliterate the past by burning classics. He also built postal highways and stan-dardized calendars, currency, and measurements. Most important to this discussion, he standardized the written language, decreeing that Small Seal was the only legal written language. Those who did not comply were severely punished, even with death. His language policy 書同文 *shūtóngwén*, "writing the same script," played a crucial role in the development of the Chinese writing system and the art of calligra-phy. For his cruelty, however, he is considered the number one tyrant in China.

To standardize the written script, the First Emperor had Prime Minister Li Si modify the Great Seal into a new script. An official index of three thousand char-acters was worked out for common use. This new script was called *Qínzhuàn* 秦篆, Qin Seal, or *xiǎozhuàn* 小篆, Small Seal. To commemorate his achievements, the First Emperor traveled around the country and erected stone monuments in the eastern provinces. Figure 8.7 is an example of the writing on the stone tablets originally on the top of Mount Tai (in today's Shandong Province), later moved indoors to protect them from the weather. The characters carved on these monu-ments are in the Small Seal Script. It is believed that most of the writing on these stones was done by Li Si.

FIGURE 8.7. Rubbings from a Mount Tai tablet in Small Seal Script (Qin dynasty).
[FROM NAN AND JI, *LONG ZHI WU*, P. 19, WHERE NO INDICATION OF SOURCE IS GIVEN]

CHARACTERISTICS OF SMALL SEAL SCRIPT

Compared to Great Seal Script, which is bold and unconstrained, characters in Small Seal are pretty and tactful. Here, in brief, are some major characteristics of the Small Seal Script. More details will be discussed in the next section.

1. Characters of equal size are written in a standard vertical rectangular shape.
2. Strokes have even thickness.
3. The direction of writing is standardized as top to bottom, with columns arranged right to left. All characters are evenly spaced.
4. Variant forms of the same character used in different areas are eliminated, keeping one standard character for one concept.

Small Seal Script was actually in use before the Qin language reform. The First Emperor and Li Si standardized the style and made it official. The pictographic nature of the symbols was greatly reduced and stylized by the modifications. The standardization and the replacement of Great Seal with Small Seal were important and necessary milestones in the development of Chinese writing. (See the examples of Small Seal Script in Figures 8.8 through 8.11.)

WRITING SMALL SEAL

Many of the brush-writing techniques used for Regular Script and much of its terminology are also relevant for writing other scripts, including Small Seal.

Strokes

Small Seal is written with only two major types of strokes: straight lines and curved lines. All strokes are written with the center-tip technique (see Chapter 4) but show no variation in thickness. The strokes are solid, full, symmetrical, and strong. They all have rounded and smooth endings, produced with the reverse-tip technique (see Chapter 4). The strokes can be thick (called "jade chopsticks") as in Figure 8.8 or thin (called "iron wire") as in Figure 8.11. Strict discipline and lack of free expression are evident in this script.

Straight lines. Your brush should move slowly, even when writing straight lines (Figure 8.12). Use reverse tip to make rounded endings, and use center tip as much as possible. Remember, all strokes should be even in thickness; there is no pressing and lifting.

Curves. The Small Seal Script is written with a large number of curved lines

FIGURE 8.8. Small Seal (in the "jade chopsticks" style) by Li Yangbing (715?–?) of the Tang dynasty. [FROM ZHU, *ZHUAN-SHU SHIJIANG*, P. 45, WHERE NO INDICATION OF SOURCE IS GIVEN]

FIGURE 8.9. Small Seal by Deng Shiru (1743–1805) of the Qing dynasty. [FROM ZHU, *ZHUANSHU SHIJIANG*, P. 76, WHERE NO INDICATION OF SOURCE IS GIVEN]

FIGURE 8.10. Small Seal by Wu Rangzhi (1799–1870) of the Qing dynasty. [FROM ZHU, *ZHUANSHU SHIJIANG*, P. 77, WHERE NO INDICATION OF SOURCE IS GIVEN]

FIGURE 8.11. Small Seal by Wang Shu (1668–1743) of the Qing dynasty. [FROM ZHU, *ZHUANSHU SHIJIANG*, P. 73, WHERE NO INDICATION OF SOURCE IS GIVEN]

(Figure 8.13). This is why the script looks wiry. Note that curves should also have rounded endings with no variation in thickness.

Circles. Circles are basically combinations of curved lines. There is no rule on how they should be written. Make sure that joints are smooth (Figure 8.14).

Structure of Characters

The uniform stroke technique used in writing Small Seal leaves the structure of characters open to manipulation and maneuvering. Therefore, characters in Small Seal Script have a number of distinct features.

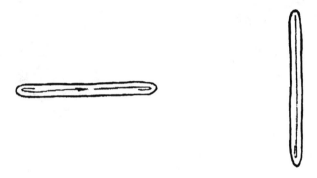

FIGURE 8.12. Small Seal: straight lines.

FIGURE 8.13. Small Seal: curved lines.

FIGURE 8.14. Small Seal: circles and dots.

First, in contrast to Regular Script, in which characters are basically square, characters in Small Seal are tall and slim. The ratio of width to height is 3:5. All characters are written the same size, which creates a very formal impression.

Second, many characters in Small Seal Script are symmetrical (that is, if a character is divided vertically in the middle, the part on the left is exactly the same as the part on the right). This is not the case in Regular Script. A comparison of some characters in these two scripts shows these differences clearly.

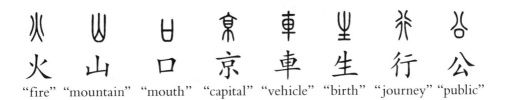

"fire" "mountain" "mouth" "capital" "vehicle" "birth" "journey" "public"

Third, many Small Seal characters are tight in the upper part and elongated in the lower portion. This gives the characters a look of elegant poise:

"stone" "flat" "see" "no" "open" "yet" "day/sky" "big" "north"

Fourth, for characters with a left to right arrangement, the two parts are not always given the same height. The part with fewer strokes is often written slightly higher (see the discussion of asymmetric balance in Chapter 7).

如 的 時 次 助 作 塊 組

When you practice Small Seal Script, you will quickly discover that it is a serpentine and meandering style, quite difficult to write even though it has fewer stroke types than Regular Script. The difficulty stems from the high-quality strokes, the strict shape of the characters, the positioning of parts, and the even distribution of curved lines that must be painstakingly executed. As a result, the speed of writing is very slow. This is probably one of the reasons why the script did not remain in practical use for very long. It was soon replaced by the Clerical Script, a much faster way of writing, which will be discussed in the next chapter.

Seal Script is still commonly used for seal engraving (see Chapter 12), although originally the script had no connection with seal carving.

DISCUSSION QUESTIONS AND WRITING PRACTICE

1. What are the characteristics of the Small Seal Script?

2. How is Small Seal different from the Regular Script, which you have been writing since the beginning of this program?

3. Compare the two characters 天 *tiān*, "day/sky," and 雨 *yǔ*, "rain," in each pair and discuss how they should be written differently in the two scripts.

4. What are the features of Shell and Bone Script and the Bronze Script, and how are they different from the Small Seal Script?

5. Practice writing the Small Seal model characters on page 220 in Appendix 1. You have already practiced writing some of these characters in the Regular Script. Before writing them in Small Seal, (1) compare the characters in the two scripts so that you have a clear understanding of how they differ, and (2) think about the brush techniques involved in order to produce the differences.

Note that, unlike the Regular Script, which is written following a strict stroke order, there is no prescribed stroke order for Small Seal characters. Follow the general guideline of top to bottom and left to right. Curved lines can be produced by combining two or more strokes, but make sure the joints are smooth. Remember, do not press down or lift the brush as you write. All the strokes should be even in thickness.

6. Observe the text "A journey of thousands of miles starts from the first step" in Small Seal Script on page 221 in Appendix 1. Note that the main text reads vertically, first the line on the right, and then the line on the left. For comparison, the same text in the same layout is provided in Clerical Script on page 224, in Regular Script on page 227, and in Cursive Style on page 230. The meaning of individual characters appears on pages 225–226.

7. Take note of two things in the Small Seal text: (1) the distance between characters in the same vertical column of text should be smaller than the distance between the two vertical columns, and (2) the inscriptions and the seal should not be dangling on the edge of the frame. Rather, they should be balanced with and form a unified whole with the main text. The composition of calligraphy pieces will be further illustrated and discussed in Chapter 12.

8. Copy the text on a blank page. You may want to practice writing the characters first; you may also want to use a pencil to sketch the size and position of each character on the sheet before you actually write them. On the inscription line, you may simply put your Chinese name, writing the characters smaller than those in the main text.

···

The Development of Chinese Calligraphy II

THE CLERICAL SCRIPT

In the previous chapter, we saw that Small Seal Script has a high degree of formality and strict rules for writing. It is not surprising that such a formal and difficult script was outlived by another script, called Clerical Script, as a popular way of writing. After examining the Clerical Script in this chapter, we will learn about the traditional Chinese dating method, which is still used to date calligraphy works today.

THE CLERICAL SCRIPT

As the story goes, in the late Qin, a minister of the First Emperor named Cheng Miao offended the First Emperor and was thrown into prison. However, he put his ten years in prison to good use by creating the Clerical Script. In reality, the development of a new script cannot be the work of only one person. Not only does the need for a new script arise from social upheaval, a new script also goes through a long, gradual process from the emergence of the individual stroke features to maturation and standardization. In this case, research shows that the Clerical Script was actually developed gradually in the pre-Qin era and matured and prevailed in

the Han dynasty (roughly when the Roman Empire was flourishing in the West from 27 BCE to 395 CE). China, at the height of its development during that time, was making significant progress in social development, technology, and, most relevant to this discussion, language. This was a time of great prosperity, and the Chinese are so proud of the period that Han 漢 is now used to name both the Chinese people (漢族 Hànzú, "Han nationality") and the Chinese language (漢語 Hànyǔ, "Han language").

During the Han dynasty, writing instruments were greatly improved. Earlier when writing on shell and bone, brushes were used to trace characters on hard surfaces as a guide before carving. Apparently sometime before and during the Han dynasty, the use of brushes in true writing became widespread. Also during the Han, the invention of paper by Cai Lun in 105 CE changed writing completely.[1] Before, scribes had to write on hard surfaces such as bone, bamboo, or wooden slats. Space limitations on these media were severe; one slat, for example, usually provides enough space for only a single column of text. When paper became available and writing spaces became much wider, another dimension to the art of writing was added: the arrangement of characters and columns in a text. In fact, some scholars today believe that the rounded, slim Small Seal characters were changed into the flat, square shape of Clerical Script owing to this increased availability of writing space, as Clerical Script characters are more stable and easier to manage in alignment and composition. Seen from this perspective, the popularity of paper played a role, although indirect, in the development of the Clerical Script.

Meanwhile, the combination of resilient brushes and soft, absorbent paper allowed more freedom for writers to easily press, lift, and turn and thereby produce a large variety of strokes. As the brush began to be used to its fullest extent, the even and wirelike lines of Small Seal gave way to more expressive styles that featured varied stroke thicknesses. This, in turn, led to the rise of more aesthetic approaches to calligraphy. Consequently, in the Han dynasty, calligraphy became an independent form of art and added aesthetic value to its original function of communication. It began to be used to write poems to describe beautiful and peaceful scenes, to record philosophical discourse, and to portray an abiding appreciation of nature. All of this was done to produce not only beautiful content, but also a beautiful form of art. Calligraphy became much more than a form of written language.

The evolution of the Chinese writing system directly paralleled the development of writing techniques. The Han was the time when Chinese characters finally broke away from pictographic symbols. With the straight lines of the Clerical Script, writing became much more stylized and abstract. The demand for wider vocabulary and more written symbols in a fast-growing society also led to a boom in phonetic borrowing and, later on, in semantic-phonetic compounds. At the governmental level, Han officials recognized Clerical Script as the first standard

script for official use. That recognition brought about increased interest and even broader promotion.

Clerical Script is so named because the script was first used by clerks; many examples have been found on official documents such as tax records and deeds. At first the script was used informally by clerks and officials as a shorthand because it can be quickly written, but later in the Han its popularity surpassed Small Seal Script, and it became the official script. Figures 9.1 and 9.2 show two examples of Clerical Script produced in the Han dynasty.

FIGURE 9.1. Wooden slats with writing in Clerical Script from the Eastern Han dynasty (ca. 200 CE). [FROM FANG, *LISHU SHIJIANG*, P. 37, WHERE NO INDICATION OF SOURCE IS GIVEN]

FIGURE 9.2. Caoquan Tablet written in 185 CE (Eastern Han dynasty). This is considered among the best works in Clerical Script. [FROM FANG, *LISHU SHIJIANG*, WHERE NO INDICATION OF SOURCE IS GIVEN]

The shift from Small Seal to Clerical Script was a major development in the Chinese writing system. Fundamental changes took place in a number of areas:

1. The thickness of strokes began to vary. The writing displays purposeful up and down movements of a soft brush tip. When different degrees of pressure started to be applied to the brush during the writing of a stroke, full-fledged brushwork began, involving more finger and wrist movement and techniques. The most distinctive feature of the Clerical Script is the so-called silkworm's head and swallow's tail (Figure 9.7 below).

2. Curved lines were changed into straight lines and round corners into sharp

angles. Semicircles and circles disappeared. These alterations not only paved the way for the formation of the major stroke types, they also set the foundation for the neat, stable, square shape of Chinese characters.

3. The shape of characters was changed from tall and slim to a short, wide, horizontally stretched look.

4. For easier and faster writing, lines were changed to dots and multiple dots were linked into lines.

Figures 9.3, 9.4, and 9.5 show three more examples of the Clerical Script.

It is commonly agreed that Clerical Script, although developed two thousand years ago, marks the beginning of modern Chinese scripts. The change from Small Seal to Clerical Script, which is the most significant change in the development of the Chinese writing system, is referred to as the "Clerical transformation" (隶变 *lìbiàn*). The new script is balanced, simple, strong, and easy to recognize. It is a style that is full of life. Even today, after more than two millennia of use, many street signs, billboards, book covers, and notice boards still feature this script because of its decorative nature.

FIGURE 9.3. Clerical Script by Gui Fu (1736–1805) of the Qing dynasty. [FROM FANG, *LISHU SHIJIANG*, P. 8, WHERE NO INDICATION OF SOURCE IS GIVEN]

FIGURE 9.4. Da Zhi Zen Master Tablet by Shi Weize, one of the top four masters of the Clerical Style in the Tang dynasty. [FROM FANG, *LISHU SHIJIANG*, P. 7, WHERE NO INDICATION OF SOURCE IS GIVEN]

FIGURE **9.5**. Amitayus Sutra by Yuan Ruan of the Qing dynasty (1644–1911). Collection of the National Palace Museum (Taipei). [FROM *MASTERPIECES OF CHINESE CALLIGRAPHY IN THE NATIONAL PALACE MUSEUM*, P. 50. REPRODUCED BY PERMISSION FROM THE NATIONAL PALACE MUSEUM]

WRITING THE CLERICAL SCRIPT

THE HORIZONTAL LINE

There are two types of horizontal lines in the Clerical Script: the normal horizontal line and the "wave line." The normal horizontal line uses basically the same stroke method as in the Small Seal (Figure 9.6). The writing procedure is as follows:

1. Start with concealed tip.
2. Change direction and move to the right.
3. At the end of the stroke, reverse and lift.

Remember: do not press down at the beginning or the end. The stroke should be straight with even thickness.

FIGURE **9.6**. The horizontal line in Clerical Script.

THE WAVE LINE

The wave line is one of the most distinctive features of Clerical Script and its most decorative stroke. In Chinese, its literal name is "silkworm's head and swallow's tail" (蠶頭燕尾 *cántóuyànwěi*).[2] Based on a normal horizontal line, it exaggerates both the beginning (the silkworm's head) and the ending (the swallow's tail) (Figure 9.7). The writing procedure is as follows:

1. Start with concealed tip, press left and downward, and pause to make the "silkworm's head."

2. Change direction and move to the right, using center tip and lifting slightly.

3. When approaching the end of the stroke, change to side tip, press right and downward.

4. Continue moving, but now in a right-upward motion, gradually lifting the brush; finish the stroke by making the flaring "swallow's tail."

THE VERTICAL LINE

The vertical line also uses the same stroke method as in Small Seal (Figure 9.8). The writing procedure is as follows:

1. Start with concealed tip.

2. Change direction and move down. Do not press down at the beginning of the stroke as in Regular Script.

3. At the end, reverse and lift. Both ends should be rounded.

DOWN-LEFT

The down-left stroke in Clerical Script usually starts thin and ends thick, just the

FIGURE **9.7**. The wave line in Clerical Script with "silkworm's head and swallow's tail."

FIGURE **9.8**. The vertical line in Clerical Script.

FIGURE 9.9. The down-left slant in Clerical Script.

opposite of the same stroke type written in the Regular Script. In Clerical Script, the stroke can be written in two ways (see Figure 9.9), with a heavy ending as on the left or with a light ending as on the right. The writing procedure for the down-left stroke with heavy ending is as follows:

1. Start with a light beginning (concealed tip optional).
2. Change direction and move down and left, gradually pressing down. The stroke should be getting thicker as you go.
3. At the end of the stroke, pause, reverse, and lift.

For a down-left stroke with light ending, follow the first two steps described above. At step (3), lift the brush in an up-left motion.

DOWN-RIGHT

The down-right stroke has an ending similar to the wave line. This stroke is also very decorative (Figure 9.10). The writing procedure is as follows:

1. Start with concealed tip.
2. Move down-right, gradually pressing down.
3. Near the end, pause and then turn up and right, lifting the brush gradually as you go.

Note that in Clerical Script, the wave line and the down-right stroke belong to the same stroke type. Within a single character, only one stroke of this type is allowed.

FIGURE 9.10. The down-right slant in Clerical Script.

TURN

The turn in Clerical Script takes the rounded turn of Small Seal and makes it more square-angled (Figure 9.11). For a turn that combines a horizontal line and a vertical line, follow these steps:

1. Slow down when you approach the corner.
2. Bring up the brush slightly so that the tip is in the corner.
3. Move down to write the vertical part of the stroke. Do
not press down at the corner as you would in Regular Script.

The same procedure applies to other types of corners.

DOTS

As a stroke type, dots have the largest number of variant forms, so be sure to observe your models carefully and practice often. The ways to write these dots should be self-explanatory (Figure 9.12).

Note that there is no hook in Clerical Script.

As can be seen from earlier examples in this chapter, Clerical Script can be written in different styles and flavors. Only the most general descriptions are given here. Learners aiming at proficiency in this script are advised to choose a model and study its specific features and techniques.

FIGURE 9.11. The turn in Clerical Script.

FIGURE 9.12. Dots in Clerical Script.

CHINESE CULTURE (4):
THE TRADITIONAL CHINESE DATING METHOD

In Chinese calligraphy, the traditional dating method is used to record the date of a work. This system is quite different from the dating method used in the West.

In the Gregorian calendar, years are dated from the birth of Jesus Christ, so that the year 2008 is the 2,008th year after his birth. This method represents a linear perception of time, in which time proceeds in a straight line from the past to the present and then on into the future.

In traditional China, dating methods were cyclic. That is, time was recorded as following a pattern that repeats again and again. Dating in calligraphy mainly concerns the recording of the year. Two cyclic systems are used to refer to years: a sixty-year cycle and a twelve-year cycle. In the following two sections, the two systems and how they correspond to each other will be described. In traditional China, most people were able to do the conversion between the two cyclic systems by heart. Since the dawn of the modern age, many, especially modern generations, have lost this ability. In the art world even today, the sixty-year cycle is still commonly used to date artworks. Thus knowledge of how the system works is essential for both the appreciation and the composition of calligraphy works. For your reference, Figure 9.14 below shows how the Western calendar years, the Chinese sixty-year terms, and the twelve-year cycle correspond to one another.

THE SIXTY-YEAR CYCLE

The sixty-year cycle is based on the combination of two sets of segments: Heavenly Stems (天干 tiāngàn) and Earthly Branches (地支 dìzhī). This method of dating is referred to as the "stem-branch" system (干支紀年法 gànzhī jìniánfǎ).

The Heavenly Stems consist of ten segments, each with a Chinese name. For illustration and easy recognition, the ten segments are represented here using the roman letters A through J to correspond to the Chinese terms. The pronunciation of these terms is indicated on the third line of the following illustration.

A	B	C	D	E	F	G	H	I	J
甲	乙	丙	丁	戊	己	庚	辛	壬	癸
jiǎ	yǐ	bǐng	dīng	wù	jǐ	gēng	xīn	rén	guǐ

The Earthly Branches consist of twelve members, represented here by the Arabic numerals 1 through 12. The corresponding Chinese terms and pronunciation are shown below:

1	2	3	4	5	6	7	8	9	10	11	12
子	丑	寅	卯	辰	巳	午	未	申	酉	戌	亥
zǐ	chǒu	yín	mǎo	chén	sì	wǔ	wèi	shēn	yǒu	xū	hài

Figure 9.13 shows how the two sets of segments are combined. The stem segments take turns combining with the branch segments, both in a cyclic fashion. Thus "A" combined with "1" produces the term 甲子 *jiǎzǐ*. Similarly, "B" combines with "2" to form 乙丑 *yǐchǒu*. After "J" is paired with "10" (producing 癸 酉 *guǐyǒu*), "A" has to pair with "11" (甲戌 *jiǎxū*) and "B" with "12" (乙亥 *yǐhài*). Then "C" pairs with "1" (丙子 *bǐngzǐ*) in the second cycle of the branch segments. The pairings then continue, with "D" paired with "2" and "E" with "3," and so forth. Since the lowest common multiple of 10 and 12 is 60, a complete combination of the two sets of segments forms a cycle of sixty years. In the end, when "J" (癸 *guǐ*) meets "12" (亥 *hài*), the sixty-year cycle is complete. A new cycle starts the following year. During the sixty years, the stem segments are used six times and the branch segments are used five times. Figure 9.14 displays three sixty-year cycles between the years of 1864 and 2043.

According to this system, *jǐchǒu* is the Chinese stem-branch term for the year 2009. The last time this term was used was sixty years ago for the year 1949, and the next time will be sixty years later for the year 2069. In ancient times, short human life spans made it unlikely that any particular term would be repeated within an individual's lifetime. To prevent confusion and to identify which cycle an actual term is referring to, the title of the ruling emperor is also used. For example, the calligraphy piece (partially shown) in Figure 9.15 is dated Jiājìng (嘉靖), *rénchén* (壬辰), summer (夏),

A1[1]	**A**11	A9	A7	A5	A3
B2	B12	B10	B8	B6	B4
C3	C1[2]	C11	C9	C7	C5
D4	D2	D12	D10	D8	D6
E5	E3	E1[3]	E11	E9	E7
F6	F4	F2	F12	F10	F8
G7	G5	G3	G1[4]	G11	G9
H8	H6	H4	H2	H12	H10
I9	I7	I5	I3	I1[5]	I11
J10	J8	J6	J4	J2	J12

FIGURE 9.13. The Chinese dating method: the sixty-year cycle.

60-YEAR CYCLE AND THE ANIMAL SIGNS

1864–1923

1.甲子	1864	13.丙子	1876	25.戊子	1888	37.庚子	1900	49.壬子	1912	mouse	鼠
2.乙丑	1865	14.丁丑	1877	26.己丑	1889	38.辛丑	1901	50.癸丑	1913	ox	牛
3.丙寅	1866	15.戊寅	1878	27.庚寅	1890	39.壬寅	1902	51.甲寅	1914	tiger	虎
4.丁卯	1867	16.己卯	1879	28.辛卯	1891	40.癸卯	1903	52.乙卯	1915	rabbit	兔
5.戊辰	1868	17.庚辰	1880	29.壬辰	1892	41.甲辰	1904	53.丙辰	1916	dragon	龍
6.己巳	1869	18.辛巳	1881	30.癸巳	1893	42.己巳	1905	54.丁巳	1917	snake	蛇
7.庚午	1870	19.壬午	1882	31.甲午	1894	43.丙午	1906	55.戊午	1918	horse	馬
8.辛未	1871	20.癸未	1883	32.乙未	1895	44.丁未	1907	56.己未	1919	sheep	羊
9.壬申	1872	21.甲申	1884	33.丙申	1896	45.戊申	1908	57.庚申	1920	monkey	猴
10.癸酉	1873	22.乙酉	1885	34.丁酉	1897	46.己酉	1909	58.辛酉	1921	rooster	雞
11.甲戌	1874	23.丙戌	1886	35.戊戌	1898	47.庚戌	1910	59.壬戌	1922	dog	狗
12.乙亥	1875	24.丁亥	1887	36.己亥	1899	48.辛亥	1911	60.癸亥	1923	boar	豬

1924–1983

1.甲子	1924	13.丙子	1936	25.戊子	1948	37.庚子	1960	49.壬子	1972	mouse	鼠
2.乙丑	1925	14.丁丑	1937	26.己丑	1949	38.辛丑	1961	50.癸丑	1973	ox	牛
3.丙寅	1926	15.戊寅	1938	27.庚寅	1950	39.壬寅	1962	51.甲寅	1974	tiger	虎
4.丁卯	1927	16.己卯	1939	28.辛卯	1951	40.癸卯	1963	52.乙卯	1975	rabbit	兔
5.戊辰	1928	17.庚辰	1940	29.壬辰	1952	41.甲辰	1964	53.丙辰	1976	dragon	龍
6.己巳	1929	18.辛巳	1941	30.癸巳	1953	42.己巳	1965	54.丁巳	1977	snake	蛇
7.庚午	1930	19.壬午	1942	31.甲午	1954	43.丙午	1966	55.戊午	1978	horse	馬
8.辛未	1931	20.癸未	1943	32.乙未	1955	44.丁未	1967	56.己未	1979	sheep	羊
9.壬申	1932	21.甲申	1944	33.丙申	1956	45.戊申	1968	57.庚申	1980	monkey	猴
10.癸酉	1933	22.乙酉	1945	34.丁酉	1957	46.己酉	1969	58.辛酉	1981	rooster	雞
11.甲戌	1934	23.丙戌	1946	35.戊戌	1958	47.庚戌	1970	59.壬戌	1982	dog	狗
12.乙亥	1935	24.丁亥	1947	36.己亥	1959	48.辛亥	1971	60.癸亥	1983	boar	豬

1984–2043

1.甲子	1984	13.丙子	1996	25.戊子	2008	37.庚子	2020	49.壬子	2032	mouse	鼠
2.乙丑	1985	14.丁丑	1997	26.己丑	2009	38.辛丑	2021	50.癸丑	2033	ox	牛
3.丙寅	1986	15.戊寅	1998	27.庚寅	2010	39.壬寅	2022	51.甲寅	2034	tiger	虎
4.丁卯	1987	16.己卯	1999	28.辛卯	2011	40.癸卯	2023	52.乙卯	2035	rabbit	兔
5.戊辰	1988	17.庚辰	2000	29.壬辰	2012	41.甲辰	2024	53.丙辰	2036	dragon	龍
6.己巳	1989	18.辛巳	2001	30.癸巳	2013	42.己巳	2025	54.丁巳	2037	snake	蛇
7.庚午	1990	19.壬午	2002	31.甲午	2014	43.丙午	2026	55.戊午	2038	horse	馬
8.辛未	1991	20.癸未	2003	32.乙未	2015	44.丁未	2027	56.己未	2039	sheep	羊
9.壬申	1992	21.甲申	2004	33.丙申	2016	45.戊申	2028	57.庚申	2040	monkey	猴
10.癸酉	1993	22.乙酉	2005	34.丁酉	2017	46.己酉	2029	58.辛酉	2041	rooster	雞
11.甲戌	1994	23.丙戌	2006	35.戊戌	2018	47.庚戌	2030	59.壬戌	2042	dog	狗
12.乙亥	1995	24.丁亥	2007	36.己亥	2019	48.辛亥	2031	60.癸亥	2043	boar	豬

FIGURE 9.14. Three sixty-year cycles (1864–2043).

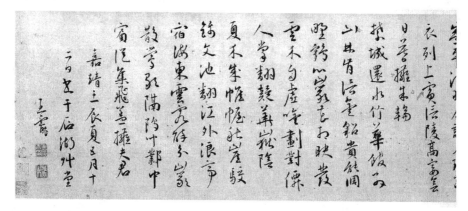

FIGURE 9.15. Chinese traditional dating method (Ming dynasty).

fifth month (五月), twelfth day (十二日) (starting from the third line and then the second line from the left).

As has been mentioned, units of time are always arranged in Chinese from the most general to the most specific. In Figure 9.15, the reign title Jiājìng 嘉靖 comes first because it is the name of a Ming dynasty emperor who ruled between 1522 and 1567. The specific year of the work, rénchén 壬辰 (which corresponds to the year 1532), comes second, followed by the season, xià 夏 (summer), and then the month and the day. Thus, we know that this piece was written on the twelfth day of the fifth month in the summer of 1532 in the Jiajing era.

Figure 9.16 shows the end of a piece written by an instructor of the Hanlin Academy. The writing is dated to the rule of the Kangxi emperor (康熙) of the Qing dynasty, who reigned from 1662 to 1721. The year 辛酉 xīnyǒu was the twentieth year of the Kangxi era, or 1681. The work was done in the twelfth month of the year, which is also referred to as 嘉平 jiāpíng.[3]

In late-nineteenth- and early-twentieth-century Chinese history, many important events are referred to using stem-branch terms. In the following examples, the first two characters are the stem-branch terms indicating the year; the last two characters record the nature of the events.

甲午戰爭 Jiǎwǔ Zhànzhēng: the Sino-Japanese War, which started in 1894

戊戌變法 Wùxū Biànfǎ: the Reform Movement of 1898

庚子賠款 Gēngzǐ Péikuǎn: Boxer Indemnity (1900)

辛亥革命 Xīnhài Gémìng: the 1911 Revolution

FIGURE **9.16.** Chinese traditional dating method (Kangxi era). Dated (the leftmost line on the right leaf) the twelfth month of *xīnǒu* 辛酉, twentieth year of the Kāngxī era. The last leaf is signed "Respectfully offered by Hànlín (翰林) Academy instructor Gao Shiqi (高士奇)."

The Chinese adopted the Western calendar in 1912. The stem-branch terms are now mainly used in art and for the Chinese New Year celebration.

THE TWELVE-YEAR CYCLE

In the stem-branch system, the twelve branch terms correspond to another cyclic system, the Chinese zodiac, which uses twelve animal signs. They are, in order, mouse, ox, tiger, rabbit, dragon, snake, horse, sheep, monkey, rooster, dog, and boar. The correspondence of the two systems is shown in Figure 9.14, where you can see that the year with the branch term 子 *zǐ* would always be the year of the mouse, and the year with the branch term 丑 *chǒu* would always be the year of the ox, and so on.

In China, the animal signs have a social function in finding out a person's age. A common practice is to ask a person's animal sign rather than his or her numerical age. By so doing, that person's age can be calculated indirectly. Often, the purpose of this exercise is to identify seniority among friends and acquaintances and to behave accordingly. In popular culture, each animal sign is also linked with certain character traits. For example, people born in the year of the dog are said to have a

deep sense of loyalty; they are honest and compatible with people born in the years of the horse, tiger, and rabbit. In comparison, those born in the year of the dragon are healthy and energetic. Although they may be short-tempered and stubborn, they tend to be soft-hearted. They get along with snakes, monkeys, and roosters. Such information is used to find out a person's potential personal traits.

In fact, the stem-branch system and the Chinese zodiac, both used in time-keeping, reflect a comprehensive Chinese worldview that is serenely cyclic. According to this view, everything in the world—days and nights, fortune and misfortune, life and death—comes and goes without beginning or end. People, like anything else in nature, are part of this gigantic system. The philosophy behind this view, that is, the Chinese belief that everything in the world goes in cycles, will be further discussed in Chapter 13.

DISCUSSION QUESTIONS AND WRITING PRACTICE

1. What are the major characteristics of Clerical Script?

2. Compare the horizontal line in Regular Script and the wave line in Clerical Script. Describe the steps in writing each respectively and discuss the differences.

3. Both Clerical Script and Regular Script are used in modern writing. How are they used differently?

4. Practice writing the strokes on page 222 and characters on page 223 in Appendix 1.

5. Observe the writing and the layout of "A journey of thousands of miles starts from the first step" in Clerical Script, and copy it on a blank sheet. You may want to practice writing the characters first and make a planning sketch with a pencil before writing.

7. Use Figure 9.14 to identify the Chinese term for the current year, and practice writing the term in the Regular Script.

8. Pick three people you know. Find out their birth years, and write the Chinese stem-branch terms for those years and their animal signs.

The Development of Chinese Calligraphy III

THE REGULAR SCRIPT

Two periods in the history of Chinese calligraphy were most crucial to script development. One was the Han dynasty (206 BCE–220 CE), during which Clerical Script was developed. In the previous chapter, we saw that Clerical Script contributed crucial features to modern Chinese writing and that it allowed Chinese calligraphy to become a true art. The other period, the Tang dynasty (618–907), was another era of great cultural prosperity. During the Tang the Regular Script reached its maturity and produced a large number of calligraphy masters.

In Chapters 3 to 7, you learned major features of the Regular Script. You have also been practicing the script in actual writing. This chapter examines Regular Script further and compares it with Clerical Script. It also looks at the lives and works of some of the greatest masters of Regular Script, who significantly influenced the development of Chinese calligraphy.

THE REGULAR SCRIPT

Regular Script is based on Clerical Script, both in individual strokes and in how individual elements are combined. Although it is still an unsettled issue exactly

when the Regular Script was developed, most would agree that it was introduced during the Han dynasty, popularized in the Wei and Jin periods, and finally reached its maturity in the great Tang era.[1]

Regular Script is, as the name suggests, "regular" in that it features distinguished and refined strokes and stroke types. Each stroke is placed slowly and carefully; the brush is lifted from the paper at the end of each stroke. Characters, square in shape, have a well-defined internal structure. It is a standardized script with prescribed techniques in three major areas: brush method (how to use the fingers and wrist to move the brush and how to take advantage of various ink effects), character method (ways of managing the internal structure of characters and making them artistically more appealing), and composition method (how to put components of a piece together to maintain good balance and coordination, and to create artistic effects). The result is a precise form of calligraphy written in a serious manner, with a firm and solid structure. The script embodies fundamental principles from which further styles can be extracted. As a *kai* or "model" script, it leaves little room for artistic license or acceptable variation. Owing to this inflexible regularity, it is also called *zhēnshū* 真書, "True Script." All these factors make Regular Script the easiest script to read and the script that beginners learn to write first.

THE REGULAR AND CLERICAL SCRIPTS COMPARED

Figure 10.1 presents a visual comparison of the Regular and Clerical scripts. It is immediately apparent that the two scripts convey different feelings and tastes. The most obvious differences are found in their stroke shapes. While Clerical Script strokes are relatively heavy, those in Regular Script are generally more extended and smoothed out. The Clerical Script convention of "silkworm's head and swallow's tail" is particularly distinctive. Also, in Clerical Script, there is no "hook." Note in Figure 10.1 how the hooks at the bottom of the Regular Script characters 好雨 *hǎoyǔ*, "good rain," are written in Clerical Script. Horizontal lines in Clerical Script are flat, although some curl up slightly, as in Figure 10.1. By contrast,

CLERICAL	VS.	REGULAR	
好雨		好雨	[good rain]
吉祥		吉祥	[auspicious and propitious]

FIGURE 10.1. Clerical and Regular Scripts.

horizontal lines in Regular Script generally slope upwards and lack the final tilt at the end that characterizes Clerical Script.

The overall shapes of the characters in these two scripts contribute to the feel they convey. Characters in Clerical Script are wide and short; they convey a sense of solemnity and antiquity. Those in Regular Script are square and have the look of standing tall and more at ease. Regular Script became popular later than Clerical Script; it preserves the precision and modulation of line width in Clerical Script but is less formal and heavy.

Another difference is the unchallenged supremacy of Regular Script for official use in modern times. Its development and perfection during the Tang dynasty not only brought Chinese writing to an age of stability and maturity, it provided calligraphy with a full set of rules and standards upon which other styles are based and that they elaborate. Since the invention of Regular Script, the study of calligraphy has emphasized the interpretation of its rules and standards, and how to add personality to the rules and standards in writing.

MASTERS OF THE REGULAR SCRIPT

The Tang dynasty produced a large number of calligraphers unmatched in any other historical period. In this section, we examine the lives and works of the four most distinguished masters of Regular Script. We will first look at Wang Xizhi, whose writing in four major script types serves as models in this book. We will then look at Yan Zhenqing and Liu Gongquan, two other names familiar to every student of calligraphy in China. We will compare the writing of these three great calligraphers, all in Regular Script, to see how their personal styles differ. Finally, we will look at Zhao Ji, another important and interesting figure in the history of calligraphy who is best known as Emperor Huizong of the Song. His work and distinct style are mentioned throughout this book.

WANG XIZHI

Wáng Xīzhī 王羲之 (303–361), the "calligraphy sage," is the most famous of all Chinese calligraphers. His work represents the summit of the art. Wang Xizhi is to Chinese calligraphy what Beethoven was to music, Shakespeare to English literature, and Confucius to Chinese culture.

Wang Xizhi lived earlier than the other calligraphers discussed in this chapter, in the Jin dynasty (265–420). During his time, there were three major popular styles of calligraphy: Regular Script, Running Style, and Cursive Style. Wang Xizhi excelled in all three, although he was best known for his Running Style. The Running and Cursive styles—as well as Wang Xizhi's best work—will be discussed in the next chapter; here, suffice it to say that the Running Style falls

between Regular and Cursive in terms of writing speed and stroke linkage. When carefully written with distinguishable strokes, it is Regular Script; when swiftly written with indistinguishable strokes, it is Cursive Script. There is no doubt that Wang Xizhi became the greatest master of the Running Style because he had also mastered the Regular Script; the former was firmly built on the foundation of the latter. His natural, unrestrained, elegant, and refined writing in Regular Script is considered "perfect beauty."[2]

Wang Xizhi was born to a wealthy family (his father was provincial governor) in present-day Linyi, Shandong Province. He began to practice calligraphy at the age of seven under the tutelage of his father and the well-known calligrapher Madame Wei Shuo. At first he seemed to have no potential; no one believed that this slow, dull child would become a calligraphy genius. However, his diligence and concentration allowed him to overcome his lack of innate talent. As a child, even when he was walking, he would often ponder the structure of characters and practice writing with his fingers on his arm, legs, and body. The story goes that he would rinse his brush and ink stone in a pond outside his home after every practice session—and he practiced so much that the water in the pond eventually turned black! This pond was subsequently named Xiyan (Rinsing Inkstone) Pool and can still be seen today at Wang Xizhi's former residence in Linyi. Wang Xizhi exemplifies diligence to students of calligraphy and commands respect for his patience and hard work.

Even during Wang Xizhi's lifetime, his writing and signature were beyond value. He was especially favored by the Emperor Taizong of the Tang, who paid extremely high prices to collect Wang's writing samples. The emperor also ordered court officials to imitate Wang's writing until it finally became a fashion, which has lasted up to the present day.

Wang Xizhi passed his talent on to his sons, particularly his seventh son, Wang Xianzhi, whose reputation at times surpassed his father's. The works of both father and son, now known as the "Two Wangs," are among those most treasured in the tradition of Chinese calligraphy.

After Wang Xizhi, in the Tang dynasty (618–907), Chinese calligraphy attained its full prominence as Regular Script matured and perfected. A number of well-known Tang calligraphers, including Yan Zhenqing and Liu Gongquan, emerged with individual styles in Regular Script.

YAN ZHENQING

Yán Zhēnqīng 顏真卿 (709–785) was a court official and successful military commander in the Tang dynasty as well as a famous calligrapher whose influence on the development of calligraphy proved to be as significant as Wang Xizhi's. Yan, who came from a poor family, was schooled mainly by relatives. Later he passed

the imperial examination and started his career as a successful official in supervisory military positions.

When Yan Zhenqing was young and his family was too poor to afford the proper training materials of brush and paper, it was said that his early training consisted of smearing mud on blank walls. Nonetheless, he distinguished himself early in writing by first learning the Wang Style and tightly composing its characters with vibrantly modulated strokes and crisply pointed ends. Later, his style changed to include much less modulation in stroke thickness and more blunted ends. As a result, his characters became more plain and severe rather than highly articulated. They have a lofty appearance as of a marshal and are as majestic as a sovereign ruler.

Gradually Yan Zhenqing became a true master of calligraphy. He had a great ability to absorb what he had learned and to use it in his own way. For example, he made drastic changes to Wang Xizhi's elegant Regular Script characters by adding strength and vigor. He imparted maximum power to each stroke with vertical lines that were generally much thicker than the horizontal lines. Not only did his characters begin to expand internally and feature less modulated strokes, the use of the concealed-tip technique made the entry points of his strokes disappear. The result was the most original style of all the Tang calligraphers: firm, sturdy, broad, and muscular. His emphasis on strength, boldness, and grandness brought Chinese calligraphy to a new realm (Figure 10.2).

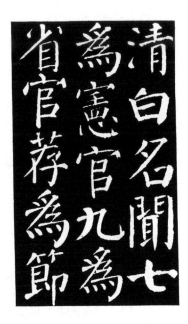

FIGURE 10.2. The Yan Zhenqing Style.

Before the mechanical printing press was invented, books in China were duplicated and preserved mainly by two means: copying by hand or carving on stone. The different functions, materials, and workmanship of these methods produced characters with markedly different features. Interestingly, Wang Xizhi's graceful, elegant style was used for hand-copying and looks best on paper, while Yan's mighty, majestic characters were ideal for stone carving—especially when seen from a distance. Therefore, Yan was often asked to write out texts to be engraved on public monuments. His earliest surviving work, the Prabhutaratna Pagoda Stele (752 CE), can still be seen today in the Forest of Steles in Xi'an.

In Chinese culture, an artist's success is often associated with his moral standards and personal conduct. In calligraphy, subjective elements such as scholastic achievements, personality, and moral virtues are all considered important in artistic achievement. Yan Zhengqing's life story provides an example. In the military realm, Yan Zhenqing was well known for his righteousness and loyalty to his country. After a successful career as a military commander, he retired but was recalled to duty to help crush the An Lushan rebellion. After a successful military campaign, he was appointed minister of law, but his outspokenness against government corruption and his unbendable character offended treacherous higher-ranking court officials and eventually cost him his life. His heavy characters display a grandeur and seriousness of expression that is seen as a perfect reflection of his personality, values, and morals. His style, later known as the Yan Style, has greatly influenced calligraphers of later generations and has been copied by calligraphy students to the present day.

LIU GONGQUAN

Liǔ Gōngquán 柳公權 (778–865), another master calligrapher of the Tang dynasty, enjoys fame and respect equal to that of Yan Zhenqing. In his childhood, Liu Gongquan also worked diligently and became knowledgeable about literature and Confucianism. After passing the national civil service examinations in his early twenties, he became a government official.

Liu Gongquan studied the calligraphy of the Two Wangs, Yan Zhenqing, and other earlier masters. In sharp contrast to Yan's bold, imposing strokes and square characters that embodied the heavy trend of the time, Liu developed a style with bony yet firm strokes and characters. Another difference between Yan's and Liu's styles is that Yan's characters were arranged modestly, with spacious center portions and tight outer strokes, while Liu's characters had strokes tightly knitted in the middle and stretched out on all sides. It is said that, in order to develop his style, Liu dissected animals to study their anatomy and observed flying wild geese and swimming fish. He was probably most influenced by the sight of deer on the run, which he considered thin, light, and skeletal. His writing,

later known as Liu Style, is distinguished by "bony" strokes and strict, rigorous structures (Figure 10.3).

Liu also dealt with the theoretical aspect of writing and the abstract and spiritual side of the art. He advocated cultivating a relationship between the mind and the brush, the need to visualize the final product before its creation, and the importance of involving well-cultivated spiritual abilities beyond simple imagination. Liu was not as active in government as Yan Zhenqing; rather, he was a devout Buddhist. His Buddhist practice surely influenced his philosophy of both life and calligraphy, particularly his emphasis on the necessity of forming a strong moral character as a basis for artistic creation. Once, when asked by Emperor Muzong of the Tang how to write upright characters, Liu responded that it depends on the mind of the writer. When a person sets the purpose of his life upright, he will be able to write upright characters. Since then, Liu's saying "An upright mind for an upright brush" (心正笔正 *xīn-zhèng-bǐ-zhèng*) has been central to the Chinese emphasis on forming a strong moral character as the basis for artistic creation.

Although different in style, both Yan and Liu have long been admired and

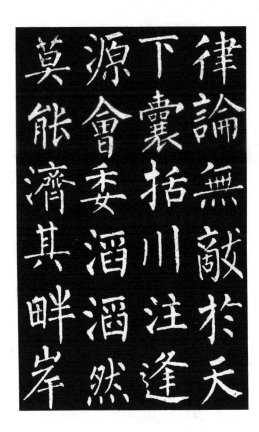

FIGURE 10.3. The Liu Gongquan Style.

followed by calligraphers and calligraphy learners not only for their writing, but also for their morality. They are often referred to as the famed "Yan-Liu." For students training in calligraphy, copybooks in both the Yan and the Liu styles are still widely used and valued.

Figure 10.4 is a comparison of the three personal styles of Wang Xizhi, Yan Zhenqing, and Liu Gongquan, all in Regular Script. Clearly, each style carries its own subtle characteristics and artistic flavor. The Liu Style reveals thinner lines that reflect his strong character, while the Yan Style looks heavier and fuller. Among the three, the Wang Style is the most relaxed and graceful. Beginning learners may choose any of these (or styles of other calligraphy masters) as a model according to personal taste and preference. Switching between styles is generally not advised.

EMPEROR HUIZONG OF THE SONG

Song Huizong (宋徽宗 Sòng Huīzōng, 1082–1135), whose personal name was Zhào Jí 赵佶, was exceedingly significant in calligraphy and painting although an infamous emperor. What intrigued Huizong the most was fine art. He honed

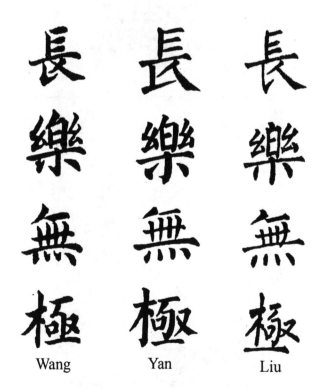

Wang Yan Liu

FIGURE 10.4. "Everlasting Happiness": a comparison of the Wang, Yan, and Liu styles.

his skill in poetry, painting, calligraphy, and music and, as a dedicated art connoisseur, filled his palace with works of art and musical instruments. Most of the members of his court were artists as well. His hobbies included architecture, garden design, and Chinese medicine; he was a tea enthusiast and wrote treatises on the Song dynasty's tea ceremonies, which are considered the most complete depiction of tea traditions recorded in Chinese history. His most significant and well-known contributions were to Chinese calligraphy. He even developed his own style, called Slender Gold, illustrated in Figures 10.5 and 10.6.

Slender Gold, so named because it has a twisted quality, like gold filament, is characterized by thin, sharp strokes and sharp turns and stops. The characters are angular, with chiseled corners. The ending of the horizontal strokes is also

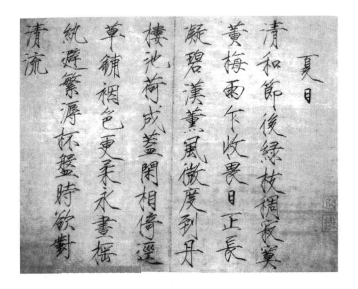

FIGURE 10.5. Slender Gold by Emperor Huizong of the Song dynasty.
[FROM NAN AND JI, *LONG ZHI WU*, WHERE NO INDICATION OF SOURCE IS GIVEN]

FIGURE 10.6. A close-up of Emperor Huizong's Slender Gold.

unique in that the brush clearly goes back in the opposite direction. The size and shape of the characters is uniform, as in Regular Script, but the strokes are long, straight, and thin, creating a sharp, wispy look. Some critics believe that Slender Gold looks too delicate and feminine, and see this as a reflection of weaknesses in an emperor that eventually led to the tragic end of his rule.

Huizong also contributed significantly to painting and is well known for his *gongbi*, a meticulous style of Chinese traditional painting that uses fine, delicate brush strokes. Both his calligraphy and his paintings were characterized by extreme brush control. His paintings were often accompanied by poems he wrote in Slender Gold. Huizong also established and directed art academies to train court calligraphers and artists.

When Huizong became emperor, he inherited conflicts that he was unable to resolve effectively. He used art as an escape from the pressures of political life and spent most of his time and the country's assets on amassing large collections of calligraphy, paintings, musical instruments, and other forms of art, as well as furthering his own skills. Living an extravagant lifestyle in a lavish palace, he indulged in amusements and spent little time or effort developing foreign policy or building up an army. The weakness of the Song military was only too apparent. When enemies attacked in 1126, Huizong panicked and abdicated. He died an exile at the age of fifty-two. He left a unique style of calligraphy that is still widely used today.

The Tang dynasty was the golden age of Chinese calligraphy as it was the golden age of Chinese literature, especially poetry. The maturation of the firm, dignified, graceful Regular Script marked the final stage of the development of Chinese script. With the perfection and standardization of Regular Script, the potential for the development of Chinese characters seems to have been exhausted. During the 1,100 years from the Tang dynasty to the present day, Regular Script has held an uncontested status both in calligraphy and as the standard script for official use. No new scripts have been invented; later writers have only developed individual styles.

DISCUSSION QUESTIONS AND WRITING PRACTICE

1. Compare the three characters meaning "dragon" below and discuss how to write them differently in the three different scripts.

2. Compare the character 書 *shū*, "book," written in the Yan and Liu styles and say as much as you can about their differences.

3. Practice writing the Regular Script characters in the text "A journey of thousands of miles starts from the first step" on pages 225-226 in Appendix 1.

4. Practice the characters on page 228 in Appendix 1. The structure of these

characters is more complex than those you have practiced before in the Regular Script. Since they are characters of common interest, they often appear in calligraphy pieces. Page 229 is a typical example of the character 福 *fú*, "blessings," which is often put at the entrance to homes, especially during Chinese New Year celebrations.

5. Practice writing the stem-branch term for the current year in the Regular Script.

The Development of Chinese Calligraphy IV

THE RUNNING AND CURSIVE STYLES

The scripts described in the previous chapters are all written stroke by stroke. The Running and Cursive styles, in contrast, are executed with linking between strokes. They are faster ways of writing, with more fluidity and freedom of expression. Of the two, the Cursive Style has the higher degree of stroke continuity. For this reason, Running Style is often referred to as "semicursive." Analysis shows that both the Running and Cursive styles developed on the basis of Clerical Script. In modern times, however, they are perceived and understood in relation to Regular Script. It is said that Regular, Running, and Cursive styles are like the three stages of standing, walking, and running.

The Running and Cursive styles also differ from Regular Script in that no standards exist for their writing. They are not taught in schools as major, formal scripts, nor are they used in official documentation. To distinguish them from the formal scripts, they are referred to as "styles."

THE RUNNING STYLE

Compared to Regular Script, Running Style is less formal, freer, and sketchier. As the name suggests, it departs from the prescribed features and strict formality of earlier scripts by increasing the speed of writing. The faster speed creates not only kinetics but also softened corner angles and different linkages between some (but not all) strokes. Sometimes shortcuts can be taken for faster execution, even at the expense of normal stroke order. This speedy and spontaneous style, like a gentle breeze, breathes life into characters and grants them grace of movement and rhythm.

DEGREES OF LINKING

The examples in Figure 11.1 highlight a distinct feature of the Running Style, the linking between successive strokes. The result is a continuous flow of energy until an intentional stop occurs. Linkages are executed in different ways. Some are overtly linking lines, such as the one between the first two strokes of 三 *sān*, "three," 文 *wén*, "text," and 大 *dà*, "big." Sometimes strokes are not overtly linked, but there is a sensed correspondence indicated by the direction in which the brush is moving; for example, the last two strokes of 三 "three," 文, "text," 大, "big," 只 *zhǐ*, "only," and all three strokes of 小 *xiǎo*, "small." In these examples, the strokes taper off in the direction of the next stroke so that the preceding stroke brings out the following one. Although the strokes are not overtly linked, the momentum is there. Whether and how to link strokes are decisions for the writer. However, when two strokes are linked, a distinction should be made between the actual stroke lines and the linking lines.

STROKE CONSOLIDATION AND CHARACTER SIMPLIFICATION

Writing with increased speed enables one to combine strokes and simplify characters. Beginners should note that combination and simplification are done by

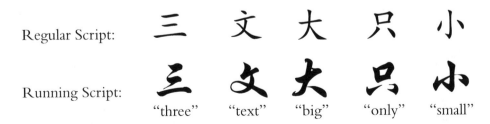

FIGURE 11.1. Different linkages in Running Style.

convention so that legibility can be preserved. As Figure 11.2 shows, simplification can be accomplished by changing lines into dots and dots into lines; strokes may also be combined.

The character in (1) in Figure 11.2 is *yǐ*, "according to." The first stroke in Regular Script, a vertical line with a right–up tick, is simplified into a dot in Running Style, which is linked with the second stroke (also a dot). The third stroke (a down-left) and the fourth (a long dot) in Regular Script are linked into one stroke in Running Style. The result is the same character with a totally different look. Again, such linking and simplification has to follow certain conventions. That is, every person writing this character in the Running Style should link and simplify

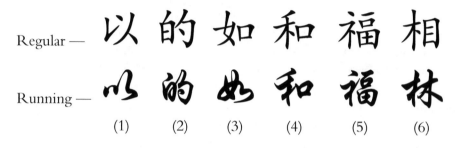

FIGURE 11.2. Comparison of Regular Script and the Running Style: stroke linking and character simplification.

the strokes in the same way so that the correspondence between the two scripts can be used for decoding. This is very much like a shorthand in any language. Similarly, in the left component of the character 的 and 的 (*de*, a possessive marker) in (2), the two horizontal lines (one inside of the box and the other the bottom closure) are linked and simplified into an upward line linking with the right component. In (3) 如 *rú*, "as if," the right side, a box 口 composed of three strokes in Regular Script, is written in Running Style with only one curved stroke. In the last three characters in (4) through (6), 和 *hé*, "harmony," 福 *fú*, "blessing," and 林 *lín*, "woods," the last two strokes on the left side of the Regular Script characters are a down-left stroke and a dot. They are simplified in roughly the same way into a down-left linked with a right-up tick, which is also linked with the component on the right side. These are all conventionalized ways of stroke linking and simplification so that characters in Running Style remain legible. An important part of learning the Running (and the Cursive) Style is to learn these conventions.

There are, however, complications. The conventions may include more than one way to simplify a character or more than one level of simplification. A comparison of (3) and (4) in Figure 11.2 shows two different ways of writing the box

口 in Running Style; in (3) there is apparently a higher degree of linking and simplification. Ultimately, whether and how to simplify a character is a decision for the writer to make in writing. Such choices enlarge the inventory of the different ways a character can be written. It is, in fact, another feature of Running Style that the same characters in the same text should never be written exactly the same way. A commonly cited example is Wang Xizhi's *Orchid Pavilion* preface (see pages 145–147), in which the character 之 *zhī* (a marker of noun modifiers) is used more than twenty times but is written differently, elegantly, and beautifully each time.

The linking and consolidation of strokes increases the flow of energy between strokes and makes the writing more cohesive. As a result, the writing of a character in Running Style should be executed in one breath.

STROKE ORDER REVISITED

The conventions for writing Running Style also involve stroke order, which can be adjusted to increase writing speed in ways that deviate from the prescribed stroke order for Regular Script. In Figure 11.3 below, the stroke order in Regular Script is compared to the way the same characters look in Running Style.

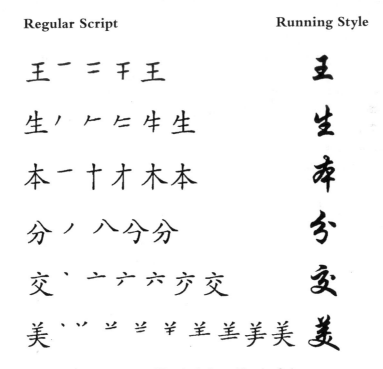

Regular Script **Running Style**

FIGURE 11.3. The stroke order of Regular Script and Running Style.

In Regular Script, in the first character, 王 *wáng*, "king," the second stroke is a horizontal line and the third a vertical. In Running Style, this order is reversed, that is, the vertical line is written first, then the brush travels up and left in a circular motion before it comes back down to write the final horizontal line. The same reversal of stroke order is also seen in the second character, 生 *shēng*, "life" or "birth." The other characters in Figure 11.3 also exemplify changes of stroke order that are part of the conventions for writing in Running style.

ARRANGEMENT OF TEXT

Another difference between Regular Script and Running Style is that characters in Regular Script are written in a uniform size, while the size of Running Style characters may vary. In fact, an important consideration in writing Running (and Cursive) Style is to adjust the sizes of characters for rhythm and balance. Such adjustments are made not only between consecutive characters, but also between adjacent columns and with regard to all other characters in the same piece. The overall layout, including the varying sizes of the characters, reflects the artistic instincts of the calligrapher. It is interesting to note that, when masterpieces in Running Style are copied and imitated, even the errors and corrections in the originals are retained because they are considered an integral part of the artwork. Any modification would destroy the rhythm and cohesion of the masterpiece. Figure 11.4 (page 146), a good example, is a copy of Wang Xizhi's *Preface to the Orchid Pavilion Collection* with all the errors and corrections in the original retained.

In the earlier discussion of stroke order, it was mentioned that two major stroke order rules dictate: one works from top to bottom and from left to right. Therefore, the writing of a character generally proceeds from the top left corner to the lower right. This general sequence works well when writing vertical text in columns in the traditional way. It is in fact a consequence of life during the initial and crucial stage of character development. Before paper was invented, texts were mainly written on wooden and bamboo slats. Because it was easier to handle slats vertically rather than horizontally, one or two columns of text were written vertically on each piece of slat, and the writing of each character would proceed from top to bottom. This tradition was kept long after paper became prevalent.

Since the advent of modern science and the influx of Western influence, and so that scientific formulas, Arabic numerals, and foreign proper names and acronyms can be more easily incorporated into Chinese texts, modern China has adopted the Western convention of horizontal text written and read from left to right. This is easy to do when the writing is in Regular Script since each character is written independently in block style. In Running and Cursive styles in which characters are linked, however, the traditional arrangement of vertical columns from top to

bottom is easier and more natural. This partially explains why calligraphy texts in Running and Cursive styles are still written in vertical columns.

PREFACE TO THE ORCHID PAVILION COLLECTION BY WANG XIZHI

Preface to the Orchid Pavilion Collection (*Lán Tíng Xù* 蘭亭序) is a masterpiece by Wang Xizhi produced at the prime of his calligraphy career (353 CE, when he was fifty-one). Written in the Running Style, it is the best-known calligraphy piece in history. Over the past 1600 years, it has had a profound influence on Chinese calligraphy far beyond the boundaries of China.

In chapter 10, Wang Xizhi has been described as one of the best-known masters of Regular Script. After he had thoroughly studied Regular Script and examined the works of earlier calligraphers, Wang Xizhi developed his own Running Style.

In 353 CE Wang Xizhi invited forty-two literati of the Jin dynasty to the Orchid Pavilion (Lan Ting) near Shaoxing (in today's Zhejiang Province) for the Spring Purification Festival. While enjoying their wine, his guests played a drinking game for which they divided into two groups and sat on either side of a coursing stream. Small cups of wine were put in the water and floated downstream. When a cup stopped in front of a guest, he had to compose a poem. Anyone who failed to write a poem had to drink the wine as a consequence. The good company and strong wine put Wang Xizhi in a good mood; as a result he spontaneously wrote the *Preface* as a prelude to the improvised poems that he planned to collect to record the happy gathering.

The *Preface* turned out to be a work of stunning beauty, a perfect example of the elegant Wang Style. Apparently the happy occasion and the effect of drink played important roles, for Wang Xizhi, the story goes, tried more than one hundred times a few days later to reproduce the *Preface* with the same quality, but he was never able to match his own incredible, spontaneous calligraphy. The brushwork, the extreme freedom and infinite variation in wielding the brush, and the composition made the piece the best he ever produced. Although it was a piece of improvisation, it flows rhythmically and is celebrated as a work of literature. The piece won Wang Xizhi the title "the number one Running Style calligrapher."

Emperor Taizong of the Tang, who admired Wang's calligraphy so much that he personally collected nearly two thousand pieces of Wang's work, ordered a search for the original *Preface*. After acquiring it, he set it as a model for court officials and calligraphers to copy and study. When the emperor died, he ordered that the original *Preface* be buried with him.[1] The emperor's high regard encouraged later calligraphers to imitate Wang Xizhi's style. The rubbings of the *Preface* today are mostly taken from imitations from the Tang dynasty, as the original was nowhere to be found (see Figures 11.4 and 11.5).

Wang Xizhi's style has continued to influence Chinese calligraphy to the pres-

FIGURE 11.4. The Shenlong version (ca. 705) of the *Preface to the Orchid Pavilion Collection*.
[FROM NAN AND JI, *LONG ZHI WU*, P. 76, WHERE NO INDICATION OF SOURCE IS GIVEN]

FIGURE 11.5. A close-up of the *Preface to the Orchid Pavilion Collection*.

ent, although few of his priceless works still exist. The Orchid Pavilion, which was rebuilt in the sixteenth century, now houses a calligraphy museum.

Running Style, which was developed in the late Han period owing to the need for increased speed in writing, provides great opportunities for casual expression and personality. With no prescribed standards, this style has artistic as well as practical value. It is the most popular calligraphy style because it lends itself well to all hand-written forms of communication. The development of the Running Style was an important step in the development of calligraphy. The path of the brush is often easy to observe in this style because the connection between strokes is clearly articulated. When fountain pens were introduced to China from the West in the early twentieth century, the techniques of writing Chinese characters using these new instruments were developed mainly based on Running Style.

THE CURSIVE STYLE

The Cursive Style, 草書 *cǎoshū*, is known for its bold and unconstrained nature. As a noun, *cao* means "grass"; as an adjective, it means "rough." A broad definition of *caoshu*, therefore, is a script written in a hurried and sketchy manner. This might have been the case when it was first used in the Han dynasty for making quick, rough copies. Later calligraphers found beauty in the style and developed it into an art form. A narrower, more technical definition of Cursive Style refers to its development on the basis of the Clerical Script. As an art form, its dynamic nature makes it drastically different from its predecessor. It is even more vibrant than Running Style and thus reflects the mood and spirit of the writer more directly.

A much larger variety of techniques are involved in the production of Cursive Style. Techniques and effects that are not seen in the formal scripts, such as subtle, slow motions and dynamic martial-arts-like attacks, accompanied by diffused ink blots and dry brush strokes, place natural and impromptu means at the artist's disposal. Stroke continuity is its most outstanding feature. As in Running Style, some conventionalized rules are followed so that the style maintains legibility. Knowledge of these rules is also required in order to read this style.

Cursive writing, which existed before the formal establishment of Regular Script, originated in the Han dynasty and developed through the Jin dynasty. In terms of manner and speed, Regular, Running and Cursive styles form a continuum from more serious, stolid characters to a quicker look and greater sense of movement. The Cursive Style breaks free from the strict rules of the Regular Script so much that it has been described as ink dancing on paper and compared to powerful, dramatic music. To live up to its name, a piece in the Cursive Style communicates great energy, power, and speed.

Cursive Style has all the features of Running Style but takes them further, toward faster writing, increased creativity, and freer emotional expression. More spe-

cifically, strokes are joined much more often and with an even higher degree of abbreviation. There is also linking between characters in which the last stroke of one character often merges with the first stroke of the next. All of these differences result in a notable distinction between the Running and Cursive styles: Although the former is generally legible, the latter is too abbreviated for many to read. Even those proficient in the Running Style cannot be expected to read the Cursive Style without training. Figure 11.6 compares individual characters in Regular, Running, and Cursive styles; Figure 11.7 is a piece in Cursive Style.

Regular	Running	Cursive	
書	书	书	"write"
可	可	可	"approve"
正	正	正	"upright"
多	多	多	"many"
还 通	还 通	还 通	"still" "through"
是 走	是 走	是 走	"to be" "walk"
等 待	等 待	等 待	"wait"
想 念	想 念	想 念	"miss/think of"

FIGURE **11.6.** Comparison of Regular, Running, and Cursive styles.

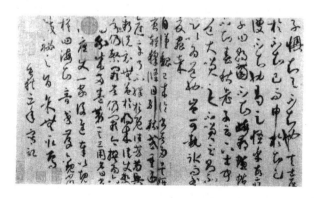

FIGURE **11.7.** Cursive Style by Sun Guoting (265–420). [FROM SUN, *CAOSHU SHIJIANG*, P. 28, WHERE NO INDICATION OF SOURCE IS GIVEN]

Because Cursive Style is written without strict guidelines, each artist writes in his or her own unique way. Actually, there are no clear dividing lines between the Regular, Running, and Cursive styles. Their differences are subtle rather than discrete. As a result, some works are categorized as Running-Regular, others as Running-Cursive. A common misunderstanding of the Cursive Style is that all strokes and all characters are linked so that the writing is done in a continuous line, like a ribbon. In Figures 11.8 and 11.9 below, you can see that, even in "wild" cursive, the most vibrant of the Cursive styles, different degrees of linking are evident. A full break is usually made every few characters.

A feature and technique shared by the Running and Cursive styles (especially the latter) has to do with the method of using ink. That is, the sense of rhythm and movement in writing depends in part on the amount of ink used. To maintain the energy flow in writing, the artist may write a number of characters before stopping to recharge the brush. To do this successfully, the brush has to start with more ink than usual so that it will not run dry before the artist is ready to stop. Consequently, right after the recharge, the bush is full of ink, and the lines are thick and dark. As writing proceeds, the ink gradually runs out, the brush becomes drier and drier, and the strokes gradually thinner and lighter. This is the time for another recharge of the brush. These cycles produce a rhythm between heavy and light, wet and dry. Heavy, wet characters look nearer to the viewer, whereas light, thin characters seem to be at a greater distance. A three-dimensional space is thus created in a piece of calligraphy; how it is done and to what degree is part of the art.

The development of Running and Cursive styles reflected a trend in Chinese calligraphy away from classic styles in favor of more innovative and individualized forms of expression. In the traditional styles, excellence was based on skillful adherence to conventional standards, while "modern" styles strive for creativity over conformity, often at the expense of legibility.

The Cursive Style is the most expressive of all traditional Chinese calligraphy styles. Probably for this reason it is the most popular with professional calligraphers. Many artists writing in this style have colorful and eccentric personalities. Two of them are Zhang Xu and Huai Su.

ZHANG XU

Zhang Xu 張旭 (ca. 658–747), who was nicknamed "Crazy Zhang," lived in the Tang dynasty. A native of Suzhou (in today's Jiangsu Province), he was an officer in the imperial court who indulged in extreme drinking. Because he believed that alcohol would release his talent and the true genius of his work, he would often drink heavily before writing a piece. (Once when he was drunk, he even dipped his hair into ink and used his head as a brush to write on the walls of his house.) He applied rhythm and movement to his calligraphy and, it is said, while writing drunk

he would wield his brush at a frenzied speed, yelling and laughing. His Cursive Style featured characters connected by continuous lines and, often, great variations in size. Because of the erratic nature of its composition, his style was referred to as Wild Cursive, the pinnacle of Cursive Style that exposes the spiritual state of the calligrapher in its expressive abstraction (Figure 11.8). Zhang Xu could not duplicate his own work with the same quality when he was sober.

When writing in the Cursive Style, Zhang Xu's brush twisted and turned in all directions as it sped across the paper. He used wild cursive as a means of expressing his inner self, putting all his feelings—happiness, sadness, disappointment, pleasure, and loneliness—into writing. In the mid-Tang dynasty, wild cursive became very influential. Zhang Xu's calligraphy, Li Bai's poems, and Pei Ming's sword dance were considered "the three perfections" in literature, calligraphy, and martial arts. Interestingly, Zhang Xu, Li Bai, and Huai Su (to be discussed below) shared a common addiction to alcohol. When Zhang Xu was sober, it is said, he could not always recognize the characters he wrote when he was drunk.

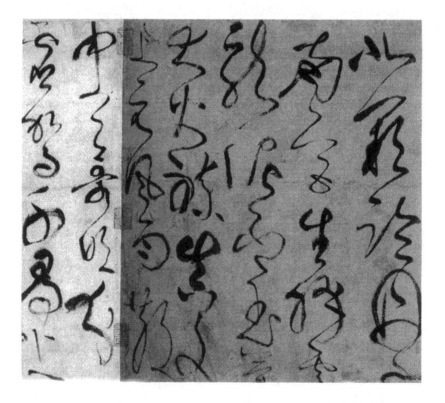

FIGURE 11.8. Wild Cursive by Zhang Xu (ca. 658–757).

HUAI SU

Huai Su 怀素 (ca.725–ca.785) was another great calligrapher of the Cursive Style. Unlike most other famous calligraphers, who were government officials, Huai Su was a free-spirited monk. He had loved calligraphy since childhood, but his family was poor and unable to support his calligraphy practice. To solve the problem he planted thousands of palm trees in his hometown and practiced writing on the leaves. After he became a monk at the age of ten, he continued practicing in his spare time after reading Buddhist scriptures and praying.

Huai Su benefited from studying Zhang Xu's style when he started working in the Cursive Style, but he created his own style as he became more experienced. One of the most noticeable differences between the two masters is that Huai Su's strokes are much thinner than Zhang Xu's. He often used a fine brush to write out large characters. His strokes are rounded and dashing, almost as if they were steel wires curled and bent. The tip of his brush was exposed where it lifted from the paper, leaving a distinctive hook. Accordingly, his unique calligraphy style was referred to as "steel strokes and silver hooks."

Similar to Zhang Xu, Huai Su's brush turned, spun, and danced to create character after character and line after line, in contrasts of heavy and light strokes. Huai Su's style represents the ultimate in Cursive Script: control with freedom and spirit with restraint (Figure 11.9).

Huai Su and Zhang Xu, considered the two greatest cursive calligraphers of the Tang dynasty, are affectionately referred to as "crazy Zhang and drunken Su"

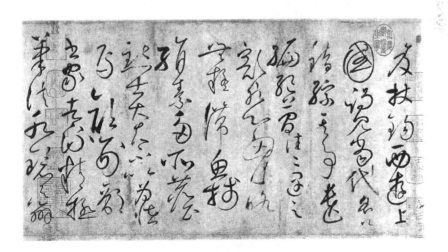

FIGURE **11.9.** *Wild Cursive Autobiography* (dated 777) by Huai Su (737–799). Collection of the National Palace Museum (Taipei). [FROM *MASTERPIECES OF CHINESE CALLIGRAPHY IN THE NATIONAL PALACE MUSEUM*, P. 4. REPRODUCED BY PERMISSION FROM THE NATIONAL PALACE MUSEUM]

because of the many similarities between their personalities and their works. Both men were free-spirited and unrestrained. Although Huai Su was a monk and con- sumption of alcohol was forbidden to him, alcohol was nonetheless an important part of his creative process. When he got drunk, he would start writing calligraphy. Sometimes he wrote on clothing or temple walls—anything he could write on.

It was great calligraphers like Zhang Xu and Huai Su whose dashing, flying characters rendered the Cursive Style the best means to express artists' feelings and emotions. Their works had an important influence on later calligraphers. For example, Yan Zhenqing, the famous Tang dynasty calligrapher, studied under Zhang Xu; later, Mao Zedong, the twentieth-century politician and calligrapher, admired and learned from Huai Su.

WRITING THE RUNNING AND CURSIVE STYLES

Because the Running and Cursive styles are informal and individualized, there are no standards for how they should be written. All the artistic dimensions discussed so far, such as stroke thickness, size and position of characters relative to other characters on the piece, stroke order, linking of strokes and characters, amount of ink, and so on, are at the discretion of the writer. A decision has to be made on each aspect and the best combination of all, in order to express the artistic effect the writer has in mind. This is why Running and Cursive are generally thought of as personal styles.

Beginners can try their hand at Running and Cursive styles by using the same method of first tracing and copying from models, although practicing the Regular Script for (many) months beforehand is always suggested. Tracing and copying these styles, however, is quite different from doing so with Clerical and Regular scripts. Because of the continuous flow of energy these styles require, planning is very important. Proficiency is required in order to produce fluidity. There should be no pause between the strokes of a character, as this breaks one's momentum. Therefore, before writing, even experienced writers pause and mentally project how the writing should proceed. Tracing does not have to be done exclusively with a brush; you could use a pencil or even your forefinger to trace a character to confirm the stroke order, the proportions, how much pressure to apply at different points, and the coordination of mind and hand. Do not start writing before you have a clear plan for the entire piece from the very beginning to the very end. Before going for Wild Cursive, a few glasses of wine may help you get closer to the state of Zhang Xu and Huai Su.

Here is a helpful tip on the use of brush: If after writing a couple of strokes your brush tip is split but you do not want to break your momentum and do not need to recharge your brush with ink, you could give your brush a slight twist so that another side can be used to continue writing.

CONCLUDING REMARKS ON THE DEVELOPMENT OF CHINESE CALLIGRAPHY

Chapters 8 through 11 have reviewed a variety of writing styles: the classical, un-polished Great Seal; the tactful, meditative Small Seal; the precise Clerical Script; the dignified Regular Script; the elegant yet unconstrained Running Style; and the dynamic Cursive Style. Each of them creates a different visual and aesthetic impression; their evolution has been a gradual process of simplification of execution and increasing aesthetic value.

Early Chinese calligraphy was written for practical purposes of communication and record keeping. The Seal and Clerical scripts, for example, were not considered art forms when they were created. It was not until the Sui and Tang periods that a significant number of theoretical treatises on calligraphy appeared and calligraphy started to be considered a form of art. At that time, Chinese calligraphy had already reached a mature stage, with all the major scripts and styles in use.

Looking over this history of development, we can see that every script style goes through stages of creation, exploration, mature perfection, and stabilization. The final stage and perfection of a style is always marked by a number of masters of the style, such as Li Yangbing for the Small Seal, the "Two Wangs" for the Running, Yan and Liu for the Regular, and Zhang Xu and Huai Su for the Cursive. During the Tang dynasty, the creation and perfection of Regular Script marked the final stage in the development of Chinese scripts. The majestic Yan Style of the Regular Script is considered a symbol of the peak of cultural development attained in the Tang era. At that point, both the Chinese writing system and the art of calligraphy entered a highly stable phase.

Today, all of the calligraphic styles are in active use with no artistic distinction made among them. The choice of style reflects the feelings, philosophy, and temperament of the calligrapher and is guided by the artist's mood and the subject of writing. Generally speaking, the Seal and Clerical scripts are considered more decorative because of their beauty and dignity, so they are used on formal and important occasions. The Seal Script, because it is an ancient script drastically different from modern characters, is more difficult to write. Only trained calligraphers can write in this script, and often they must use a dictionary. The Regular and Running scripts are more suitable for practical purposes.

When reading about the lives and works of great calligraphers, it is fascinating to note that the majority of accomplished calligraphers throughout the dynasties were government officials or even emperors. Apparently, throughout the history of China, calligraphy as an art has been closely associated with political power. This is partly because calligraphy was, for a dozen centuries, an important part of the nationwide civil service examination. Many scholars developed individual calligraphic styles as a way to distinguish themselves socially. It is not that calligraphers were

attracted to politics, but rather the other way around. Throughout Chinese history, members of the upper class and government officials were expected to possess advanced skills in calligraphy. Such expectations, as part of Chinese culture, have continued to the present day.[2]

DISCUSSION QUESTIONS AND WRITING PRACTICE

1. Using the name of Wang Xizhi as examples, describe the differences between the Regular, Running, and Cursive styles. Specifically, how does Running Style differ from Regular Script, on the one hand, and Cursive, on the other?

2. Choose two of the three writings samples for this chapter on pages 230–232 in Appendix 1, and practice writing them. Make a sketch first if necessary.

3. Figure out how you can write your Chinese name in the Running or Cursive style. First practice writing it using a hard pen, and then write it with a brush.

4. Use Figure 9.14 to identify the Chinese stem-branch term for the current year. Practice writing the Chinese term in Running Style based on the examples below.

甲 乙 丙 丁 戊 己 庚 辛 壬 癸
甲 乙 丙 丁 戊 己 庚 辛 壬 癸

子 丑 寅 卯 辰 巳 午 未 申 酉 戌 亥
子 丑 寅 卯 辰 巳 午 未 申 酉 戌 亥

··

The Art of Composition

Previous chapters have focused on the writing of individual strokes, characters, and scripts. In this chapter, we devote our discussion to the challenge of putting together the whole calligraphy piece. You will see that the art of calligraphy resides not only in composing characters, but also in composing with characters. Composition is a crucial part of the artistic creation and expression, in which micro-, meso-, and macroscopic visions are all balanced.

There are many ways to put a calligraphy piece together. Considerations include dimensionality—such as the size and shape of a piece (horizontal, vertical, square, round, fan-shaped, and so on)—length of text, writing style, and balance of components. Here, only the most basic elements will be described. For a general idea of the major components and layout patterns, let's first look at a few pieces of calligraphy. Some of the pieces illustrated in other chapters may also serve this purpose. Figures 12.1 through 12.4 are all works done in the Qing dynasty (1644–1911).

Usually when you trace, copy, or write in order to learn calligraphy, you concentrate on one stroke or a character at a time. There is so much to consider that you can hardly attend to anything else. When you plan to write a piece, however, you have to expand your awareness and have the entire piece in your mind. You

FIGURE 12.1. Vertical
scroll by Deng Shiru.
[FROM ZHU, *ZHUANSHU SHIJI-
ANG*, P. 76, WHERE NO INDICA-
TION OF SOURCE IS GIVEN]

FIGURE 12.2. Round fan by Huang Shiling. [FROM ZHU, *ZHUANSHU SHIJIANG*, P. 61,
WHERE NO INDICATION OF SOURCE IS GIVEN]

FIGURE 12.3. Vertical scroll by Zhao Zhiqian. [FROM
ZHU, *ZHUANSHU SHIJIANG*, P. 80, WHERE NO INDICATION OF
SOURCE IS GIVEN]

FIGURE 12.4. Clerical Script by Ba Weizu.
[FROM FANG, *LISHU SHIJIANG*, P. 55, WHERE NO INDICA-
TION OF SOURCE IS GIVEN]

have to think about what to write, in what style, how large you want the piece to be, the layout, the proportions of parts, how you want to sign and date the work, and where you are going to put your seal(s). The planning of a piece involves all aspects and phases of production. Each element plays a crucial though subtle role in the overall impact of the piece.

The composition of a piece reflects an important aesthetic principle of Chinese calligraphy: emphasizing the overall arrangement and macro coordination. Each part must be subordinate to the whole. Another aspect of Chinese calligraphy, which is conspicuous and also of vital importance, is the management of space. This includes not only the spaces that are filled (known as "figures") but also spaces that are left blank (known as "ground"). Beginners should note especially that white space, the void between elements, which is secondary in traditional forms of Western art, is just as important as the writing to the Chinese artist. The black writing and the white background are complementary, as water is to fish and air to birds. It is a common mistake to pay attention only to the figure and not the ground. Furthermore, it is not only the inside of a character that forms the ground, but also the external geometry. In terms of an entire piece, your overall plan should include not only the layout pattern and balance of the main text, inscriptions, and seal(s), but also the spaces around these elements. The importance of the "empty" portions of a calligraphy piece can also be found in Chinese painting, where the part played by blank spaces cannot be overlooked.

COMPONENTS OF A CALLIGRAPHY PIECE

Generally speaking, a calligraphy piece has three major components: (1) the main text, (2) inscriptions, and (3) a seal or seals. The main text is referred to as the "host"; it is the main point of interest. The inscriptions and seals are "guests" who play a balancing yet secondary role, as leaves do for a flower (see Figure 12.5).

FIGURE 12.5. Calligraphy by Wang Chunjie (contemporary), an artist in the Washington, DC, area. Main text: "Coinciding with nature." Inscription: Written with long-lasting happiness by Wang Cuiren.
[REPRODUCED BY PERMISSION FROM THE CALLIGRAPHER]

Needless to say, the main text should be in the center of a piece, occupying a commanding position. The inscriptions, smaller in character size, are written on the sides. For beginners, it is always a good idea to make a rough sketch to lay out the content, the style of writing, the number of characters in each line, the size and positioning of each character, the arrangement of the supporting text, and so forth. Sometimes, alternative plans or sketches are necessary before a final decision is made.

MAIN TEXT

For beginners, the easiest way to assemble a calligraphy piece is to find the characters you want to write in a model. Make sure all the characters in the main text are in the same style. For example, you can choose the Yan Style or the Liu Style, but do not mix them even though they are both in the Regular Script. When you have the model characters at hand, practice writing them by following the model precisely, adjusting the size if needed. When you are ready, assemble the characters to form the main text.

When planning the main text, ample space should be left on all sides, including the space that will remain unfilled. Do not forget to plan the space for inscriptions and seal(s) at the same time. No matter what style and script you choose, there should be breathing space both within and around each character. Spaces are not simply blank; they provide balance and background for the characters. The direction of your writing will be vertical, from top to bottom. Multiple columns should be arranged from right to left. A single line with a horizontal arrangement also goes from right to left. No punctuation marks should be included anywhere in a piece.

Text arrangement is determined by the style of writing. In the traditional styles (Small Seal, Clerical, and Regular), main text characters on the same piece are usually written in a uniform size and evenly spaced. Note that the distance between columns may be the same as or different from the distance between characters in the same column (see Figure 12.4 above). For pieces with multiple columns, there are two options. You can choose to line up characters in both columns and rows, which will place the center of the characters on a straight line both horizontally and vertically. This can be seen in Figure 12.1, 12.3, and 12.4 above. Or, you can line up the characters only vertically in columns. This is shown in Figure 12.2 above and Figure 12.6 below.

In Running and Cursive styles, both the size of characters and the space between them may vary. If you use multiple columns, there should be interplay between them; an extended stroke in one column should be paired with a skillful dodge in the adjacent column. Similarly, a character that is small or light may be compensated by another one that is large or heavy. Interplay of this kind can take place between

FIGURE 12.6. Five-syllable verse in Running Script by Harrison Xinshi Tu (Tu Xinshi) (contemporary), an artist residing in the Colorado area. Inscriptions: 甲申 (*jiǎshēn*, i.e., 2004) 秋 (*qiū*, "autumn") 新时 (Xīnshí, [signature]) 书 (shū, "write"). [REPRODUCED BY PERMISSION FROM THE CALLIGRAPHER]

FIGURE 12.7. Seven-syllable verse by Wu Ju of the Song dynasty (960–1279). Collection of the National Palace Museum (Taipei). [FROM MASTER-PIECES OF CHINESE CALLIGRAPHY IN THE NATIONAL PALACE MUSEUM, P. 9. REPRODUCED BY PERMISSION FROM THE NATIONAL PALACE MUSEUM]

characters in different columns, in different parts of the text, or even at the beginning and the end of the main text, as well as between consecutive characters in the same column. When a character appears more than once in the same piece, it should be written differently each time. The character 橋 *qiáo*, "bridge," in Figure 12.7 is an example: the first character in the first column (from the right) and the fifth character in the second column are written in different ways. Such coordination will largely determine the overall quality and impact of the piece.

Despite various conventions and guidelines for the approximate placement of characters, columns, and inscriptions, in practice, the best presentation is mainly measured by eye and determined by experience. Learners need to make keen observations in order to develop intuition. Generally speaking, the larger the number of characters, the more factors such as style, composition, and balancing of characters will be involved; the fewer the characters, the more significant the role of each character will be. A piece with a single character as the main text, 福 *fú*, "blessings," 龍 *lóng*, "dragon," or 壽 *shòu*, "longevity," for example, is like a solo performer onstage—the center of everyone's attention.

INSCRIPTIONS

Inscriptions are supporting or explanatory texts that supplement the main text. Although written in smaller characters and placed in a noncentral position, they form an integral and indispensable part of a piece. They should create a coherent whole with the main text rather than hang on the edge of the paper. Inscriptions usually consist of specific parts in a particular order: (1) the time or date that the work was done, (2) the name of the artist, and (3) a location.

The shortest inscription may include only one of these parts, usually the name of the artist. Occasionally, however, one may see a piece with no inscription at all, such as Figure 12.7. Long inscriptions may include the age of the artist (in case the person is exceptionally young or old), an explanation of why the work was done, or even reflections on the main text. Inscriptions are normally placed to the left of the main text (that is, at the end of the piece), near the lower portion. The length of an inscription depends on the length of the main text and the available space. Because of their supporting nature, inscriptions should never overwhelm the main text by length or by character size.

The style of the inscriptions can be the same as the main text or from a later period. For example, if the main text is in Clerical Script, the inscriptions could be in Regular or Running style (Running Style would be the most common). The size of the characters should be smaller and more fluid than the main text. These niceties will create contrast and balance between your main and supporting texts, between large and small characters, and between stylistic stillness and fluidity. In Figure 12.8 below, for example, the main text is in Clerical Script, while the inscriptions are

in Running Style. The last line of the inscriptions reads: 辛巳 (*xīnsì*, i.e., 2001) 冬 (*dōng*, winter) 新时 (*xīnshí*, [signature]) 书 (*shū*, write).

Date

For dating a Chinese calligraphy piece, preference is given to the traditional Chinese calendar terms. Often only the year in the stem-branch term (for example, 戊子 *wùzǐ* for 2008; see Figure 9.14) is recorded followed by an optional month or season, such as 春 *chūn*, "spring," 夏 *xià*, "summer," 秋 *qiū*, "autumn," or 冬 *dōng*, "winter." The exact day is usually left out.

Similarly, the month is also determined according to the Chinese calendar. The third column in Table 12.1 shows some commonly used traditional Chinese terms for months. Note that, generally speaking, the Chinese lunar calendar differs from the Western calendar by about a month; a Chinese year usually starts around early February.

FIGURE 12.8. Quote from the *Yi jing* by Harrison Xinshi Tu (contemporary). Main text in Clerical Script and inscriptions in Running Style. [REPRODUCED BY PERMISSION FROM THE CALLIGRAPHER]

TABLE 12.1. Months in Chinese

ENGLISH	CHINESE	TRADITIONAL TERMS
first month	一月	正月、孟春
second month	二月	仲春、杏月
third month	三月	季春、桃月
fourth month	四月	梅月
fifth month	五月	榴月
sixth month	六月	荷月
seventh month	七月	蘭月
eighth month	八月	桂月
ninth month	九月	菊月
tenth month	十月	良月
eleventh month	十一月	冬月
twelfth month	十二月	臘月

The piece in Figure 12.9 shows the typical way to date a piece: 壬午 (*rénwǔ*, i.e., 2002) 十月 (*shíyuè*, the tenth month) 毛戎 (Máo Róng, [signature]). Alternatively, the year may be represented using Western calendar terms, with the year first, followed by the month. For example: 二〇〇二 年 十 月 (2 0 0 2 year tenth month, or October 2002).

Signature

A piece of work can be signed with the artist's full name, the given name only, a pen name, or a nickname, depending on the purpose and formality of the piece. The name of the author can be followed by an optional character 書 (or 书) *shū*, "written," as in "written by so-and-so."

Location

The place where the work is done is recorded following the principle of most general to more and more specific units. Be as brief as possible and use authentic

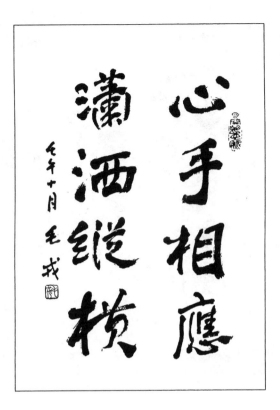

Figure 12.9. Running script by Mao Rong (contemporary), an artist in the Washington, DC, area. Main text (from the right column to the left): "Mind and hand in concert, refined strokes with great ease." [REPRODUCED BY PERMISSION FROM THE CALLIGRAPHER]

place-names if you can. In Figure 12.10, the inscriptions include 歲在癸未, "in the year of *guǐwèi* [2003]"; 新时, "Xīnshí [signature]"; 书於北美, "written in North America."

Name of Recipient

When a piece is written as a gift, the recipient's name may also be included. Note that the surname of the recipient is usually left out unless the given name has only one character. The name should be accompanied by an appropriate title, such as 先生 *xiānsheng*, "mister," or 伉儷 *kànglì*, "married couple," and a courtesy expression such as 雅正 *yǎzhèng*, "please kindly point out my inadequacies," or 指正 *zhǐzhèng*, "please give me your valuable comments." The recipient's name could be put at the beginning of a piece before the main text or after the main text as the first part of the inscriptions. In China, exchanging calligraphy and painting is considered an

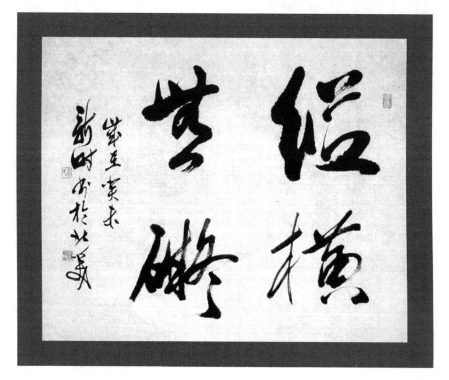

FIGURE **12.10.** Running Style by Harrison Xinshi Tu (contemporary). Main text: "Gallop without boundaries." [REPRODUCED BY PERMISSION FROM THE CALLIGRAPHER]

elegant habit; it is also a common way to make friends and connections. Even when a piece is written for sale, the buyer will often request that his or her name be put on the work.

The piece in Figure 12.11 is a couplet by the well-known calligrapher Wú Chāngshuò 吳昌碩 of the Qing dynasty. It was written as a gift to a person with the given name of 玉泉 Yùquán, which appears first on the inscription line on the right. The date, which appears last on the same line, is 甲寅 jiǎyín (i.e., 1914), 六月 liùyuè, "the sixth month," while the signature is on the left.

THE SEAL

Putting a seal (or seals) onto a piece completes the work. It is the last yet very important step. The red seals create a sharp contrast on the black and white background. By adding color and balance to the work, they lighten up the entire piece and enhance the aesthetic value of the artistic creation.

The name seal of the artist, usually square, is put under the signature of the author, with a space of about one character in between. Alternatively, the seal could be

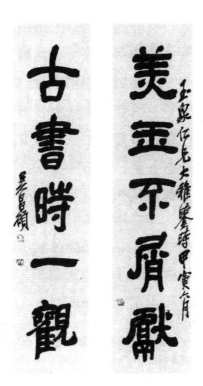

FIGURE 12.11. Couplets by Wu Changshuo of
the Qing dynasty. [FROM FANG, LISHU SHIJIANG, P. 17,
WHERE NO INDICATION OF SOURCE IS GIVEN]

put on the left side of the author's name, depending on the layout of the piece and
the available space. Two seals may be used instead of one, but in this case one should
be a white-character seal (intaglio) and the other red (relief). The seal(s) should be
about the same size as, or slightly smaller than, the characters in the inscriptions. In
addition to the name seal, an optional leisure seal might be put at the beginning of
the main text, to the right of the first two characters (see Figures 12.1, 12.5, 12.6,
12.8, 12.9, and 12.10 above). The leisure seal can be rectangular, round, oval, or
another shape. The content of the leisure seal could be name of the study, a motto,
or a well-known saying. Note that the same seal cannot be used more than once on
the same piece of work.

Although seals are made in many different sizes and shapes, with characters in
various scripts, a combination of red and white is always used for the actual stamps.
To get a seal to show up properly on a piece of paper, follow this procedure:

1. First press the seal into a red ink pad and make sure the
ink has been applied to the entire seal surface.

2. Check to make sure the seal is oriented correctly by look-

ing at the characters on it. This is very important. A mis-imprint of a seal ruins an artwork or cancels the validity of a document.

3. Check to make sure the paper you are going to put the stamp on has at least a few sheets of paper underneath to serve as a cushion. Particularly if the surface underneath the paper is hard, add a few sheets of paper. This will increase the clarity of the seal imprint.

4. Carefully press the seal onto the paper, distributing the pressure evenly.

In general, the writing of a piece should be done in one sitting to avoid losing continuity and coherence. The amount of supporting text, the size of the characters, their location, and their layout should be determined in accordance with the design of the entire piece so that it forms a coherent part of the whole. After the main text is completed, pause to take an overall look at the piece to see how much space is left. Then you can make decisions about the inscriptions and the position of the seal or seals.

Artistically, inscriptions are as important as the main text and should be treated with the same care. In fact, inscriptions can be used to adjust the balance and increase the overall quality of a piece. They tell a great deal about the compositional skills and the overall artistic attainment of the artist. A mistake made in the inscriptions will spoil the piece just as mistakes in the main text do.

The piece in Figure 12.12 is a quotation from the *I Ching* by Harrison Xinshi Tu. It shows a modern style in which two script styles are mixed and are written in different colors. The two characters in the upper part are in Clerical Script and in red, while the text in the lower portion is in Running Script and in black. No inscriptions other than the two seals are included.

The compositional principles of calligraphy not only focus on its linear quality, but also reflect elements that are universal to all art forms: balance, symmetry, tension, harmony, and proportion. Calligraphic characters should complement with one another with no harshness or discord. The main principle of good balance and poise is similar to that of a figure standing, walking, dancing, or executing other lively movements in coordination with other figures—the entire piece should display an elegant air and a refined appearance. In addition, contrasts of opposites are in full play: forward and backward, rising and falling, strong and weak, sparse and crowded, confrontational and yielding.

CHINESE CULTURE (5): CHINESE SEALS

Generally speaking, seals are used to affix a stamp onto documents or other items of importance to establish authorship or ownership. They work well as a form of identification because they are difficult to forge and only the owner has access to

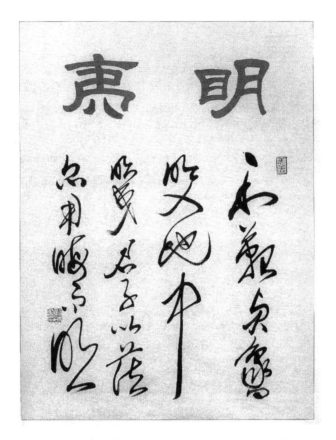

FIGURE 12.12. Quotation from The *I Ching* (*Yi jing*) by Harrison Xinshi Tu (contemporary). [REPRODUCED BY PERMISSION FROM THE CALLIGRAPHER]

his or her personal seal. Seals are used all over the world, but they are especially important to the Chinese. Seals in China have traditionally been considered more officially binding than signatures, and therefore they are much more widely used than in the West for government, business, and private matters. No document is official without the stamp of a red seal. In addition, the important role of seals in Chinese artworks such as calligraphy and painting is unrivaled by anything in other parts of the world.

SEALS FOR GENERAL USE

Chinese seals have been a part of the nation's history since its early days. Some people maintain that a yellow dragon with a chart on its back gave the first seal to the Yellow Emperor (ca. 2600 BCE). Others say that a phoenix gave it to Emperor Yao (ca. 2300 BCE) while he was sitting in a boat. Both accounts are simply legends. The earliest forms of seals date back to the Shang dynasty (1700 BCE–1100 BCE). They

were discovered at the same site as the Shell and Bone Script.[1] At that time, seals were simply shaped and featured crude pictographic characters or decorative patterns, most likely representing clan names. Early seals were used mainly for security purposes, for example, when government documents were transferred between two locations. Before the invention of paper, important documents written on bamboo or wooden slats were transported inside a hollow wooden trough sealed with mud at both ends or with plaques bound with cords. A seal was sometimes pressed into the mud or clay, imprinting its image onto the surface. A broken seal would make it obvious that the document had been read or tampered with while traveling to its recipient. It would also furnish proof of the sender's identity. These stamps were much deeper than the seals used today so they could penetrate far enough into the mud to leave an impression (Figure 12.13).

After the Qin dynasty, seals used by the emperor were given a special name, 璽 xǐ. These large, square imperial seals were often made of jade. Imperial seals served many functions. They were symbols of power, authority, and approval. Emperors also used them to appraise and appreciate art; paintings and calligraphy acquired by emperors were affixed with their imperial seals. Thus, many famous paintings from the Forbidden City, for example, bear the seals of generations of subsequent emperors. (See Figures 12.14 and 12.15.)

Official seals used at lower levels of government, called 印 yìn, were issued or revoked when appointments or removals of official titles were announced. From the central government to the local government, officials could be identified by grade according to the seals they possessed. For many centuries, seals were a symbol of power used only for official purposes.

Seals are still used daily in China at various levels of government. Modern official seals are usually circular instead of the traditional square shape. Less elaborate than personal stamps, they are engraved with the name of the governmental organization arranged in a semicircle, with a star in the center. The characters are usually in the script called Song Style (see Figure 12.16), which is also used for printing books, newspapers, and magazines. Official documents always bear such a red seal to indicate authenticity and government approval. Documents such as proposals and applications that need approval from numerous levels of government travel from office to office, collecting a new stamp at each place.

Seals, when stamped in red ink, are legally binding in business matters. Most people possess a personal name seal to use when opening a bank account, making business transactions, or collecting parcels or registered mail in a post office. However, very recently the use of seals in legal matters in a modern society has begun to be questioned. Today, personal identification may include a handwritten signature and/or a seal imprint.

Figure 12.17 below shows the logo of the 2008 Beijing Olympic Games, in which a seal design is used as a national symbol of China.

FIGURE 12.13. Mud seal from the the Qin dynasty (221–206 BCE). [FROM ZHU, ZHUANSHU SHIJIANG, P. 84, WHERE NO INDICATION OF SOURCE IS GIVEN]

FIGURE 12.14. Emperor's seal (left: imprint; right: intaglio).

FIGURE 12.15. Seal (relief) of the Empress Dowager (Ci Xi, 1835–1908) of the Qing dynasty. [FROM NAN AND JI, LONG ZHI WU, WHERE NO INDICATION OF SOURCE IS GIVEN]

FIGURE **12.16.** Official seals of modern China. Reading clockwise: Beijing University (left); China Medical University (right).

FIGURE **12.17.** Logo of the 2008 Beijing Summer Olympic Games with a seal design.

SEALS FOR CALLIGRAPHY

The Chinese practice of affixing a seal on artworks such as calligraphy and painting started around the Song and Yuan dynasties (960–1368).[2] It has been mentioned that a seal not only establishes authorship, but also provides balance to the composition and adds interest by virtue of its own value as an artistic creation. Seals are so important in Chinese art that they are referred to as the "eyes of the artwork." A

piece of art without a seal is like a face without eyes. Artists, collectors, and intellectuals possess full sets of various kinds of seals. There are three types of seals for calligraphy: name seals, leisure seals, and studio seals.

Name seals are seals that bear a person's real name or pen (brush) name(s). They are usually square with characters in Seal Script. They can be used on artworks alongside the signature of the artist or simply by themselves (see Figure 12.18).

Leisure seals can appear in many shapes. They may bear a short inscription of a well-known quotation or a motto dear to their owner. Some typical examples are "Respect fate," "Attain wisdom," "Open-minded," and so on. Leisure seals are chosen for their size, shape, content, and what is needed to create a pleasing composition. Serious painters and calligraphers may own several dozen or even hundreds of leisure seals. Qi Baishi (1863–1957), a well-known painter and calligrapher, took the brush name "The Three-Hundred-Stone Millionaire" (三百石富翁) in honor of his collection of seals.

Studio seals contain the name of an artist's private studio. They are usually rectangular and can be used just about anywhere in a piece of artwork, for balance (see Figure 12.19).

In addition to these three types of seals, one often sees collector seals on artworks. Collector seals are mainly used for authenticating pieces of art. A seal of a famous collector or connoisseur can substantially raise the value of a piece. Thus, it is not uncommon to see Chinese calligraphy and paintings covered with dozens of different seals that have been affixed over the course of several centuries.

SEAL ENGRAVING

Seal carving is an art in and of itself. Carvers must be skillful in three specific areas: calligraphy, composition, and handiwork. The engraver today must be proficient in the ancient Seal Script in order to design a seal. He or she must also be skillful enough to shape a number of characters into a small space to achieve a vigorous or graceful effect in perfect balance. Familiarity with the various seal materials is another requirement, so that the right exertion, technique, and rhythm are applied with the cutting knife. Every seal is unique; the material and character style can be chosen to match the personality of the owner. For these reasons, engravers are considered artists. Some famous calligraphers are also known for their engraving abilities.

Seals are made in a variety of materials, including wood, metal, stone, glass, bone, ceramic, and plastic. The most common material for calligraphy seals is stone that is soft enough to be carved but hard enough not to wear out. If the stone is too hard, it will resist the carver's knife and chip easily. Shoushan stone (壽山石 *shòushān shí*) from Fujian Province is the most famous stone for seals. It is known for its fine texture, multicolor hues, and carvability. Chicken blood stone (雞血石 *jīxiě shí*),

FIGURE **12.18**. Personal seal of Zhao Zhiqian
(1829–1884) (intaglio), Qing dynasty. Reading
counterclockwise starting from the top right: 趙
之謙印 (Zhao Zhiqian seal). [FROM ZHU, *ZHUANSHU
SHIJIANG*, P. 86, WHERE NO INDICATION OF SOURCE IS GIVEN]

FIGURE **12.19**. Studio seal of three characters (Pine-
Snow-Studio) by Zhao Mengfu (1254–1322) (relief),
Yuan Dynasty (1206–1368). 松雪 (pine-snow) is
Zhao's pen name. [FROM ZHU, *ZHUANSHU SHIJIANG*,
P. 85, WHERE NO INDICATION OF SOURCE IS GIVEN]

which gets its name from its appearance of being covered with randomly splashed
blood, is not as precious and expensive. But it does contain cinnabar (used to make
the red ink), which imparts a beautiful, unique look to each seal. Often seal knobs
have animal figures on top that represent the twelve Chinese zodiac signs. If you
select a piece of seal stone with an animal design on it as a gift, make sure the design
matches the recipient's animal sign.

There are two types of seal engravings: relief and intaglio. In relief engraving,
characters stand out from the background so that the stamp shows red characters
against a white background. This is also called a *yang* seal or *zhuwen*, "red-character,"
seal. In intaglio, the characters are carved into the face of the seal, creating white
characters on a red background. This is also called a *yin* or *baiwen*, "white-character,"
seal. Figures 12.14 to 12.19 show examples.

The characters engraved on the seal face can be of various script types, but Seal Script is the most common. Although seals vary in shape and size, four characters in the shape of a square, with one character in each corner, is very common—especially for name seals. When a personal name consists of three characters, an additional character 印 *yìn*, "seal," is often added to create balance. Usually, such a seal reads from top to bottom and from right to left. The seal in Figure 12.18, however, is an exception, which reflects another important balancing rule. In this seal comprising the four characters 趙之謙印, two of the characters (the first and the third) are much more complex than the other two. The normal arrangement would put the two complex characters on top and the two simple ones at the bottom, giving the seal a top-heavy look. In such cases, an adjustment can be made to present the characters in a counterclockwise arrangement in order to achieve a balanced structure.

When placing more than one seal onto a piece of calligraphy or painting, the imprint order is name seal, leisure seal, and then the studio seal. Because the number of seals and their placement affects the composition and balance of a piece, these matters must be judged carefully.

Seals, in the eyes of Chinese literati, have special aesthetic value. The quality of a seal depends on the quality, shape, and color of the stone; the design of its characters; the calligraphic style used; and the sculpted figures on top of the stone. In addition, characters and designs may be carved on the side of stones to increase their beauty. As a symbol of power, authority, and identification, Chinese seals have grown in variety and usage over the years. Although personal seals may not be as common today as they once were, they will always be an integral part of Chinese culture and society.

DISCUSSION QUESTIONS AND WRITING PRACTICE

1. Seal carving is an independent art form in China. How is it related to calligraphy?

2. Try your hand at making a personal stamp by using a piece of eraser:

 a. Cut a piece of eraser to the size you want.

 b. Place the eraser face down on a piece of paper and trace its outline.

 c. To design the words you want to show on the stamp, use a pencil to write the character or characters within the outline in the size and style you prefer. Make changes as you want.

 d. When you are ready, fill in the characters using a brush and ink.

 e. Before the ink dries, press the eraser firmly down onto the paper so that the ink on the surface of the eraser forms a mirror image of the design.

 f. Use a sharp knife to cut the surface of the eraser to make
either a relief or an intaglio stamp.

 3. Page 233 in Appendix 1 consists of three phrases, each with four characters arranged on a vertical line. Practice writing these phrases.

 4. On a blank sheet, write a piece with the text "Content is happiness" in the format shown on page 234 in Appendix 1. Put your signature and personal stamp on the inscription line.

···

The Yin and Yang
of Chinese Calligraphy

The fundamental philosophical principle of yin and yang is reflected in every aspect of Chinese calligraphy. This chapter introduces that principle. It also covers the appreciation of calligraphy works and the relationship of calligraphy and health.

DIVERSITY IN HARMONY

The study of Chinese calligraphy is not only a study of Chinese writing. In many ways, it is also a study of Chinese philosophy and the Chinese worldview. Aesthetic principles and standards are rooted in cultural and philosophical tenets, and Confucianism and Daoism form the basis of Chinese culture. Of the two Daoism has the stronger influence on art. It is no exaggeration to say that Daoism, from its place at the core of Chinese culture, is the spirit of Chinese art. Many characteristics of Chinese calligraphy reflect Daoist principles.

Dao literally means "way," the way of anything and everything in the universe. It is the way things come into being, the way they are organized, and the way they move about, each in its prescribed manner. Thus the notion of Dao can be understood as the overall organizing principle: everything has its own Dao; together, the

entire universe has the universal Dao. Any being, existence, motion, or force is a manifestation of Dao—hence its power.[1]

Studies of the development of cultures have found that the beginning of human cognition is marked by perceiving and categorizing things in the world as pairs of opposites, such as light and darkness, male and female, life and death, good and evil, sun and moon, old and young. Binary oppositions are a basic way by which ideas and concepts are structured. Claude Lévi-Strauss, the well-known anthropologist, observed that, from the very start, human visual perception has made use of binary oppositions such as up/down, high/low, and inside/outside; objects in the surrounding world, such as animals and trees, were also categorized based on a series of oppositions. Thus, from humankind's earliest days, these most basic concepts have been used for the perception and understanding of the world around us.[2] In modern times, the concept of binary thinking remains deeply ingrained in every aspect of daily life, from the design of electrical switches with on/off positions, to the yes/no questions we answer every day, to the digital principles behind the design of a computer.

The Chinese are no exception in this respect. To them, the world consists of and operates on two great powers that are opposing in nature: yin, similar to a negative force in Western terms; and yang, analogous to a positive one. These two concepts are represented in the Daoist symbol known as the Great Ultimate, shown in Figure 13.1. In this figure, the black part is yin and the white part is yang. Figure 13.2 shows what yin and yang each represent.

FIGURE 13.1. The Daoist symbol of the Great Ultimate.

As we can see, yin and yang are two poles between which all manifestation takes place. There is, however, a major difference in the Chinese view of these opposites from the metaphors of Western culture, in which oppositions are always in conflict. Light is at war with darkness, good with evil, the positive with the negative, and so forth; they are pitted against each other and compete with each other

陰 Yin	陽 Yang
雌 female of species	雄 male of species
夜 night	晝 day
黑 black	白 white
地 earth	天 sky
月 moon	日 sun
溼 wet	干 dry
軟 soft	硬 hard
小 small	大 big
…	…

FIGURE 13.2. The oppositions of yin and yang.

for dominance. In the Chinese view, by contrast, the two fundamentally different forces are not in opposition but in perfect harmony. They complement each other and come together to form a whole. This philosophy is illustrated by the Great Ultimate, which simultaneously represents duality and unity. One member is integral to the other and cannot exist without the other: such is the Daoist philosophy of the unity of opposites. The basic aim of Dao is attaining balance and harmony between the yin and the yang.[3] Because there cannot be yang without yin, and vice versa, the art of life is not seen as holding to one and banishing the other, but rather as keeping the two in balance.

The Chinese have emphasized such harmony since ancient times. To them, harmony has consistently been paired with diversity. Yin and yang are the two basic opposing forces in the universe, but they are not hostile toward each other. Their union is essential for creation; they also work together for the well-being of everything. Things are in a good state if there is a good balance of the two. Therefore, the Chinese concept of yin and yang is not a concept of oppositions, but rather one of polarity.

The Great Ultimate symbol also has the appearance of a spiral galaxy, implying that all living things are constantly in cyclic motion. The energy source causing the motion is understood to be the breath of Dao, called Qi, or "life force." For example, one may see yang as the sunny side of a mountain or as dawn, and yin as the shady side of a mountain or twilight. These phenomena may differ in appearance, but they are caused by the same energy source. As time progresses, yin becomes yang and yang becomes yin. Nothing stays the same all the time. By the same principle, all other things in the world—such as wars and wealth, births and deaths—come and go in everlasting cycles.[4]

DIALECTICS IN THE ART OF CALLIGRAPHY

The Daoist philosophy of yin and yang and the dialectic of diversity within unity have nurtured and fundamentally determined the character of the art of calligraphy.[5] The pure contrast of black writing on a white background is a perfect example. From classical calligraphy treatises to modern-day copy models, descriptions of the techniques of calligraphy are based on elaborations of a full range of contrasting concepts. Such concepts along with classical wisdom are the foundation of the aesthetics of Chinese calligraphy.[6] Jin Kaicheng and Wang Yuechuan, for example, list twenty pairs of opposing concepts to illustrate the aesthetic dimensions of Chinese calligraphic art, including square (方 fāng) versus round (圓 yuán), curved (曲 qū) versus straight (直 zhí), skillful (巧 qiǎo) versus awkward (拙 zhuó), elegant (雅 yǎ) versus unrefined (俗 sú), large (大 dà) versus small (小 xiǎo), guest (賓 bīn) versus host (主 zhǔ), and so forth.[7] In writing practice, the artist manipulates and elaborates on the balance between opposites, emphasizing diversity within parts and the harmony or unity of the whole.

The yin-yang philosophy and dialectics are so fundamental to Chinese thinking that they are reflected in the vocabulary of the language. In Chinese, a group of abstract nouns is formed by compounding two characters of opposite meanings; each of these nouns specifies a dimension of variation. For example, 輕重 qīngzhòng, literally "light-heavy," means "weight"; 疾徐 jíxú, literally "fast-slow," means "speed"; 長短 chángduǎn, "long-short," means "length," and so on. These nouns are frequently used to describe the techniques of calligraphy. Table 13.1 lists some of these words and the areas they can be used to describe. Note that many of these abstract nouns (which is in itself a contradictory term) do not have equivalents in English. Thus, in the table, the meaning of each individual character is used to indicate the intended dimension of variation. You will see that many of these abstract nouns denote aesthetic dimensions discussed earlier. Apparently, combining two words of opposite meaning is a typical way to coin abstract nouns in the Chinese language, but it is not a favored method of word formation in English.

In calligraphy, these contrasts may become the basis for artistic expression. The most fundamental ones, such as "lift-press" and "thick-thin," are used in virtually every step of writing. The identification of writing styles as wild, pretty, powerful, delicate, or elegant is often based on these concepts. For example, more rounded strokes are generally thought to constitute a graceful style, while squarer strokes are believed to suggest power and strength. Characters with concealed tips look more reserved, while those with more revealed tips are outgoing and more expressive. These words and concepts reveal the relationship of writing techniques and aesthetic values to Daoist philosophy. In writing practice, the contrast and unity of opposites in various dimensions create contour and rhythm of movement.

Rhythm in calligraphy refers to various effects such as dry and wet, or light

TABLE 13.1. Pairs of Opposing Concepts Used in Descriptions of Calligraphy

Stroke techniques	輕重	light-heavy	曲直	curved-straight	
	疾徐	fast-slow	方圓	square-round	
	收縱	retreating-confronting	藏露	hidden-revealed	
	粗細	thick-thin	長短	long-short	
	提按	lift-press			
Characters	向背	face-back	仰俯	upward-downward	
	增減	increasing-decreasing	欹正	biased-neutral	
	疏密	dispersed-compressed	肥瘦	fat-slender	
Composition	黑白	black-white	丑媚	ugly-beautiful	
	首尾	beginning-ending	鈍銳	blunt-sharp	
	抑揚	fall-rise	屈伸	bend-stretch	
	大小	large-small			
Ink	濃淡	dark-light	燥潤	dry-wet	
General	虛實	superficial-concrete	遠近	far-close	
	動靜	movement-tranquillity	剛柔	strong-gentle	
	雅俗	elegant-vulgar	巧拙	delightful-artificial	

and heavy, created by the contrasting techniques described in Table 13.1. When a piece of writing has rhythm and a harmonious combination of elements, it has an innate flowing vitality that is of primary importance to the artistic quality of a piece. Rhythmic vitality gives the piece life, spirit, vigor, and the power of expression. With it, a piece is alive; otherwise, it looks dead. The beauty of Chinese calligraphy is essentially the beauty of plastic movement, like the coordinated movements of a skillfully composed dance: impulse, momentum, momentary poise, and the interplay of active forces combine to form a balanced whole. The effect of rhythmic vitality rests on the writer's artistic mind as well as training in basic techniques and composition skills (see Figure 13.3).

Rhythm can be found in a single brush stroke, a character, or in an entire composition. How strong the rhythm is depends on the degree of contrasts and their intervals. Generally speaking, Running and Cursive styles have stronger rhythm than the more traditional scripts. This is why many artists favor these two styles. When a piece is created with the vital forces of life and rhythm, the result is fresh in spirit and pleasing to the eye.

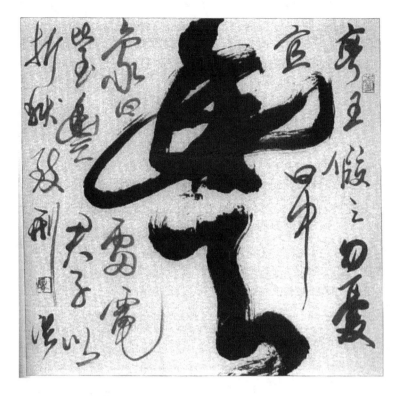

FIGURE 13.3. *Feng* by Tu Xinshi (contemporary).
[REPRODUCED BY PERMISSION FROM THE CALLIGRAPHER]

The Daoist principle of yin and yang represents a dynamic view of the world. Only when yin and yang are in perfect harmony can the life force travel smoothly and exert its vigor. Without the Daoist principle of diversity in harmony, there would be no Chinese calligraphy. Chinese calligraphy is often likened to Chinese Zen in that it does not lend itself very well to words and can only be experienced and perceived through the senses.

The way of calligraphy and the way of nature, although differ in scope, share similar principles. Calligraphy best illustrates Daoist philosophy when the brush embodies, expresses, and magnifies the power of the Dao. Thus, an adequate understanding of the concept of yin and yang and its manifestations in calligraphy, and how various techniques are implemented to create contrast and unity in writing, is essential to your grasp of the core of the art.

APPRECIATION OF CALLIGRAPHY

Beginning learners of calligraphy often ask, "What is good writing?" and "How can you tell?" Unfortunately, there are no simple answers to these questions. Chinese

calligraphy continues to hold a special position in art because of the strong aesthetic impact created by its layout, its space dynamics, its black and white contrast, the quality of its strokes, and its coordination of dots and lines. The evaluation of calligraphy has to take all these things into consideration. Below we will look at a general procedure for appreciating a calligraphy piece. This procedure is divided into stages that illustrate the dimensions in which calligraphy works may vary.

A good metaphor for the appreciation of a calligraphy piece is that it is like meeting a person for the first time: A general impression is formed first, followed by more detailed observations.

A general impression starts from first sight. This can usually be achieved fairly quickly. Aesthetic judgment at this point includes the identification of style. The viewer forms an initial impression: for example, the style of writing is wild, pretty, powerful, delicate, or elegant. Based on this impression, assumptions can be formed about the writer's personality, interests, and even morals. It is believed that, since calligraphy is a highly individualized art, writing offers a glimpse of the heart. In Chinese calligraphy, insight into the ability to gain the writer's personal traits is considered one area of aesthetic judgment.[8] Two pieces of writing may be equally good but convey different feelings. For example, Figure 13.4 is a piece written by Mi Fu (1051–1107) of the Song dynasty. It shows a style comprising angular characters with forceful turns and hooks. This is thought to be an indication of a strong and willful personality.

Figure 13.5, in comparison, is a piece written by Zhao Mengfu (1254–1322) of

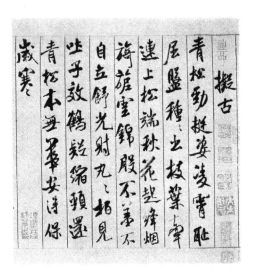

FIGURE **13.4.** Mi Fu's Running Style. Collection of the National Palace Museum (Taipei). [FROM MASTERPIECES OF CHINESE CALLIGRAPHY IN THE NATIONAL PALACE MUSEUM, P. 18. REPRODUCED BY PERMISSION FROM THE NATIONAL PALACE MUSEUM]

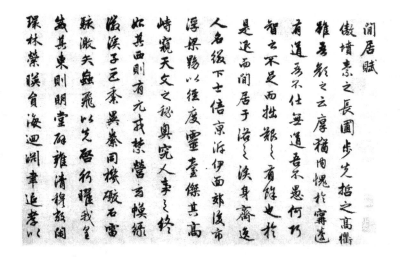

FIGURE 13.5. Zhao Mengfu's Running Style. Collection of the National Palace Museum (Taipei). [FROM MASTERPIECES OF CHINESE CALLIGRAPHY IN THE NATIONAL PALACE MUSEUM, P. 26. REPRODUCED BY PERMISSION FROM THE NATIONAL PALACE MUSEUM]

the Yuan dynasty. The style is more tactful, which is likely to indicate that the calligrapher was a more sophisticated and modest man.

When a learner chooses a certain style as a model, the choice itself may reveal, in addition to personal taste, that the learner and the writer of the model have similar personal traits. Listen to your heart when choosing a model. When following a model that you have a genuine liking for, you will be able to write better.

Overall composition and spatial arrangement also play a significant role in the initial impression. The main piece of writing must be well balanced by the placement of the seals, signature, and other elements written along the side. These elements are to complement, but not overwhelm, the main writing.

After the general impression, the viewer starts a closer examination of brushwork and character writing. This second stage focuses on the techniques of writing. Knowledge of Chinese scripts and calligraphy is required at this stage. The viewer observes what brush techniques are used when creating a particular style. Important qualities to look for include the strength of strokes and texture in writing. A natural movement of energy is the life force that makes a piece lively. The viewer will observe whether the lines flow naturally with rhythm and vitality, whether the characters are well balanced, and whether they cooperate with one another with no harshness or discord. While doing this, the viewer imagines how the writing was produced by the brush from the beginning to the end. This adds great interest and enjoyment to the process.

The third stage involves an evaluation of the content or the theme of writing,

its significance, and the atmosphere the piece produces. This evaluation includes not only the main text, but also inscriptions as well as the red seals and the suitability of script and style to the content of the work. From there, the viewer would go further to pursue a spiritual understanding of the work. This includes going beyond the form (the written lines) to understand the connotative meaning of the work and how the work connects or reveals aesthetic principles at a more abstract level. The viewer may also use imagination and association to create sympathy and response with the artist and the work at the spiritual level. Calligraphy is different from painting in that symbols of language are not direct physical images; they are abstract linguistic symbols that create meaning indirectly. The abstractness permits a great deal of potential in implication and interpretation.

As we can see, the three stages described above are at three distinct levels. The first stage can be achieved by the general public, with or without the knowledge of the Chinese language or calligraphy. It is like viewing a painting; a general impression can be formed without appealing to specialized knowledge. The second stage is more technical and artistic. If a piece receives a positive rating by a knowledgeable viewer at this stage, it is most likely good writing. The third stage moves beyond the technical details into the realm of imagery association and abstract thinking. The aesthetics of Chinese calligraphy typically emphasizes this area. Thus the appreciation at this level requires not only an artistic mind in both the viewer as well as the writer, but also solid background in Chinese culture, including philosophy, aesthetics, literature, and painting.

A piece of calligraphy is a piece of artwork. Whether there is communication between the artist and the viewer and how much communication there is depends not only on the quality of the work, but also on the knowledge of the viewer. The more a viewer knows about calligraphy, the more he or she will get out of a piece. Thus, as a learner, the best way to refine your taste is to acquire background knowledge, wide exposure to the classics and calligraphy works, and to practice brush writing constantly. When you know what to look for, it opens up an entirely new world.

CHINESE CALLIGRAPHY AND HEALTH

Chinese calligraphy is not only an enjoyment; it is also an effective way of keeping fit. In the Chinese way of life, cultivation is a goal that can be achieved through contemplation and concentration. Calligraphy is an ideal means to achieve this goal because it not only requires peace of mind and concentration, it also reinforces them during writing.

Calligraphy is a mental exercise. In modern society people live a busy life, overwrought and exhausted by worries, anxiety, job pressure, appointments, and responsibilities. Various stresses cause the human body to release hormones that produce physiological responses such as shallow breathing and muscle tension. This stress,

in turn, reinforces physically constricted conditions and perpetuates a vicious cycle. In Chinese medicine, it is believed that the seven major types of human emotions (joy, anger, melancholy, brooding, sorrow, fear, and shock) produce negative energy that accumulates in the body and causes disease. Suppressing emotions only makes things worse. Calligraphy is a moderate, healthy way to express emotions and release blocked energy. It provides a channel to disperse negative buildup in the body, breaking the cycle and helping the busy mind to quiet down.

In East Asia, calligraphy is also practiced to mold one's temperament and to cultivate one's mind. Even before writing starts, a writer typically initiates an effort to calm down by letting go of daily worries and concerns and cutting off interference from the outside world. During writing, the writer refrains from talking and concentrates on the task at hand. By so doing, he or she is able to project the characters in his or her mind accurately onto the paper through precise muscle and brush control. At the same time, the writing process also exerts a stabilizing influence on the writer's mind, resulting in an even more transcendent sense of peace and clarity of thought. Thus calligraphy is commonly recognized as an effective way to remove anxiety and discover calmness and emotional grace. This is why in East Asian films scenes of calligraphy writing are often shown while the protagonists are making important decisions.

Calligraphy is also a light, soothing form of physical exercise, very different from strenuous workouts such as running or weight lifting. Writing involves almost every part of the body, from the fingers and shoulders to the back muscles and the muscles involved in breathing. Similar to Taiji, calligraphy is based on a typical Chinese philosophy that emphasizes moderation and detachment. Through slow, moderate movements, the energy generated in the lower chakras passes through the writer's back, shoulders, arms, wrists, palms, and fingers, onward to the brush tip and, finally, is projected onto the paper. This process encourages a balance between the brain's arousal and control mechanisms, increases blood circulation and the vitality of blood cells, and thereby slows aging.

The function of calligraphy as a way to keep fit has a physiological basis. Because the writing brush has a soft tip, its control requires more attention, vigilance, and accuracy than any other writing tool. Carelessness or interference from the surrounding environment will affect the quality of writing; therefore, control over any possible interference, including natural bodily rhythms such as breathing and the heartbeat, is crucial to creating optimal conditions for writing. Theories of calligraphy never fail to emphasize the importance of calming down before writing, concentration, and breath control as the brush moves across the paper.

Physiological analysis indicates that the high degree of concentration required in brush writing causes significant changes in the writer's physical responses. For example, the initiation of writing is usually accompanied by a decrease in heart rate and lowered blood pressure. When a high degree of concentration is reached, the

heart rate significantly decelerates and blood pressure drops significantly.[9] These responses are similar to those created by meditation with one major difference: Meditation seeks tranquillity in a state of rest, whereas calligraphy seeks tranquillity in motion. This contrast is a perfect example of the Daoist principle of harmonizing opposites. When the body is relaxed in the motion of writing and the mind is at ease, the creative spirit takes flight into the formation and expression of beautiful ideas. This brings about a satisfaction and contentment of artistic creation that cannot be found in meditation.

The psychological and physiological activities that occur during calligraphy writing were noted by the Chinese as early as in the Tang dynasty. Prolonged practice of calligraphy can play a significant role in keeping one fit and improving one's health. This explains the well-known fact that, in traditional China, most calligraphers lived to an age well beyond the average life span. In contemporary China, with the upsurge in promoting traditional Chinese culture and public health, a new form of Chinese calligraphy has emerged, the so-called ground calligraphy mentioned in Chapter 1. This form of calligraphy is practiced early in the morning, in the fresh open air, mainly as physical exercise. Because its purpose is not to create art, it is done with simple instruments and the most basic writing material. It can also be done as a group activity, during which participants enjoy each other's company and exchange ideas and opinions about writing. Because of its gentle, moderate nature, ground writing is a physical exercise most popular among elderly retirees. As a way to keep fit for longevity, it is a new way in which the traditional art form has adapted to the modern era.

DISCUSSION QUESTIONS AND WRITING PRACTICE

1. Discuss the Chinese philosophy of yin and yang as you understand it and how it can be applied to different aspects of life.

2. How is the philosophy of yin and yang reflected in Chinese calligraphy?

3. It is said that Yan Zhenqing's style has a lot of yang in it, and the Slender Gold has a lot of yin. Do you agree? Discuss your view.

4. Explain how practicing Chinese calligraphy can be used as a way to keep fit.

5. Practice writing the characters on page 235 in Appendix 1.

6. Choose two of the three layout patterns on page 236 to write two pieces (using the same or different main text). Design your own inscriptions.

...

By Way of Conclusion

CHINESE CALLIGRAPHY
IN THE MODERN ERA

The word "modern" in this chapter denotes approximately the past one hundred years. During this time, modernization and globalization have become increasingly greater factors in the ways people experience everyday life, carry on traditions, and practice art. Vast economic, social, technological, cultural, and political changes have led to increased interdependence, integration, and interaction among people in disparate locations. In this context, Chinese calligraphy, similarly to other aspects of Chinese tradition, has changed and adapted.

In this chapter, we first look at the developments of Chinese calligraphy in modern China and its new life in the Western world. In the last section of this book, we discuss the challenges Chinese calligraphy faces in the new era.

MODERN DEVELOPMENTS IN CHINESE CALLIGRAPHY

One of the most fundamental characteristics of Chinese culture, which it shares to some degree with other Asian cultures, is its stability and resistance to forces of change from outside. Chinese calligraphy, as a defining feature of Chinese culture, is at the core of this stable structure. In previous chapters we have seen that

the development of calligraphy reached its peak in the Tang dynasty (618–907), with numerous masterpieces created by the greatest calligraphers in history. Also in the Tang dynasty, the development of the art entered a stable stage. For the next thousand years artists have practiced the art by imitating classic works, rearranging patterns, and adding personal touches to the existing scripts. No new calligraphic styles have been created.

In traditional China, the brush was used for daily writing. Every educated person wrote with a brush. Gradually, owing to the aesthetic features of Chinese writing, an artistic function developed that would eventually become the dominant function of brush writing. When China entered the twentieth century, modernization and Western influences began to show their impact. First, the adoption of hard-tipped pens from the West changed people's writing habits entirely; later also came TV, the Internet, and other freely accessible media. Chinese society, like the rest of the world, is becoming more and more commercialized and computerized. People favor readily available means of communication and entertainment, gradually losing patience and motivation to use the brush and to practice calligraphy. Since the 1980s, with political reform in China and the liberalization of political control, the stable structure of Chinese culture is experiencing a radical transformation. On this fast track of modernization, great changes have occurred in the area of calligraphy.[1]

Traditional art must adapt to changing times. While the practical, daily functions of brush writing are becoming obsolete, the artistic nature of calligraphy has supplied enough life force for it not only to survive but also to prosper in modern society. This renewed vigor has led to a number of new developments, including ground calligraphy. Here we will examine two additional areas in which new developments are taking place: hard-pen calligraphy and the Modernist and Avant-Garde movements.

HARD-PEN CALLIGRAPHY

Calligraphy can be roughly divided into two types: brush calligraphy and hard-pen calligraphy, which includes writing with any instrument other than a brush, for example, fountain pens and ballpoint pens. The two forms differ only in the instruments used. To produce artistic effects, hard pens for calligraphy may have a special design with a slanted rectangular tip. Future development of the art may lead to further innovations, such as writing with nylon soft pens and finger writing.

Hard-pen calligraphy apparently began in reaction to the adoption and fast spread of hard-tipped pens from the West. Hard pens were first imported into China in the early twentieth century along with Western notions of science and democracy. Because of their convenience, hard pens rapidly surpassed the brush as the major tool for daily writing. In the early 1950s, during the mass-education campaign, young

men wearing a fountain pen in the upper pocket of a Mao suit became a fashionable symbol of education.

Like any art form whose growth requires preparation, exploration, and fertile territory, writing with hard pens remained a convenience until the 1980s, when relaxed government policies led to a Chinese renaissance. While brush calligraphy thrived during this period, the time was also ripe for the development of hard-pen calligraphy. The convenience and popularity of hard pens together with the societal emphasis on writing paved the way. There was a nationwide upsurge of interest and public excitement quickly ignited. Books and writing models were published with soaring sales. *Fast Writing with a Fountain Pen*, for example, was one of the first books on hard-pen calligraphy. After its publication in 1978, 13 million copies were sold. Symposia, classes on TV, national contests, and exhibits, as well as newspaper articles and entire magazines, were devoted to the subject. In 1988 alone, more than sixty national contests were held, some of which attracted more than a million entries. The magazine *Chinese Fountain Pen Calligraphy* has a regular distribution of 400,000 copies. In 2003 a hard-pen calligraphy website called Chinese Hard Pen Calligraphy Online (http://www.yingbishufa.com), among dozens of competitors, attracted 60,000 hits per day. Hard-pen calligraphy has become a popular, versatile, and vital calligraphic form.

Building on this popularity, hard-pen calligraphy developed along the same route as brush calligraphy, from an initial practical function to more emphasis on principles and artistic features, and finally to the separation of practical writing from artistic production. The rules and principles of hard-pen calligraphy are similar to those of brush calligraphy, although reinterpretation of the principles and adjustments in application have been made for the difference in instrument. Hard-pen calligraphy can be written in the same major script styles: Seal, Clerical, Regular, Running, and Cursive. Regular Script produced in hard-pen calligraphy is subject to similar stroke techniques and has the same character structure as that described earlier in this book. As with brush writing, the learning of hard-pen calligraphy also starts with Regular Script, by first following the standards and rules precisely, and adding individuality later. Many hard-pen calligraphers nowadays write in the Yan Zhenqing or Ouyang Xun styles; those with high artistic achievements also develop personal styles based on Tang dynasty standards. (See Figure 14.1.)

Calligraphy, like fashion, reflects the trends of the times. Writing in the Qin and Han dynasties, for example, was characterized by classic elegance; that of the Jin dynasty featured graceful charm; the Tang emphasized principles; the Song and Yuan emphasized spirit and poise; and the Ming and Qing stressed unadorned artistic delight.[2] In Chapter 10, two styles within the Regular Script were discussed: the Yan Zhenqing Style, which was disposed to stone carving, and the Wang Xizhi Style, which was best viewed when handwritten on paper. Some artists try to reinterpret these traditions in hard-pen calligraphy by producing new styles that incor-

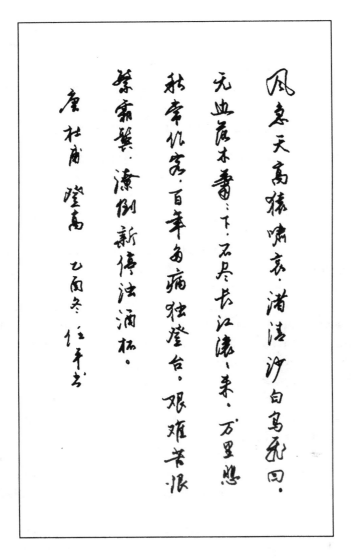

FIGURE 14.1. Hard-pen calligraphy by Ren Ping (contemporary), an artist in China. [REPRODUCED BY PERMISSION FROM THE CALLIGRAPHER]

porate both the grandeur of Yan and the grace of Wang. To overcome the built-in limitations of hard tips in artistic expression and the size of written characters, emphasis is given to innovations in writing instruments and their effects. Thus, from the initial fountain-pen calligraphy, forms of writing using ballpoint pens, pencils, chalk, wood, bamboo, and feather pens have been developed.

Despite these developments, hard-pen calligraphy, like brush calligraphy, is threatened. The fast spread of computers and the Internet is rapidly changing not only people's way of life and work, but also their way of writing. As technology

provides ever easier and faster character encoding methods and convenient ways of converting audio to text files, handwriting is rapidly losing ground to mouse and keyboard. This new, sweeping, modern-world trend brings excitement to some and worries to others for the future of the art of calligraphy.

THE MODERNIST AND AVANT-GARDE MOVEMENTS

The Modernist movement in calligraphy dates back only to 1985, shortly after China reopened its doors to the world and thus also to Western culture and ideas. In a provocative Beijing exhibit, which is often compared to the 1913 Armory Show that introduced Cubism to America, a group of young artists challenged and astonished viewers with a kind of calligraphy never before seen. These artists believed that in order for calligraphy to develop and remain relevant in modern China, rigorous traditional rules had to be broken to give way to new creative expression. While still conversant in traditional calligraphy, they departed from its canon by varying methods, materials, and scales. They also explored different media and techniques, such as reshaping Chinese characters, taking titular characters back to their pictographic origins, and mixing various writing styles on the same piece. While still using traditional instruments, they continue to apply innovative brush methods, ink methods, and treatment of paper for various effects. They handle Chinese characters in an unorthodox manner and often mix calligraphy with painting. Straddling the line between calligraphy and painting is the trademark of their work.[3]

The Modernist movement did not stop there. After the explorations of the 1980s, some Avant-Garde artists were ready to go even further. Drawing inspiration from the experimental calligraphers of Japan and Taiwan, the Abstract Expressionists of the 1950s and 1960s, and also from contemporary Western art, they began to take Chinese calligraphy in the directions of conceptualism and abstraction. Their work uses calligraphy techniques to create abstract symbols and images, some of which are based on the shape and structure of Chinese characters but carry no linguistic meaning. Western ideas and art have lit a fire beneath time-honored traditions, as these young artists have become the mainstream of the modern calligraphy movement.

The Avant-Garde artists contend that, in order to revitalize Chinese calligraphy, calligraphers in the modern world should participate in exchanges with the international art community. Chinese characters have isolated the traditional art from international recognition and have prevented those without knowledge of Chinese characters from gaining access to the art. Therefore, true modernization of the art, they contend, will not be possible unless it breaks away from the exclusive use of Chinese characters. Calligraphy, the Avant-Gardists argue, is the art of lines; it does not have to be the writing of Chinese characters. Therefore, in their work, readable Chinese characters are discarded. Brush strokes and ink are used to draw shapes without linguistic meaning.

While modern calligraphy does not communicate words, it does communicate emotion through shape, color, shade, and placement. New Calligraphers argue that this abstract level of emotion, precisely because it is beyond words, is in fact purer, truer, and deeper. The same driving principle lies behind many twentieth-century movements in Western art and literature, including Abstractionism, Cubism, and the fragmentism pioneered by painters like Picasso and Miró, and vers libre poetry like that of Gertrude Stein and e.e. cummings, all of which sought to evoke emotion via connotation rather than literal coherence or precise visual reproduction.

Modern calligraphers hold that their works have distinct Chinese characteristics. At the same time, they open a wide space for artistic expression and the possibility of connections with Western forms of modern art. Modern calligraphy also allows those who are unfamiliar with Chinese characters to participate in calligraphic appreciation and even the creation of calligraphy works. They argue that this is the most promising direction for the future development of Chinese calligraphy.[4]

It is no surprise that these trends have been strongly opposed by traditional Chinese artists. They argue that calligraphy is defined and universally recognized as writing and that writing in Chinese calligraphy consists of characters written in brushwork. The properties of brush-written characters as both an art form and linguistic units are the unique feature of Chinese calligraphy that distinguishes it from any other form of art. Any attempt to replace orthodox Chinese calligraphy with a character-free form would destroy it. It would also cause tremendous cultural disruption, depriving future generations of the chance to experience and appreciate this invaluable treasure of Chinese culture.

Chinese calligraphy is a symbol of Chinese culture and the soul of Chinese aesthetics.[5] It has become an integral part of Chinese history, philosophy, and the Chinese mentality. It is a mature art form, with aesthetic principles and an aesthetic spirit. Once the aesthetic spirit declines and the principles are lost, the life of the art is gravely threatened. The so-called New Calligraphy, the traditionalists contend, is like trees without roots and rivers without headwaters. The artistic value and the linguistic function of Chinese calligraphy are like the two sides of a coin. The coin cannot be sliced open without losing its value. An art form devoid of linguistic meaning is not calligraphy.

The works of the Avant-Garde calligraphers are referred to as "modern," "anticalligraphy," "noncalligraphy," "destruction of calligraphy," and "New Calligraphism." In a society that has kept calligraphy on a pedestal for so long, making it both an inextricable cultural centerpiece and an elitist symbol, the traditions and values of calligraphy are now being pulled apart and reexamined along with China's national and international identity.

CHINESE CALLIGRAPHY IN THE WEST

When the influence of Chinese calligraphy made its first marks on Western abstract painting in the early twentieth century, it sparked an international conversation about image, text, texture, and meaning in art that continues to this day. Some Western artists believe that Chinese calligraphy is the most ancient and most condensed of abstract art forms. It has the beauty of image in painting, dynamism in dance, and rhythm in music. Thus abstract art—the ultramodern art of the West— takes cognizance of the most ancient art—the calligraphy of the East—and establishes an intimate relationship between the two. Thus, although calligraphy's home is in China, it does not belong exclusively to China.

Wassily Kandinsky (1866–1944), one of the fathers of Abstract Expressionism, became famous for his attention to nonrepresentational forms and his distinct mixtures of dots, colors, lines, and textures. He and his fellow artists and theorists believed their art shared much with the tradition of Chinese calligraphy. They intellectualized their work with Chinese philosophies—just as Chinese artists would, decades later, also engage in cultural borrowing, intellectualizing their modernist and Avant-Garde work with Western philosophies. The use of lines of varied power, pressure, movement, and flow by artists such as Kandinsky and Willem de Kooning (1904–1997) was believed to be modeled after the Chinese Running and Cursive scripts. Many people also think that Franz Kline (1910–1962), whose best-known abstract expressionist paintings are in black and white, closely emulates Chinese calligraphy, although the artist himself may not acknowledge that connection.

Some world-renowned artists, such as Pablo Picasso (1881–1973), Henri Matisse (1869–1954), and Jackson Pollock (1912–1956), openly declared the influence of Chinese calligraphy on their works. In Matisse's paintings, the trained eye can perceive traces of calligraphy strokes. These are more clearly seen in some of his later mixed-media works that were largely done in ink. Some of Pollock's paintings also display the impact of the Cursive Script. Picasso once said: "Had I been born Chinese, I would have been a calligrapher, not a painter," acknowledging both the influence on his work and his reverence for calligraphy as a high art form.

In spite of this recognition and appreciation by several masters of Western art forms, Chinese calligraphy influenced the works of Western artists only in terms of the techniques they used in the production of lines. Traditional Chinese calligraphy, used to write Chinese characters, was never more fully incorporated into Western art. This situation has not changed even after World War II, when the Western world has become much more involved with East Asia.

The first formal exhibition dedicated to Chinese calligraphy in the United States is believed to have been held at the Philadelphia Museum of Fine Art in 1972.[6] In more recent years, with the opening of China and the introduction of Chinese art to the Western world, the art of Chinese calligraphy has found a new audience in

FIGURE 14.2. *Wu* (Void) by Harrison Xinshi Tu (contemporary). [REPRO-
DUCED BY PERMISSION FROM THE CALLIGRAPHER]

the West. You have already seen some works of these Chinese artists. Figure 14.2 is
a modern piece by Harrison Xinshi Tu.

Most of the major art centers, such as the British Museum in London and the
Smithsonian Institution in Washington, DC, now offer a respectable amount of
Chinese calligraphy on permanent display. Many calligraphy works, both traditional
and modern, can also be viewed on their (and other) websites. Some modern Chi-
nese calligraphers now live and work in the West, where they mix Western abstract
art with Chinese calligraphy and computer technology to create a universal visual
language for the new millennium and also express the contradictions and com-
plexities of multiculturalism. Not only is their art displayed across the globe, special
exhibits frequently showcase newer works as well. In its new contexts, Chinese cal-
ligraphy is proving applicable to a full range of expression, including that of modern
identity consciousness and politics.

Figure 14.3 below shows a work by Xu Bing, one of the most universally ac-
claimed expatriate Avant-Garde artists, who now lives in Brooklyn, New York. Xu

FIGURE 14.3. *Word Play* by Xu Bing (contemporary), an artist in New York. [REPRODUCED BY PERMISSION FROM THE CALLIGRAPHER]

Bing manipulates language in his art, bringing fresh understandings of the powerful role words play in our lives. In works such as *Word Play*, Xu Bing uses the instruments and techniques of Chinese brush writing to write English words. Such works challenge the preconceptions of written communication and reflect the complexities of cross-cultural communication. In 2002, *Word Play* featured in one of the first major exhibitions focusing on the work of a living Chinese artist in the Arthur M. Sackler Gallery in Washington, DC.

Abstract or modern calligraphy exhibitions are more successful in the West than exhibits of traditional works. Western viewers often state that because they are unable to read traditional Chinese calligraphy texts, they cannot fully appreciate the works. Some also say that cultural differences hinder their appreciation. The work of abstract calligraphers, often influenced greatly by Western abstract art without the involvement of Chinese characters, is usually more accessible to such viewers.

Whether or not the typical museum visitor is aware of the rationale and arguments behind New Calligraphism, the postmodern tendency toward unintelligibility has aided its reception in museums across the Western world. For the first time, Western viewers have not been handicapped in their appreciation of a piece simply because of their inability to read it as a text. Non-Chinese and Chinese alike are qualified to "read" a piece of New Calligraphic art.

Outside of high art, Chinese calligraphy is also entering the everyday life of non-Chinese populations. A simple trip to a local Wal-Mart or Target store may reveal examples of Chinese calligraphy in various forms, such as a set of napkin holders that feature brush-written characters for the elements (天 *tiān*, "sky," 地 *dì*, "earth," 風 *fēng*, "wind," 水 *shuǐ*, "water," 火 *huǒ*, "fire," 金 *jīn*, "gold"); framed posters or prints of individual characters such as 智 *zhì*, "wisdom," or 勇 *yǒng*, "courage," or more abstract notions such as 自由 *zìyóu*, "freedom," complete with their English translations written below; necklaces and bracelets displaying the characters 福 *fú*, "blessings," and 愛 *ài*, "love"; and men's and women's shirts emblazoned with Chinese characters in calligraphy. Apparently, designers have worked quickly to incorporate Chinese culture into their products to satisfy the interest and curiosity of Western consumers. They have taken what was once the idealistic center of China's art and united it with the ideals of Western art to create a completely different feel. Although it takes place within the familiar styles of Western popular art and fashion, this cross-pollination has played a large part in bringing Chinese art styles into mainstream Western life.

WHAT IS CHINESE CALLIGRAPHY?

A literal translation of 書法 *shū fǎ*, "Chinese calligraphy," was provided at the beginning of this book. Now, before closing it, we come back to the basic question of what is Chinese calligraphy.

Earlier in this chapter, we saw that modern calligraphy is an experimental form of modern art trying to respond to two of the questions facing Chinese calligraphy in the context of contemporary international culture: (1) How can it maintain indigenous Chinese characteristics; and (2) How can it participate in communication about modern art in the global community? The modernist movement in calligraphy that began in the 1980s soon became engaged in an inevitable, heated debate regarding whether it is possible to have an art called calligraphy in which no traditionally meaningful characters are written at all. Controversies continue to rage about the basic nature and definition of calligraphy.

A traditional definition of Chinese calligraphy is that it is the art of writing Chinese characters using a Chinese brush. This definition entails three basic features of Chinese calligraphy: its artistic nature, the writing of Chinese characters, and the use of a brush. By this definition, Chinese calligraphy is truly a visual art and yet not

only a visual art. Both its creation and its appraisal involve unique, profound connotations within the context of Chinese culture. It uses Chinese characters as the media of expression to write poems, lyrics, prose, and philosophical sayings. The literal content and the artistic, visual beauty complement each other. The perfect combination of the beauty of form and the beauty of content is the very reason the Chinese have been fascinated by the art for thousands of years.

By contrast, the definition promoted by the Avant-Garde movement is that calligraphy is the art of lines, and Chinese calligraphy is no exception. By this definition, calligraphy is deprived of its linguistic requirement and treated simply as one more form of visual art. Like painting, the Modernists contend, Chinese calligraphy was originally meant to create images that represent objects in the real world (by the use of pictographic symbols). But this bottom line has long been broken, first by the creation of individual nonpictographic symbols as early as in the Shell and Bone Script and then by an overall abstraction of the writing system through the Clerical transformation in the Han dynasty. The Modernist movement is taking calligraphy one step further in the direction of abstraction. If painting without representational images can still be painting, then calligraphy without readable characters can still be calligraphy. The Modernists maintain that questioning the illegibility of modern calligraphy is irrelevant because modern art, in general, increasingly blurs the line between different types of visual art.

Over more than two thousand years, until the 1980s, Chinese calligraphy and its practitioners did not interact with outside influences. Chinese and Western cultures were isolated from each other for so long that artistic exchange would have been unimaginable. Now as they meet and interact, we see more and more that calligraphy, a defining feature of Chinese culture and the greatest of the traditional Chinese arts, is more than just beautiful writing, as the word suggests. Instead, it is the embodiment of an entire art style. The dialogue between tradition and modernization and between East and West can be seen as healthy and energizing for its future development.

The Modernist movement does have deep concerns about the continued viability of the art. This anxiety is affirmed in the fact that the Modernist movement is not a hermetic or unidirectional progression; new concepts of all kinds continue to play a strong, catalyzing role in inspiring new techniques. At the same time, the new trends have not signaled the end of previous styles. All over China today, modern trends based on all traditional and classical script styles can be found.

The current debate on the future direction of Chinese calligraphy is essential to reestablishing its values and investigating its possibilities. While the new global era is bringing about new thinking and exploration, as well as modernizing Chinese calligraphy and involving it in contemporary art worldwide, it is difficult to imagine that Chinese calligraphy will either retain its traditional forms and meanings by rejecting new methods and ideas or carve out a new identity by discarding

its time-honored traditions. More likely, various factions and methods will learn to coexist peacefully, reinforcing each other under the Daoist principle of harmony with diversity.

DISCUSSION QUESTIONS AND WRITING PRACTICE

1. In China, the overwhelming majority of people use their right hand for writing. The percentage is much higher than in the rest of the world. Many "lefties" in China are "corrected" early in life to make sure they use their right hand to write. After reading this book and practicing calligraphy for a while, why do you think the Chinese insist that writing should be done with the right hand?

2. What is your view about discarding the writing of characters in Chinese calligraphy? What would you think about English calligraphy developing toward a wordless form of visual art?

3. Practice writing the characters for "Good fortune as you wish!" (See page 237.)

4. Write two pieces with different layout patterns, one of each on pages 236 and 238 in Appendix 1: "Let your aspirations soar" and "Good fortune as you wish!"

Brush Writing Exercises

Stroke Type 1: The Dot

1. Starting from the upper-left corner (1), press down at an angle of approximately 45 degrees so that the bottom of you brush reaches (2).
2. Move the head of the brush slightly toward you and downward so the bottom reaches (3).
3. Push the bristles slightly away from you, to launch the brush in an upward motion toward (4); gradually lift it off the pap

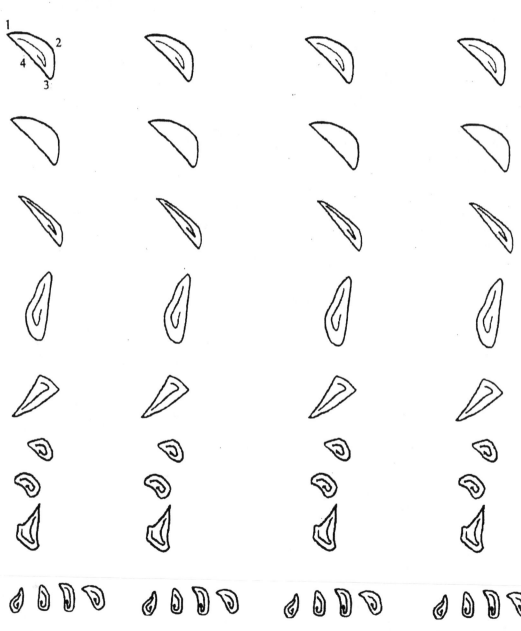

Stroke Type 2: The Horizontal Line

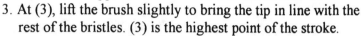

1. Press down at (1) at approximately a 45 degree angle (the same angle used in writing a dot). The tip of the brush remains at (1). Pause.
2. Slanting the brush handle slightly to the right, move the bristles rightward toward (2), gradually lifting them slightly as the brush approaches the middle of the stroke.
3. At (3), lift the brush slightly to bring the tip in line with the rest of the bristles. (3) is the highest point of the stroke.
4. Press down so that the thickest portion of the bristles reaches (4) at a 45-degree angle (the same angle you used for the first point). This is done without actually moving the brush downward on the paper; the tip of the brush stays at (3).
5. Turn the bristles to the left, gradually lifting them as they move toward (5).

For the horizontal strokes with concealed tips in the fourth to sixth rows below, see Chapter 4.

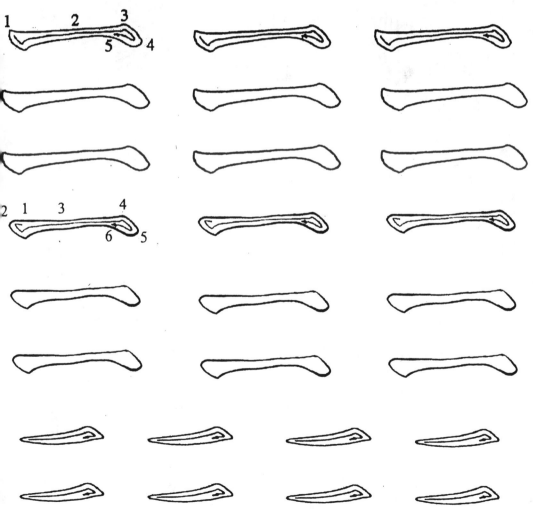

Stroke Type 3: The Vertical Line

1. Press down at (1) at a 45-degree angle so that the bottom of the brush reaches (2).
2. Start moving the brush downward.
3. At (3), bring up the brush and adjust the position of the tip so that it fills out the point.
4. Press down at a 45-degree angle so that the bottom of the brush reaches (4).
5. Move back up toward (5), gradually lifting the brush from the paper.

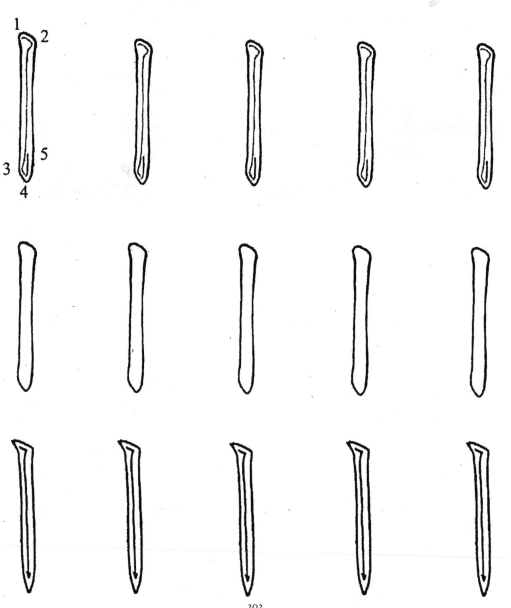

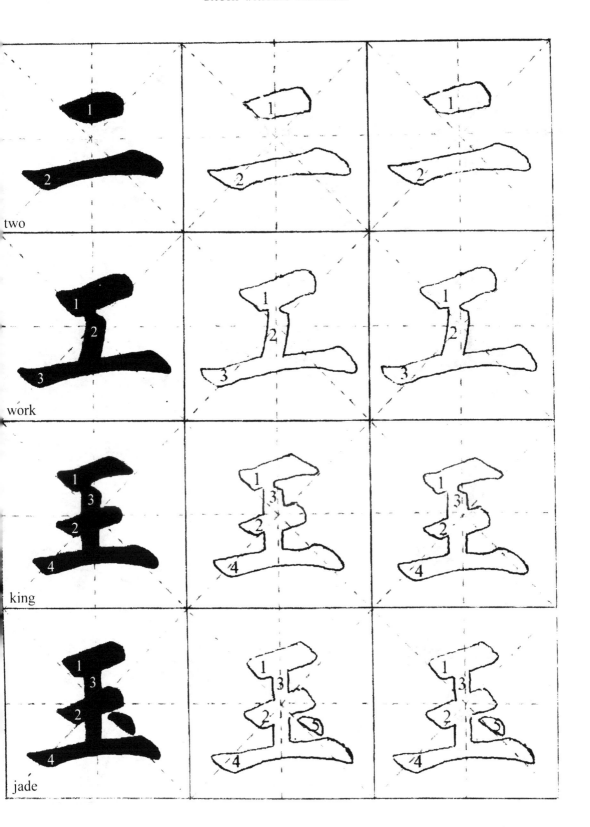

two

work

king

jade

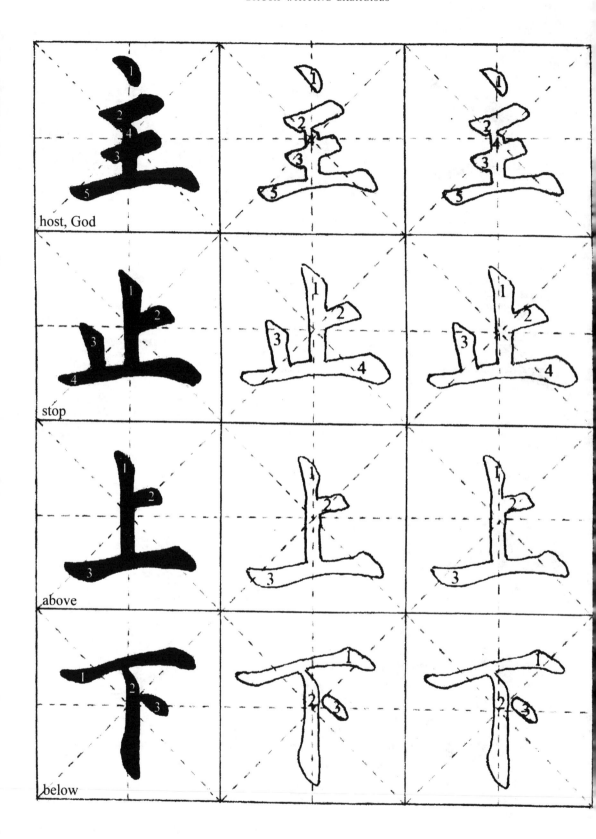

host, God

stop

above

below

For Chapter 4

Stroke Type 4: The Down-Left Slant

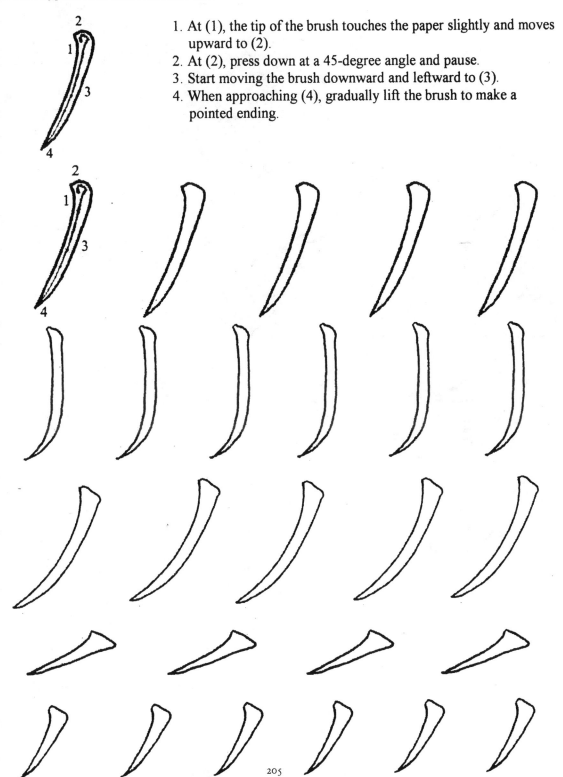

1. At (1), the tip of the brush touches the paper slightly and moves upward to (2).
2. At (2), press down at a 45-degree angle and pause.
3. Start moving the brush downward and leftward to (3).
4. When approaching (4), gradually lift the brush to make a pointed ending.

Stroke Type 5: The Down-Right Slant

1. Start lightly at (1), moving down and right toward (2) and gradually putting more pressure on the brush.
2. Press down hard at (3) and pause slightly.
3. Change the direction of the brush, now moving rightward toward (4) and gradually lifting the brush.
4. Make a pointed ending at (4).

Stroke Type 6: The Right-Up Tick

1. At (1), press down (with either a revealed or a concealed tip) and pause.
2. Start moving upward to the right (2), gradually lifting the brush.
3. Make a sharp ending at (3).

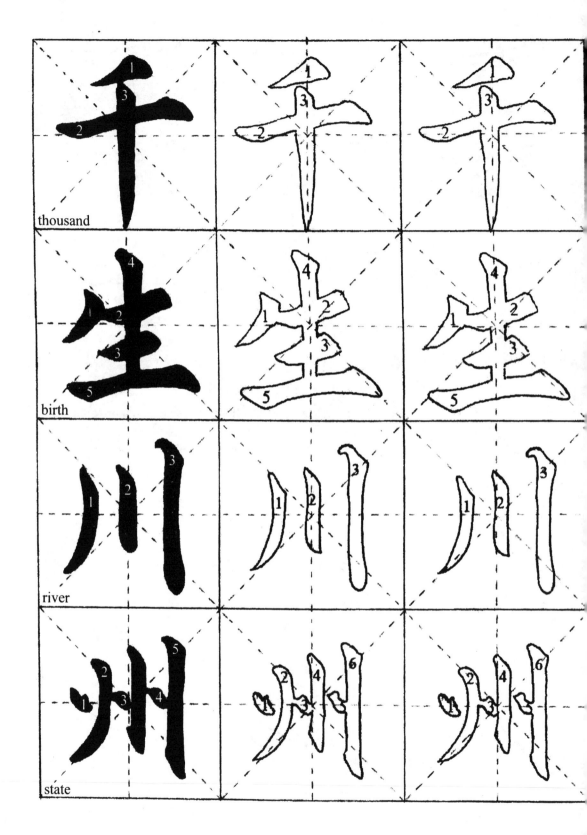

thousand

birth

river

state

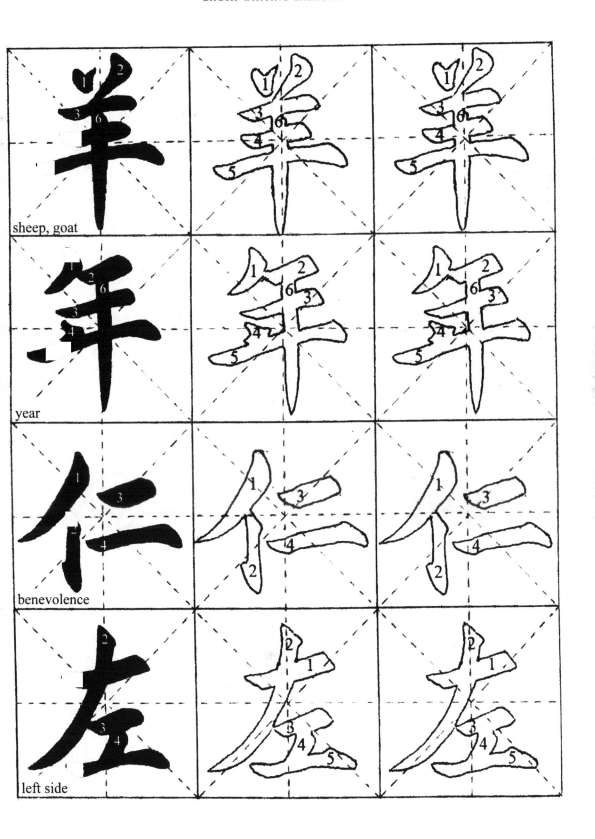

sheep, goat

year

benevolence

left side

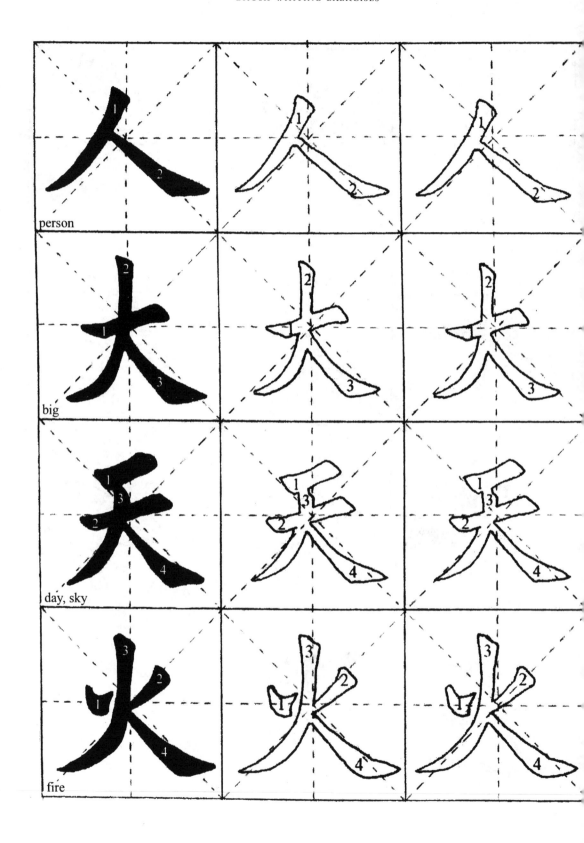

person

big

day, sky

fire

For Chapter 5

Stroke Type 7: The Turn

1. Starting from (1), press down and move to the right toward (2).
2. At (3), lift the brush slightly to bring the tip to the highest point of the stroke.
3. Press down at a 45-degree angle so that the bottom of the brush reaches (4); then pause. This is done to make the thick turning point. Be sure that the brush tip remains at (3).
4. Start moving down toward (5) and end the stroke.

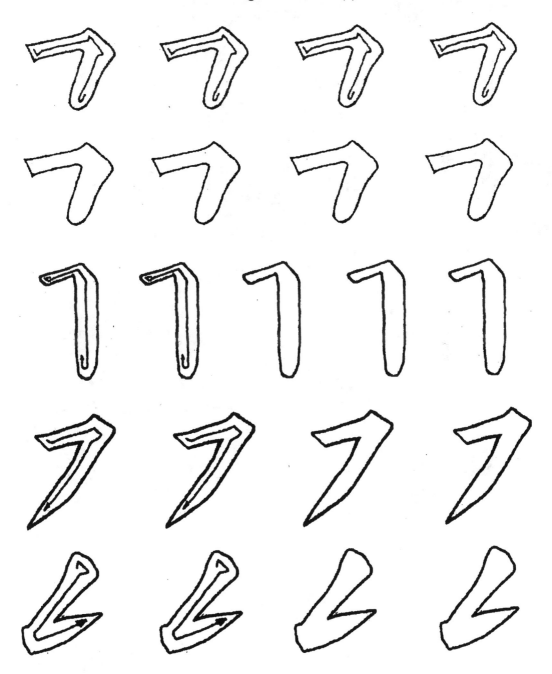

Stroke Type 8: The Hook

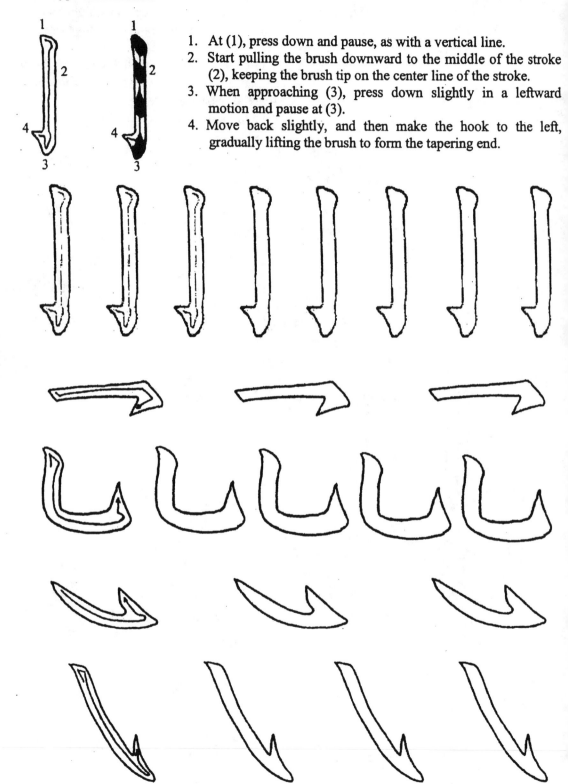

1. At (1), press down and pause, as with a vertical line.
2. Start pulling the brush downward to the middle of the stroke (2), keeping the brush tip on the center line of the stroke.
3. When approaching (3), press down slightly in a leftward motion and pause at (3).
4. Move back slightly, and then make the hook to the left, gradually lifting the brush to form the tapering end.

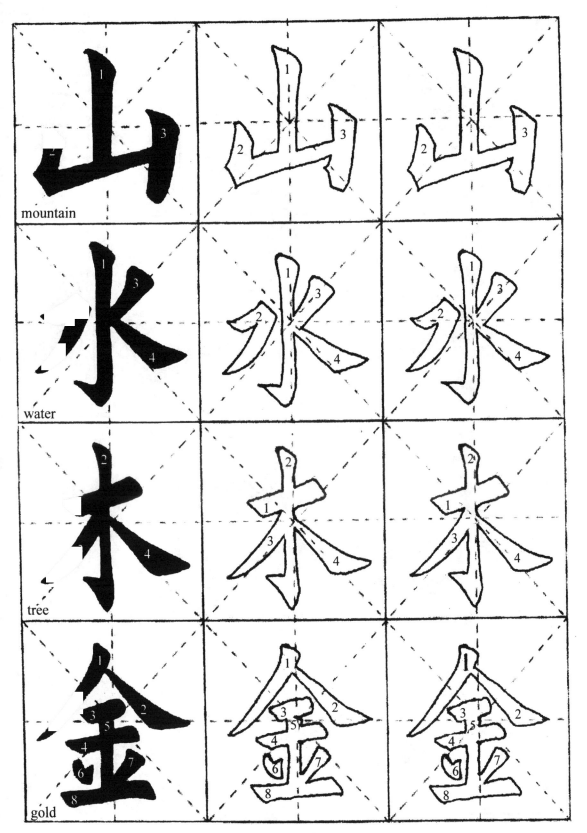

mountain

water

tree

gold

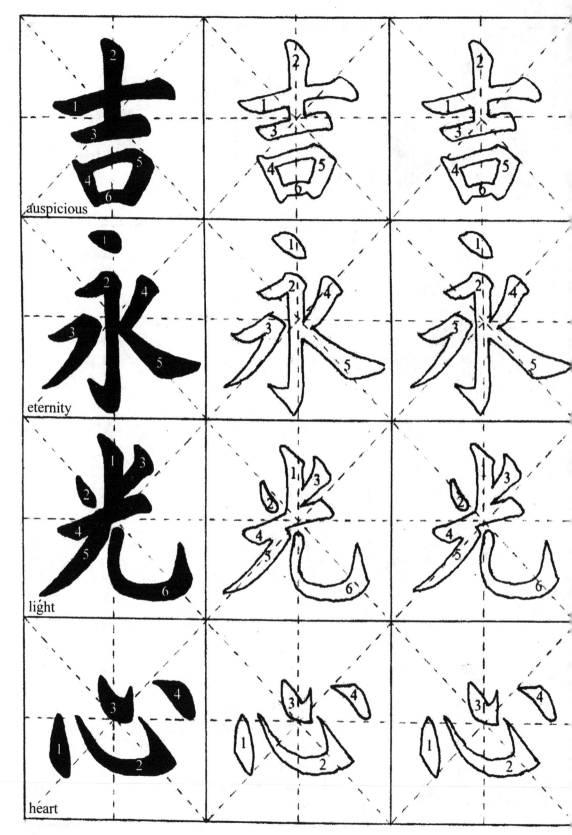

auspicious

eternity

light

heart

For Chapter 6

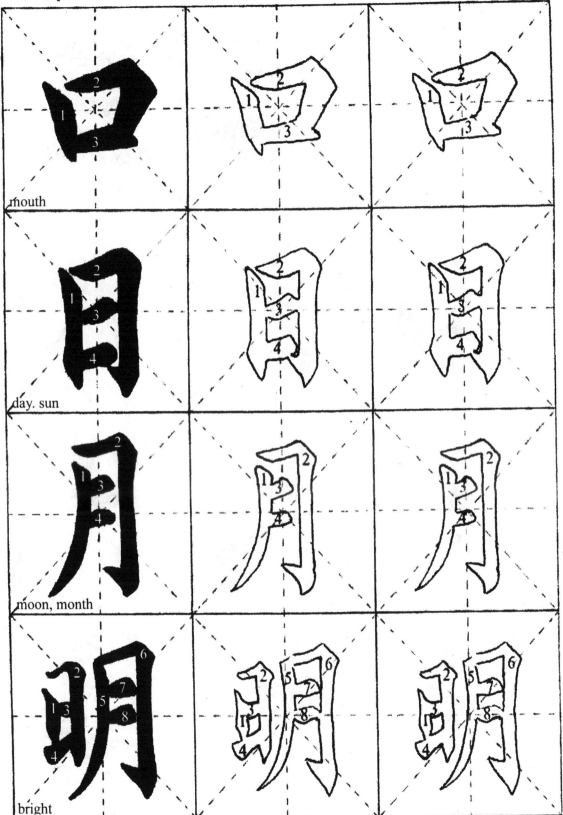

mouth

day. sun

moon, month

bright

one

two

three

four

five

six

seven

eight

nine

ten

year

write

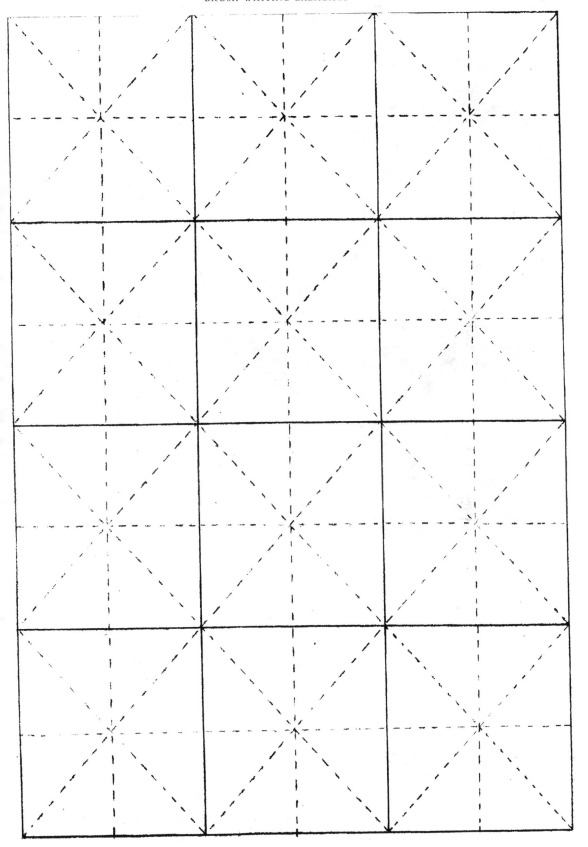

For Chapter 7

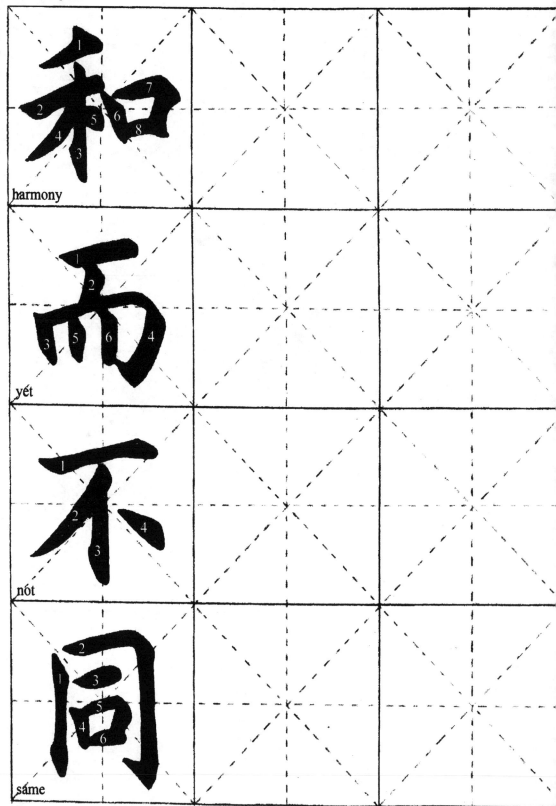

harmony

yét

nót

same

[Harmony with diversity.]

[sun-moon-mountain-river]

For Chapter 8

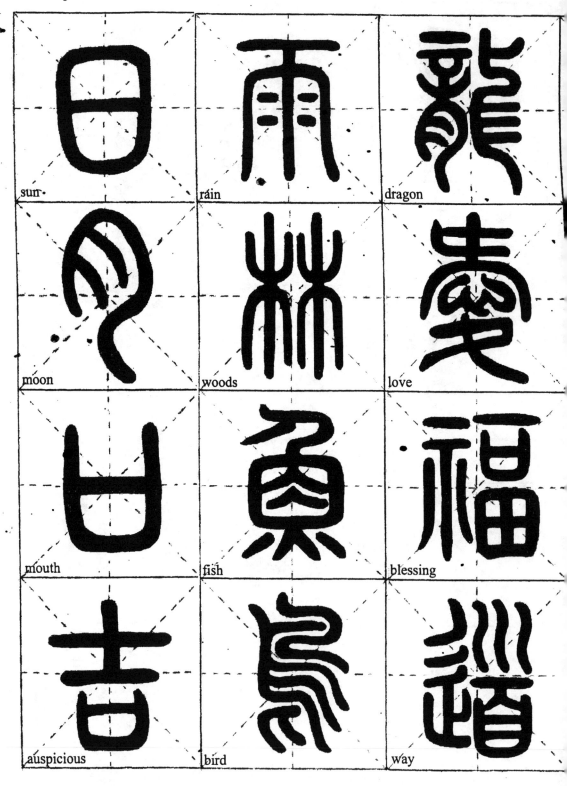

sun

rain

dragon

moon

woods

love

mouth

fish

blessing

auspicious

bird

way

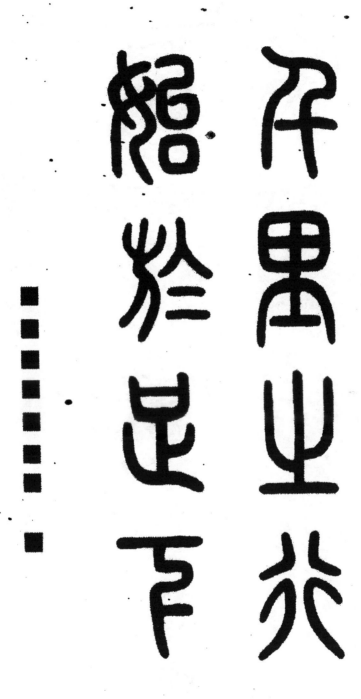

[A journey of thousands of miles starts from the first step.]

For Chapter 9

<u>Clerical Script</u>: The Wave Line, with Silkworm's Head and Swallow's Tail

water

day, sun

Dao/way

rain

month, moon

blessing

woods

year

predestined

fish

bird

dragon

千里之行

始於足下

[A journey of thousands of miles starts from the first step.]

For Chapter 10

千 thousand		
里 mile		
之 of		
行 journey		

始
start

於
from

足
foot

下
under

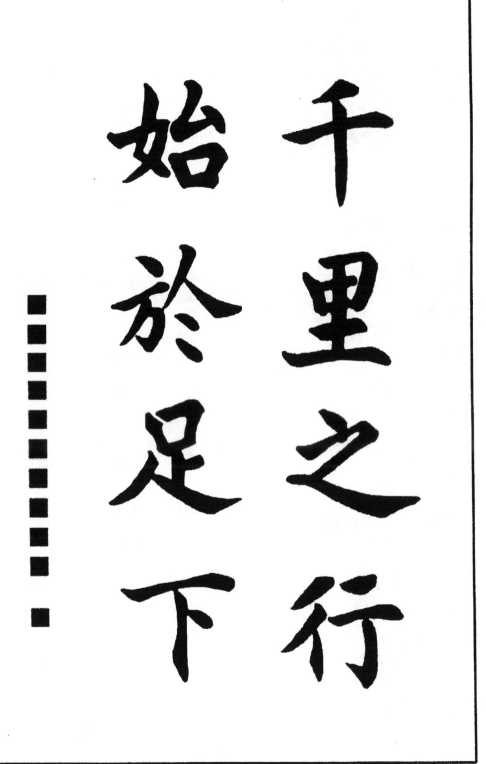

[A journey of thousands of miles starts from the first step.]

福 blessing		
道 Dao/way		
愛 love		
樂 happy		

For Chapter 11

[A journey of thousands of miles starts from the first step.]

[At the height of growth and vigor.]

[The cool breeze passes through sleeves and the bright moon enters the arms.]

For Chapter 12

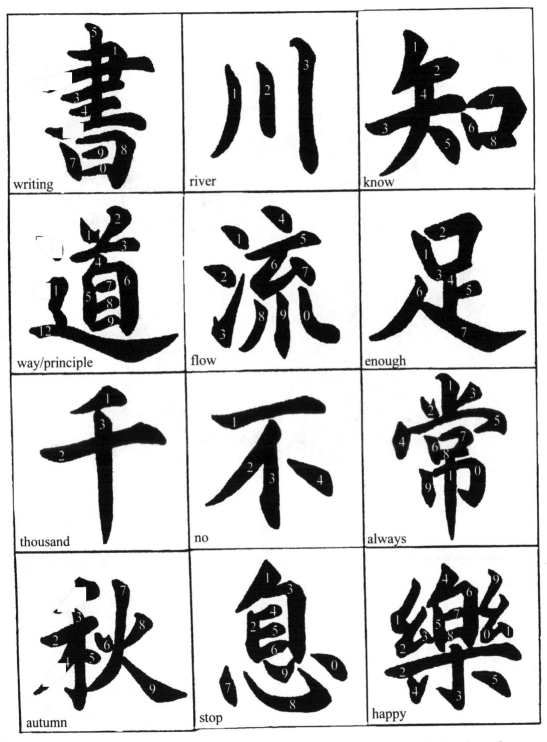

writing

river

know

way/principle

flow

enough

thousand

no

always

autumn

stop

happy

(left): [Calligraphy depicts ultimate reality.] (right): [Content is happiness.]

(center): [Rivers flow nonstop.]

[Content is happiness.]

For Chapter 13

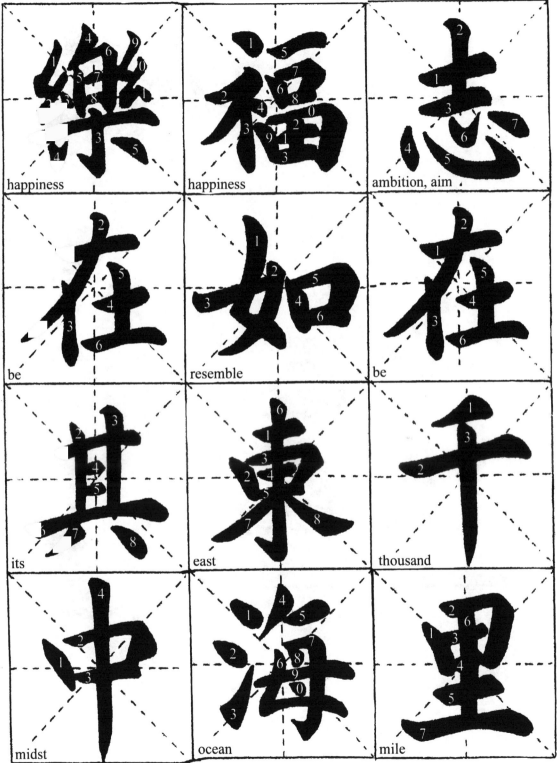

happiness

happiness

ambition, aim

be

resemble

be

its

east

thousand

midst

ocean

mile

(left): Happiness resides in the endeavor.] (right): [Let your aspirations soar.]
(center): [Happiness is as vast as the Eastern Sea.]

里千在志

志在千里

[Let your aspirations soar.]

For Chapter 14

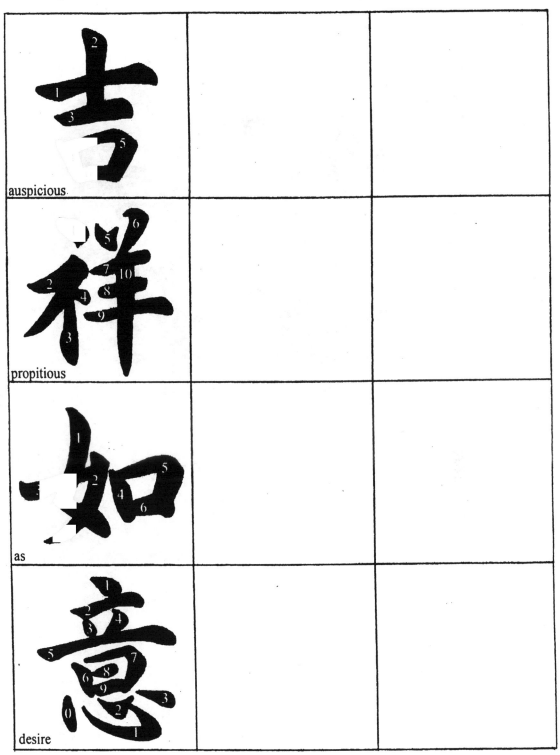

auspicious

propitious

as

desire

[Good fortune as you wish!]

[Good fortune as you wish!]

Pinyin Pronunciation Guide

PINYIN PRONUNCIATION GUIDE	
b–	as in _bay_
c–	as in _it's hell_
ch–	as in _cheese_, with the tongue curled more to the back
d–	as in _day_
f–	as in _food_
g–	as in _gay_
h–	as in _hay_
j–	as in _jeep_
k–	as in _car_
l–	as in _lay_
m–	as in _may_
n–	as in _net_
–ng	as in _sing_
p–	as in _pay_
q–	as in _cheap_, with the tongue higher and more to the front
r–	as in _red_, with the tongue tip curled far back, lips unrounded
s–	as in _say_
sh–	as in _shoe_, but with the tongue tip curled far back
t–	as in _tea_
w–	as in _way_
x–	like _sh_ in _she_, with the tongue higher and more to the front
y–	as in _yard_
z–	like _ds_ in _beds_
zh–	like _j_ in _just_, but with the tongue tip curled far back

	PINYIN PRONUNCIATION GUIDE
a	as in *far*
ai	as in *idle*
an	as in *bunch*
ang	*far* + *sing*
ao	as in *loud*
e	like the British *er*, with tenser muscles
ei	as in *eight*
en	as in *elephant*
eng	as in *lung*
er	like saying the letter *r*
i	as in *tea*
-i	(after z-, c-, s-, zh, ch-, sh-, r-) a vowel produced by keeping the tongue in manner of the preceding consonant
ia	i + a (like *Yah*)
ian	i + en (like *yen*)
iao	i + ao (like *yow* in *yowl*)
ie	i + e (like y*eh*)
in	like in
ing	as in *sing*
iong	i + ong
iu	i + (o)u (like *you* or *yoo* in *yoo-hoo*)
ong	*hood* + *sing*
ou	like *oh*
u	as in *rule*, but with more lip rounding

PINYIN PRONUNCIATION GUIDE	
ü	(=yu) like _tea_ but pronounce with the lips rounded as for the oo of _ooze_ (written as u after j, q, x, y)
ua	u + a as in wa̲t̲e̲r̲
uai	u + ai (like saying the letter "y")
uan	u + an (or ü + an after j, q, x, y)
uang	u + ang
ue	ü + e
ui	u + ei (like _weigh_)
un	u + n
uo	u + o

THE FOUR TONES

Voice range is divided into five levels to indicate the pitch contour of a tone: high (5), mid–high (4), mid (3), mid–low (2), and low (1). A tone mark is put on top of a vowel in a syllable.

first tone	5-5 flat like a hesitative "Ah—"
second tone	3-5 rising as in the question "What?"
third tone	2-1-4 as in a skeptical "Yeah . . . "
fourth tone	5-1 falling, as in an emphatic "Yes!!"

Notes

CHAPTER 1

1. See Kraus, *Brushes with Power*, for an in-depth discussion of the role calligraphy plays in politics in China.

CHAPTER 2

1. For further discussion, see Chen, *Chinese Calligraphy*, and Tseng, *A History of Chinese Calligraphy*.

2. Chen, *Chinese Calligraphy*; Tseng, *A History of Chinese Calligraphy*.

3. See Tseng, *A History of Chinese Calligraphy*.

CHAPTER 4

1. For further discussions of Chinese names, see Lip, *Choosing Auspicious Chinese Names*, and Louie, *Chinese American Names*.

2. Because there are different romanization systems in use, these surnames could

be spelled differently. For example, Zhang 張 could also be spelled Chang, Wang 王 is sometimes Wong, Zhao 趙 may be Chao, and Chen 陳 could also be Chan.

3. The consonant at the beginning of a syllable is optional; a nasal (such as "n") is also possible at the end of a syllable. Thus syllables such as "en" and "ing" (also written "ying") are acceptable.

CHAPTER 5

1. The effort to simplify traditional characters has both positive and negative implications. For further discussion, see DeFrancis, *The Chinese Language.*

CHAPTER 6

1. See chapter 2 of Kraus, *Brushes with Power,* for a discussion of this and other misconceptions regarding Chinese characters and calligraphy.

2. See DeFrancis, *The Chinese Language.*

3. 口 by itself is not a character and, thus, no pronunciation is assigned to it. Consequently, there is no romanization for the symbol.

CHAPTER 7

1. Square is the general shape of Chinese characters, although different script styles (e.g., Seal, Clerical, and Regular Script) vary to some extent in character shapes. This issue will be discussed in Chapters 8 through 10.

2. Zhou, *Hanzi jiaoxue lilon yu fangfa,* chap. 2.

3. See Chiang, *Chinese Calligraphy,* and Kwo, *Chinese Brushwork,* for excellent and comprehensive discussions of this topic.

CHAPTER 8

1. See Jin and Wang, *Zhongguo shufa wenhua daguan,* 9–12 for further discussion.

2. Refer to Tseng, *A History of Chinese Calligraphy,* for further discussion and an English translation of an elaborate classification of about ninety script styles by Yu Yuanwei of the Liang dynasty (sixth century).

3. Script names and the exact time periods they were used are an area of academic debate. Tseng, for example, presents a different view of the Great Seal Script. The English translations of the script names also vary from author to author. Jin and Wang also offer a discussion of this topic (*Zhongguo shufa wenhua daguan,* 9).

4. This is, again, an area of debate. Research has identified markings on black pottery and bronze vessels that predate the Shell and Bone Script, but scholars'

views differ on whether they can be considered symbols of a true written language (see Boltz, *The Origin and Early Development of the Chinese Writing System*; He et al., *Hanzi wenhua daguan*; Keightley, "The Origin of Writing in China"; Tseng, *A History of Chinese Calligraphy*).

5. See Liu, *Bainian hua jiagu*.

6. See also Liu, *Bainian hua jiagu*.

7. See Tseng, *A History of Chinese Calligraphy*.

CHAPTER 9

1. This is another example of a long and gradual development credited to one person. Although the official date for the invention of paper is 105 CE, archaeological evidence shows that paper was used for writing at least one hundred years before Cai Lun (Jin and Wang, *Zhongguo shufa wenhua daguan*, 452).

2. It could also be "silkworm's head and wild goose's tail" (蠶頭雁尾). 雁 and 燕 have the same sound, *yàn*, in Chinese but differ in meaning.

3. The twentieth year of the Kangxi era generally corresponds to the year 1681. But the twelfth month of the year in the Chinese calendar would be in 1682, owing to calendar differences.

CHAPTER 10

1. See Jin and Wang, *Zhongguo shufa wenhua daguan*, 20, for further discussion.

2. See Chiang, *Chinese Calligraphy*.

CHAPTER 11

1. See Tseng, *A History of Chinese Calligraphy*.

2. See Kraus, *Brushes with Power*, for further discussion.

CHAPTER 12

1. See Jin and Wang, *Zhongguo shufa wenhua daguan*, 687, and Tseng, *A History of Chinese Calligraphy*.

2. See Jin and Wang, *Zhongguo shufa wenhua daguan*, 43.

CHAPTER 13

1. See Watts, *Tao*, and Welch, *Taoism*.

2. See Lévi-Strauss, *Totemism*, and Pearson, *Shamanism and the Ancient Mind*, for more discussion.

3. For further discussion of the harmony of yin and yang, see Cooper, *Yin and Yang*; Watts, *Tao*; and Tang, "Opposition and Unity."

4. See Cooper, *Yin and Yang*, chap. 2 for further discussion.

5. See Jin and Wang, *Zhongguo shufa wenhua daguan*, 355–357, for further discussion.

6. Discussion of this topic can be found in Chen Zhenlian, *Shufa meixue*; Gu, *The Three Steps of Modern Calligraphy*; Kwo, *Chinese Brushwork*; and Xiong, *Zhongguo shufa lilun tixi*.

7. Jin and Wang, *Zhongguo shufa wenhua daguan*, 120–138.

8. Further discussion can be found in Jin and Wang, *Zhongguo shufa wenhua daguan*, 138–148.

9. See Kao et al., "Chinese Calligraphy and Heartrate Reduction," for reports on related physiological experiments.

CHAPTER 14

1. Part 3 of Kraus, *Brushes with Power*, offers a more detailed discussion of this point.

2. See Jin and Wang, *Zhongguo shufa wenhua daguan*, 7, for further discussion.

3. See Gu, *The Three Steps of Modern Calligraphy*.

4. Further discussion can be found in Barrass, *The Art of Calligraphy in Modern China*, and Gu, *Three Steps*.

5. See Jin and Wang, *Zhongguo shufa wenhua daguan*, 7, and Xiong, *Zhongguo shufa lilun tixi*, for further discussion.

6. See Tseng, *A History of Chinese Calligraphy*.

Glossary

bamboo slats	竹簡	*zhújiǎn*
boar (zodiac)	豬	*zhū*
borrowing	假借	*jiǎjiè*
Bronze Script	金文	*jīnwén*
brush	毛筆	*máobǐ*
calligraphy	書法	*shūfǎ*
center tip	中锋	*zhōngfēng*
character formation	造字	*zàozì*
chicken blood stone	雞血石	*jīxiě shí*
Clerical Script	隸書	*lìshū*
Clerical transformation	隸变	*lìbiàn*
collector seals	收藏章	*shōucángzhāng*
composition	章法	*zhāngfǎ*
copying	臨	*lín*
Cursive Style	草書	*cǎoshū*
dog (zodiac)	狗	*gǒu*
dot (stroke)	點	*diǎn*

down-left (stroke)	撇	*piě*
down-right (stroke)	捺	*nà*
dragon (zodiac)	龍	*lóng*
Duan inkstone	端硯	*Duānyàn*
Earthly Branches	地支	*dìzhī*
goat hair (brush)	羊毫	*yángháo*
Great Seal Script	大篆	*dàzhuàn*
hard (tipped) pen	硬筆	*yìngbǐ*
Heavenly Stems	天干	*tiāngàn*
hook (stoke)	鈎	*gōu*
horizontal line (stroke)	橫	*héng*
horse (zodiac)	馬	*mǎ*
Hu brush	湖筆	*Húbǐ*
Hui ink	徽墨	*Huīmò*
indicatives	指事	*zhǐshì*
ink	墨	*mò*
ink stone	硯	*yàn*
instruments	工具	*gōngjù*
intaglio	白文印	*báiwényìn*
large-size characters	大楷	*dàkǎi*
leisure seals	閑章	*xiánzhāng*
lift	提	*tí*
mid-size characters	中楷	*zhōngkǎi*
mi-grid	米字格	*mǐzìgé*
mixed hair (brush)	兼毫	*jiānháo*
model (for writing)	帖	*tiè*
monkey (zodiac)	猴	*hóu*
mouse (zodiac)	鼠	*shǔ*
name seals	名章	*míngzhāng*
nine-cell grid pattern	九宮格	*jiǔgōnggé*
official seals	官印	*guānyìn*
outline tracing	勾描	*gōumiáo*
ox (zodiac)	牛	*niú*
pause	頓	*dùn*
personal seals	私章	*sīzhāng*
pictographs	象形	*xiàngxíng*
press down	按	*àn*

rabbit (zodiac)	兔	*tù*
red tracing	描紅	*miáohóng*
Regular Script	楷書	*kǎishū*
relief	朱文印	*zhūwényìn*
rice paper	宣紙	*xuānzhǐ*
right-up tick (stroke)	提	*tí*
rooster (zodiac)	雞	*jī*
royal seals	璽	*xǐ*
Running Style	行書	*xíngshū*
script	書體	*shūtǐ*
seal carving	篆刻	*zhuànkè*
seals	印	*yìn*
Seal Script	篆書	*zhuànshū*
semantic compounds	會意	*huìyì*
semantic-phonetic compounds	形聲	*xíngshēng*
semantic transfer	轉註	*zhuǎnzhù*
sheep (zodiac)	羊	*yáng*
Shell and Bone Script	甲骨文	*jiǎgǔwén*
Shoushan stone	寿山石	*shòushān shí*
side tip	側锋	*cèfēng*
Small Seal Script	小篆	*xiǎozhuàn*
small-size characters	小楷	*xiǎokǎi*
snake (zodiac)	蛇	*shé*
square-grid pattern	方格	*fānggé*
strokes	筆畫	*bǐhuà*
stroke techniques	筆法	*bǐfǎ*
studio seals	斋馆印	*zhāiguǎnyìn*
tiger (zodiac)	虎	*hǔ*
tip	鋒	*fēng*
tracing	摹	*mò*
turn (stroke)	折	*zhé*
vertical line (stroke)	竪	*shù*
weasel hair (brush)	狼毫	*lángháo*
Wild Cursive Script	狂草	*kuángcǎo*
wooden slats	木簡	*mùjiǎn*

References

Atsuji Tetsuji. *Tushuo hanzi de lishi* 图说汉字的历史 (An illustrated history of Chinese characters). Translation into Chinese by Gao Wenhan. Shandong Huabao Chubanshe, 2005.

Barrass, Gordon S. *The Art of Calligraphy in Modern China*. Berkeley: University of California Press, 2002.

Boltz, William G. *The Origin and Early Development of the Chinese Writing System*. New Haven, CT: American Oriental Society, 1994/2003.

Chen, Tingyou. *Chinese Calligraphy*. Beijing: Wuzhou Chuanbo Chubanshe, 2003.

Chen Zhenlian 陳振濂. *Shufa Meixue* 書法美學 (Aesthetics of Chinese calligraphy). Xi'an: Shanxi Renmin Yishu Chubanshe, 2004.

Chiang, Yee. *Chinese Calligraphy: An Introduction to Its Aesthetic and Technique*. Cambridge, MA: Harvard University Press, 1973.

Cooper, Jean C. *Yin and Yang: The Taoist Harmony of Opposites*. Wellingborough [England]: Aquarian Press, 1981.

DeFrancis, John. *The Chinese Language: Fact and Fantasy*. Honolulu: University of Hawai'i Press, 1984.

Fang Chuanxin 方传鑫. *Lishu shijiang* 隶书十讲 (Ten lectures on Clerical Script). Shanghai: Shanghai Shuhua Chubanshe, 2003.

Gu, Gan. *The Three Steps of Modern Calligraphy*. Beijing: Chinese Book Publishing House, 1990.

Gugong fashu xuancui 故宮法書選萃 (Masterpieces of Chinese calligraphy in the National Palace Museum). Taipei: National Palace Museum, 1973.

Gugong wenju xuancui 故宮文具選萃 (Masterpieces of Chinese writing materials in the National Palace Museum) Taipei: National Palace Museum, 1971.

Guo, Bonan. *Gate to Chinese Calligraphy*. Beijing: Foreign Language Press, 1995.

Guo Nongsheng 郭農聲 and Li Pu 李甫, eds. *Shufa jiaoxue* 書法教學 (The teaching of Chinese calligraphy). Taipei: Hongye Wenhua Shiye Youxiangongsi, 1995.

He Jiuying 何九盈, Hu Shuangbao 胡双宝, and Zhang Meng 张猛, eds. *Hanzi wenhua daguan* 汉字文化大观 (A grand exposition of the culture of Chinese characters). Beijing: Beijing Daxue Chubanshe, 1995.

Jin Kaicheng 金開誠 and Wang Yuechuan 王岳川, eds. *Zhongguo shufa wenhua daguan* 中國書法文化大觀 (A grand exposition of Chinese calligraphy). Beijing: Beijing Daxue Chubanshe, 1995.

Kao, Henry S. R., Ping Wah Lam, Nian-Feng Guo, and Daniel T. L. Shek. "Chinese Calligraphy and Heartrate Reduction: An Exploratory Study." In *Psychological Studies of the Chinese Language*, edited by Henry S. R. Kao and Rumjahn Hoosain, 137–149. Hong Kong: The Chinese Language Society of Hong Kong, 1984.

Keightley, David N. "The Origin of Writing in China: Scripts and Cultural Contexts." In *The Origins of Writing*, edited by Wayne Senner. Lincoln: University of Nebraska Press, 1989.

Khoo, Seow Hwa, and Nancy L. Penrose. *Behind the Brushstrokes: Tales from Chinese Calligraphy*. Singapore: Graham Brash, 1993.

Kraus, Richard Curt. *Brushes with Power: Modern Politics and the Chinese Art of Calligraphy*. Berkeley: University of California Press, 1991.

Kwo, Da-wei. *Chinese Brushwork: Its History, Aesthetics, and Techniques*. Montclair, NJ: Allanheld and Schram, 1981.

Lévi-Strauss, Claude. *Totemism*. Boston: Beacon Press, 1963.

Lip, Evelyn. *Choosing Auspicious Chinese Names*. Torrance, CA: Heian International, 1997.

Liu Zhiwei 刘志伟. *Bainian hua jiagu* 百年话甲骨 (One hundred years of oracle bone inscriptions). Beijing: Haichao Chubanshe, 1999.

Louie, Emma Woo. *Chinese American Names: Tradition and Transition*. Jefferson, NC: McFarland, 1998.

Nan Zhaoxu 南兆旭 and Ji Zhongming 姬仲鸣, eds. *Long zhi wu—Zhongguo*

lidai mingren mobao dadian 龙之舞—中国历代名人墨宝大典 (Dancing of dragons—masterpieces of Chinese calligraphy). Beijing: Hongqi Chubanshe, 1997.

Pearson, James L. *Shamanism and the Ancient Mind: A Cognitive Approach to Archaeology*. New York: Altamira, 2002.

Sun Jiafu 孙稼阜. *Caoshu shijiang* 草书十讲 (Ten lectures on Cursive Script). Shanghai: Shanghai Shuhua Chubanshe, 2004.

Tang Huisheng. "Opposition and Unity: A Study of Shamanistic Dualism in Tibetan and Chinese Prehistoric Art." *Rock Art Research* 23.2:217–227 (2006).

Tseng, Yu-ho. *A History of Chinese Calligraphy*. Hong Kong: Chinese University Press, 1993.

Watts, Alan. *Tao: The Watercourse Way*. New York: Pantheon Books, 1975.

Welch, Holmes. *Taoism: The Parting of the Way*. Boston: Beacon Press, 1965.

Xiong Bingming 熊秉明. *Zhongguo shufa lilun tixi* 中國書法理論體系 (Theoretical systems of Chinese calligraphy). Taipei: Xiongshi Tushu, 1999.

Zhou Jian 周健. *Hanzi jiaoxue lilun yu fangfa* 漢字教學理論與方法 (Theories and practices of Chinese character teaching). Beijing: Beijing Daxue Chubanshe, 2007.

Zhu Tianshu 朱天曙. *Zhuanshu shijiang* 篆书十讲 (Ten lectures on the Seal Script). Shanghai: Shanghai Shuhua Chubanshe, 2004.

Books in English for Further Study

Bai, Qianshen. *Fu Shan's World: The Transformation of Chinese Calligraphy in the Seventeenth Century*. Cambridge, MA: Harvard University Asia Center, 2003.

Billeter, Jean Francois. *The Chinese Art of Writing*. New York: Skira Rizzoli, 1990.

Chang, Ch'ung-ho, and Hans H. Frankel. Two Chinese Treatises on Calligraphy. New Haven, CT: Yale University Press, 1995.

Chang, Joseph, and Qianshen Bai. *In Pursuit of Heavenly Harmony: Paintings and Calligraphy by Bada Shanren from the estate of Wang Fangyu and Sum Wai*. Washington, DC: Freer Gallery of Art, Smithsonian Institution, in association with Weatherhill, Inc., 2003.

Chang, Léon Long-yien, and Peter Miller. *Four Thousand Years of Chinese Calligraphy*. Chicago: University of Chicago Press, 1990.

Farrer, Anne. *The Brush Dances and the Ink Sings: Chinese Paintings and Calligraphy from the British Museum*. London: South Bank Centre, 1990.

Fazzioli, Edoardo. *Chinese Calligraphy: From Pictograph to Ideogram: The History of 214 Essential Chinese/Japanese Characters*. New York: Abbeville Press, 1987.

Fu, Shen. *Traces of the Brush: Studies in Chinese Calligraphy*. In collaboration with Marilyn W. Fu, Mary G. Neill, and Mary Jane Clark. New Haven, CT: Yale University Press, 1977.

Huang, Quanxin. *A Self-Study Course in Seal Script*. Beijing: Sinolingua, 1998.

Lai, T. C. *Chinese Calligraphy: An Introduction*. Seattle: University of Washington Press, 1975.

Ledderose, Lothar. *Mi Fu and the Classical Tradition of Chinese Calligraphy*. Princeton, NJ: Princeton University Press, 1979.

Li, Leyi. *Tracing the Roots of Chinese Characters: Five Hundred Cases*. Beijing: Beijing Language and Culture University Press, 1994.

Liu, Shi-yee. *Straddling East and West: Lin Yutang, a Modern Literatus: The Lin Yutang Family Collection of Chinese Painting and Calligraphy*. Edited by Maxwell K. Hearn. New York: Metropolitan Museum of Art, 2007.

Murck, Alfreda, and Wen C. Fong, eds. *Words and Images: Chinese Poetry, Calligraphy, and Painting*. New York: Metropolitan Museum of Art; Princeton, NJ: Princeton University Press, 1991.

Sturman, Peter Charles. *Mi Fu: Style and the Art of Calligraphy in Northern Song China*. New Haven, CT: Yale University Press, 1997.

Sullivan, Michael. *The Three Perfections: Chinese Painting, Poetry, and Calligraphy*. New York: G. Braziller, 1980.

Unger, J. Marshall. *Ideogram: Chinese Characters and the Myth of Disembodied Meaning*. Honolulu: University of Hawai'i Press, 2004.

Wang, Fangyu. *Introduction to Chinese Cursive Script*. New Haven, CT: Institute of Far Eastern Languages, Yale University, 1958.

Wu, Jianhsin. *The Way of Chinese Characters: The Origin of Four Hundred Essential Words*. Boston: Cheng and Tsui, 2007.

Yao, Min-Chih. *The Influence of Chinese and Japanese Calligraphy on Mark Tobey (1890–1976)*. San Francisco: Chinese Materials Center, 1983.

Yin, John Jing-hua. *Fundamentals of Chinese characters*. New Haven, CT: Yale University Press, 2006.

Index

About the Author

Wendan Li is associate professor of Chinese language and linguistics in the Department of Asian Studies at the University of North Carolina at Chapel Hill. She has taught a course entitled Chinese Culture through Calligraphy for eight years and has conducted workshops and presented papers at national and international conferences on course design and teaching Chinese calligraphy to American college students. Li is currently on the board of the American Society of Shufa Calligraphy Education, of which she is a past president. She co-chaired the 5th International Conference on East Asian Calligraphy Education held in Hiroshima, Japan, in 2006.

Li has also written *Topic Chains in Chinese—A Discourse Analysis and Applications in Language Teaching,* has co-edited *East Asian Calligraphy Education,* and is published regularly in academic journals on Chinese language teaching.